P9-DMS-777

colin cowie
wedding
chic

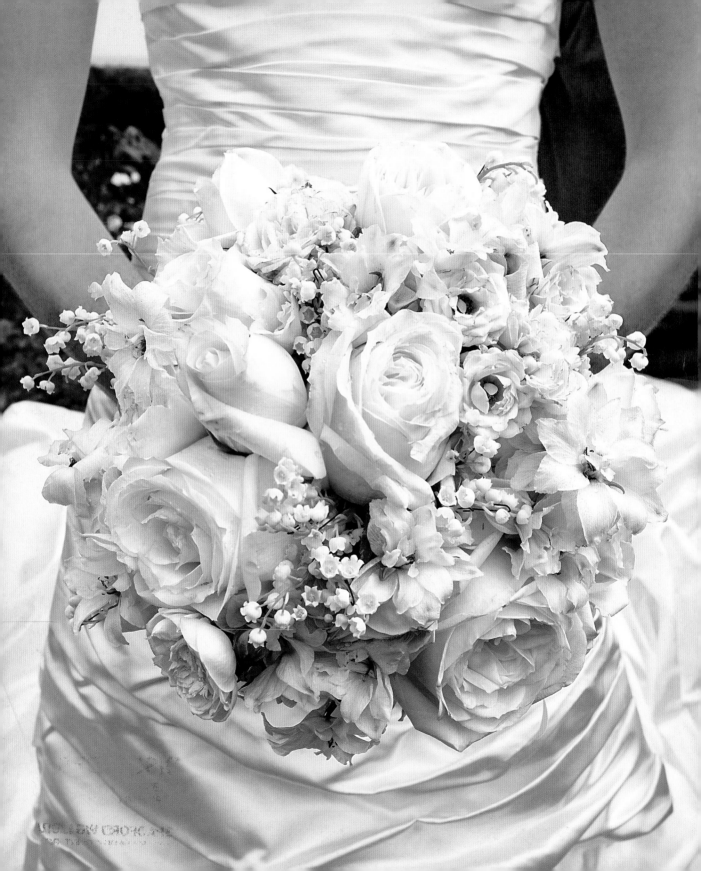

colin cowie

wedding chic

1001 ideas for every moment of your celebration

clarkson potter/publishers
new york

DISCARDED
BRADFORD WG
PUBLIC LIBRARY

BRADFORD WG LIBRARY
100 HOLLAND COURT, BOX 130
BRADFORD, ONT. L3Z 2A7

Copyright © 2008 by CAW Cowie, Inc., a California corporation

All rights reserved.
Published in the United States by CLARKSON POTTER/PUBLISHERS,
an imprint of the CROWN PUBLISHING GROUP,
a division of RANDOM HOUSE, INC., New York.
www.crownpublishing.com
www.clarksonpotter.com

CLARKSON POTTER is a trademark and Potter with
colophon is a registered trademark of Random House, Inc.

Library of Congress Cataloging-in-Publication Data

Cowie, Colin, 1962–
 Colin Cowie wedding chic : 1,001 ideas for every moment of your celebration / Colin Cowie.
 p. cm.
 Includes index.
 1. Weddings—Planning. 2. Wedding decorations. 3. Weddings—Equipment
and supplies. I. Title.
 HQ745.C684 2008
 395.2'2—dc22
ISBN 978-0-307-34180-8 2007051282

Printed in China

See page 352 for photograph credits

DESIGN BY JENNIFER K. BEAL DAVIS

10 9 8 7 6 5 4 3 2 1

First Edition

To every member of my team who graduated from The University of Whatever It Takes, my eternal gratitude for helping make these dreams come true. Without your hard work, untiring energy, dedication, and passion, these stories would never have come to life the way they did.

Thank you for being part of the magic.

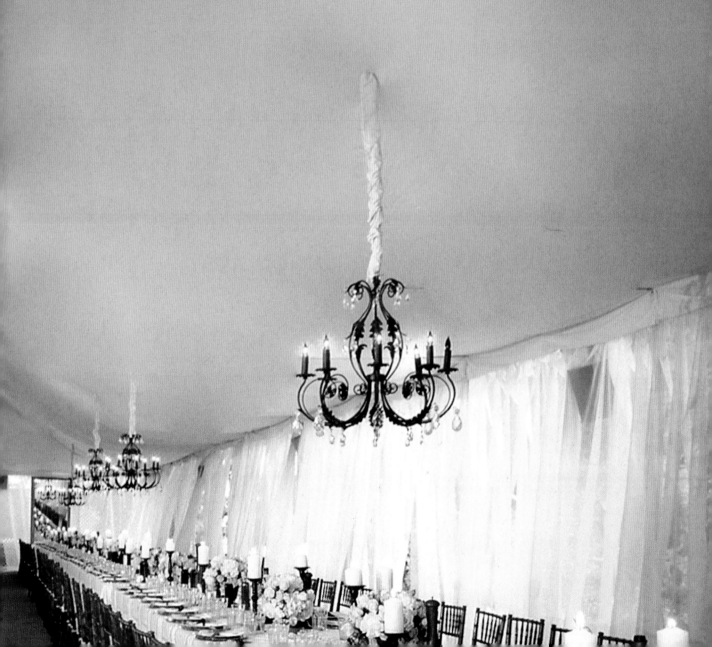

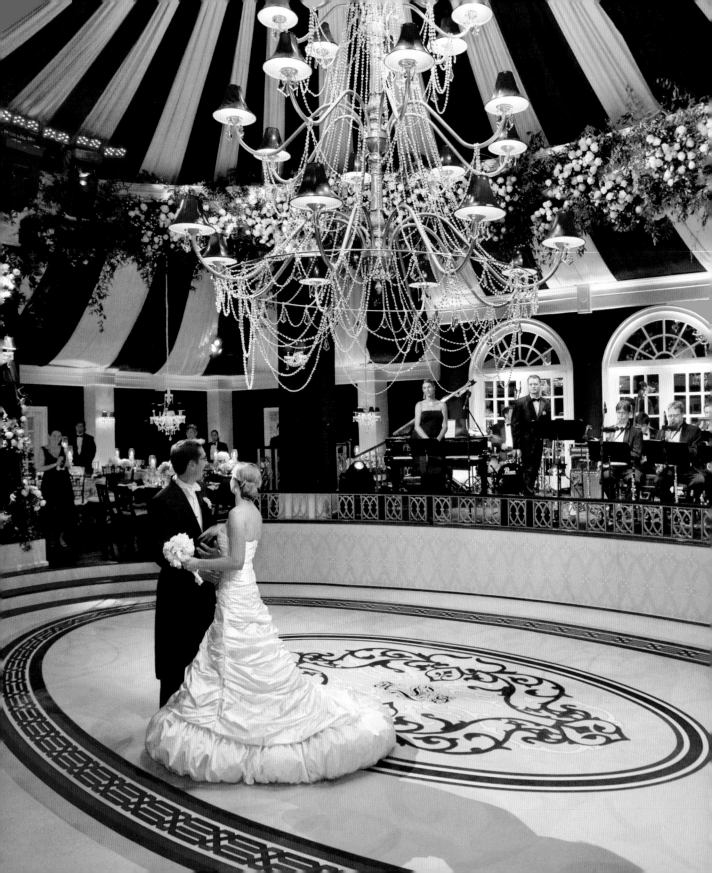

contents

introduction

Wouldn't it be great to hear your friends say they just came back from the most amazing wedding ever? Perhaps they'd recall how magnificent the bride looked as she came down the aisle, groom waiting handsomely at the altar. Or how they dined on delicious food, danced for hours until the sun came up, and had the best time of their lives. You can almost feel the excitement as the story is told, details recounted with such precision you'd think they had recorded everything on videotape. Nine times out of ten you'll find that what they remember most is some small detail that was special and unique, personal to the bride and groom. It may have been an orchestration of music playing during the ceremony, the flattering cut of the dress and the dazzling necklace the bride was wearing, the groom's toast while cutting the cake, or the party favors waiting in the car; there are so many pieces to the puzzle, and how they're all put together is what makes memories that will last forever.

And now it's your turn to be the bride. It's your wedding from beginning to end and it needs to be entirely about you and your fiancé. The pictures in this book are meant to inspire and excite you. Some may be exactly what you've been envisioning and others may not spark inspiration. Use them as your guide, weed and filter through what's right for you and what's not. The invitations you send, the dress you wear, the foods you serve, the decorations in the room, and even the flavor of your wedding cake should all reflect your personal tastes and style.

Every bride I meet wants her party to be special. Your wedding is the beginning of a wonderful journey and getting married is a milestone that needs to be celebrated with passion. The care you put into each decision, even the smallest of details, is a reflection of you and your fiancé, and the love you put in will come back to you tenfold. I still remember the very first wedding I designed, back in 1985, when I moved to Los Angeles from South Africa and started a catering business. The bride and her mother came to my office with hundreds of tear

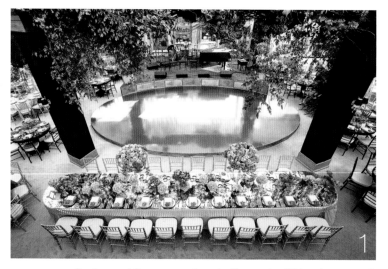

sheets and fabric swatches, pictures of topiaries and wildflowers, palaces and beach resorts, a thousand fantasies, and a million ideas. The bride's mind was reeling in every conceivable direction: She wanted everything she'd ever seen and read about to be a part of her wedding. My job was to remind the bride to breathe, to organize and edit her thoughts, to focus on designing the big picture first, and then, and only then, to fill in the small details, discard whatever didn't fit into the larger scheme, and build on the elements that truly worked. After spending several hours and sharing a bottle of wine, I went from being the caterer to the party planner; we knew exactly how the napkins were going to be folded, which flowers she would carry, how her cake would be designed, what music should accompany her first dance, the way her tables would look, and even the party favors her guests would be taking home! We covered every nuance in that meeting and devised a game plan for her wedding that was gracious, inspiring, and deeply personal. By the time her wedding day rolled around, nothing had been overlooked; we had woven a consistent thread of style from beginning to end. And for me, there was no turning back: I found my calling and had a new career that I could only have dreamed about back in Africa.

More than two decades later, I still remember every detail of that wedding as if it were yesterday: the wording on the invitations, the font style, the color scheme, even the color of the ink and the quality of the card stock. And after organizing countless other parties, I still use the same approach: Imagine the big picture,

1 SPECTACULAR SETTING: The focal point of this party, besides the stunning main table, is the glittering gam-covered oval dance floor positioned in the center of the room. 2 LOGO'D WELCOME: I try to personalize every event as much as possible, and in this instance that's accomplished by projecting the wedding's logo—the bride's and groom's initials—onto the bottom of the swimming pool, welcoming guests to the after-party.

then fill in the details, down to the smallest touch—a touch that may seem to go unnoticed by all except for me and the bride, but believe me, it actually does produce a ripple effect; when the bride is delighted, so are the guests!

I recommend this same approach to you—and to every bride I meet. Give it some serious thought and really focus on who you and your groom are, what you're about, and how that translates to the visual aspects of your celebration and the guest experience. Are you the type of casual couple for whom a barefoot-on-the-beach destination wedding is perfect? Does earthiness define you, with olive greens and rich aubergines as your colors of choice? Do you envision a formal affair with all the attendant pomp and circumstance and a horse-driven carriage? Is there one special place that fills your heart, an oasis that defines your wedding?

Getting married is one of life's greatest milestones, and it should be as personal as possible—this begins by making the ceremony and celebration something that's driven by your passions, your priorities, the things that bring you genuine happiness. You don't have to get married with a large bridal party, offer a sit-down multicourse dinner, or serve Champagne at the cake cutting. This truly is your day, and the rituals, ceremony, and conventions can be infinitely adapted, interpreted, reinvented. I'll let you in on a little secret: It's not about being extravagant and spending a small fortune, it's about making the day special and ensuring that everyone is made to feel welcome and comfortable. The amount of money you spend has nothing to do with style. Don't limit yourself when dreaming big; you can always cut your coat according to the cloth when it's time to make your final decisions. Think big, then edit as you go along.

Whatever sort of event you choose—whether an intimate affair for a small group of your nearest and dearest, or a major blowout for hundreds who've gathered from around the globe—it's the little things that will be remembered for years to come. Although seeing the big picture is the first step, it's important to consider even the

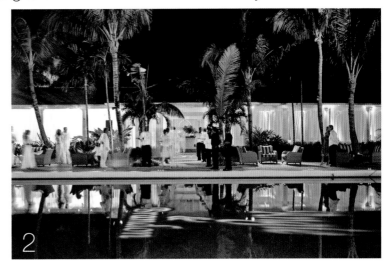

smallest detail. Even if you're planning to elope, you'll still need a bouquet, a dress, and a bottle of chilled bubbly afterward! What you'll wear, what you'll carry, and what you'll drink will be remembered as clearly as the vows you'll exchange. Don't discount off-the-cuff ideas you may have, or inspirations you want to include. But be sure to keep in mind my mantra: Great style comes from ruthless editing. Every detail should serve and enhance the big picture.

That's the focus of this book: inspiration and advice to help you go that extra mile and create those once-in-a lifetime moments—the things that dreams are made of. So if it's a Champagne reception after an evening ceremony, consider how the bubbly is served, the shape and weight of the glass, whether you'll pour from an magnum or have waiters passing it as guests enter the room.

This book is about choosing those details: the cut of your gown, the heft and texture of your table linens, the pin-spot lighting illuminating the flowers at the reception, the song that will be playing when it's time to dance, spirits are high, and everyone's ready to get the party started. I hope this book will be a tool that allows you to use my energy, imagination, and years of experience to help you create your own path down the aisle.

Be inspired, have fun, and enjoy the journey.

1 CLASSIC COMBINATION: Cream roses surrounded by a cuff of Leonidas brown roses and lemon leaves are a subtle, elegant favorite. 2 MATCHED SET: These bridesmaids wear identical dresses and shoes and carry identical bouquets for a uniform and elegant look. 3 FITTED BODICES: For a Saturday-morning ceremony, these bridesmaids look ethereal in their tight bodices and full tulle skirts front-lit by the sun. 4 CAKE TO MATCH THE TABLECLOTH: The floral pattern of the tablecloth is hand-painted onto the cake and finished with the lavish use of an iced ribbon.

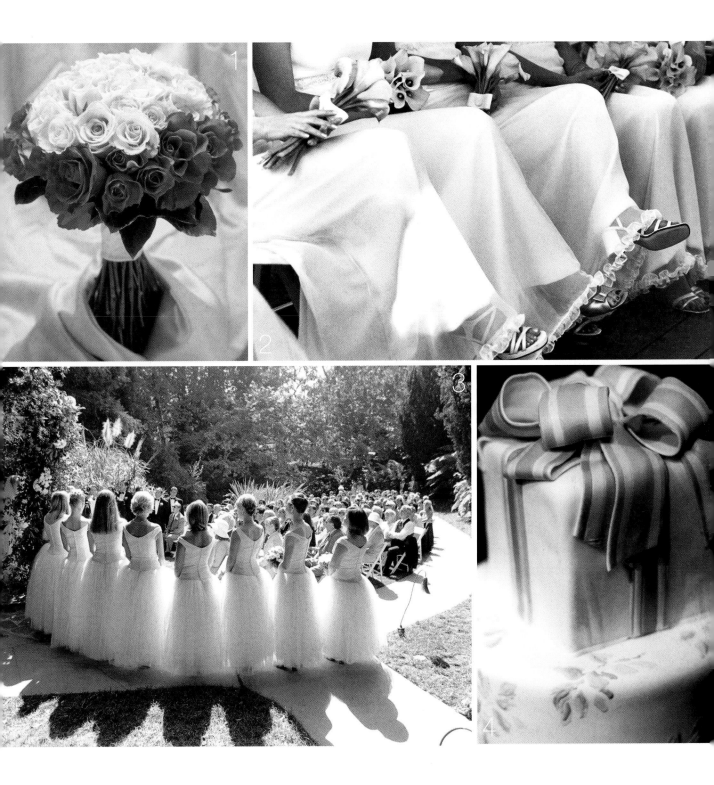

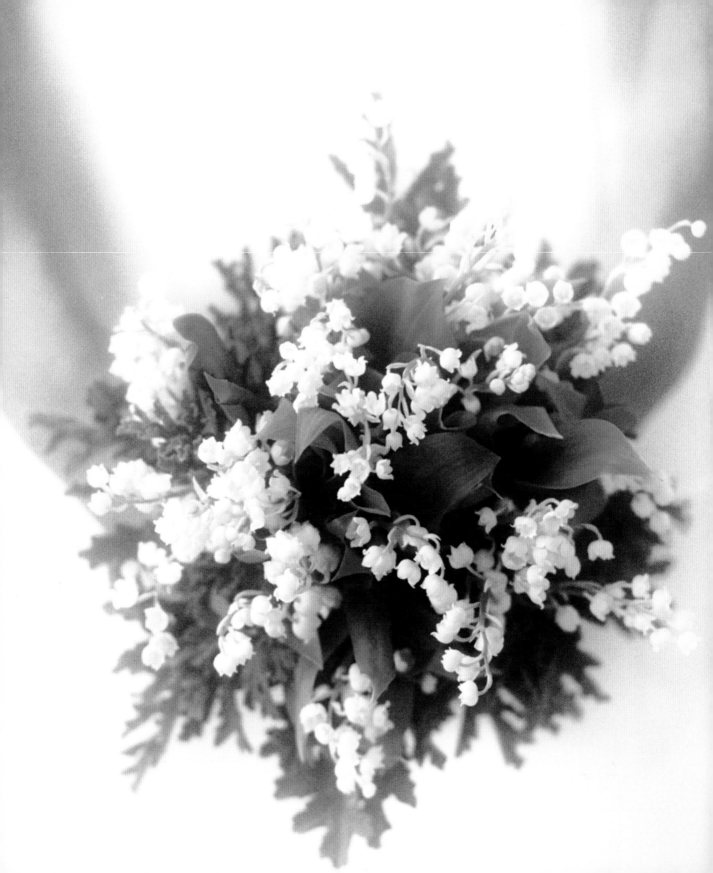

1
bouquets and other ceremony flowers

When you dream of your wedding, you probably imagine exchanging vows before a hushed gathering of family and friends. You can practically see yourself at the altar, taste the Champagne, and hear the song that will be playing when you join your groom on the dance floor. But more than anything else, you're probably picturing yourself in a gorgeous gown, complete with shoulder-skimming veil, a pair of fabulous satin shoes that make it look as if your legs go on forever, and, to top it all off, the absolutely magnificent bouquet you'll carry as you glide up the aisle, ready to embark on a new life.

As you already know, bridal bouquets come in different shapes, colors, sizes, and styles: nosegays, cascading bouquets, pomanders, free-form, wired, and hand-tied varieties. What's right for you depends on the design of your dress, the style of your celebration, your body type—all of these factors need to be considered when you speak with the florist about your personal flowers. You should discuss fragrance: Do you want the particularly heady perfume of heirloom lilacs—or something more citrusy? The flowers themselves range from fresh-from-your-own-backyard garden roses tied with a simple silky lime-green ribbon to the ultradelicate, sculpted, stark white fragrant stephanotis blossoms, which actually need to be plucked one small bud at a time from their waxy vines, then individually

MY SIGNATURE AND FAVORITE BRIDAL BOUQUET: Lily of the valley surrounded by a cuff of scented geranium is not only a beautiful arrangement and one of the most delicate, but also presents an extraordinary combination of fragrances.

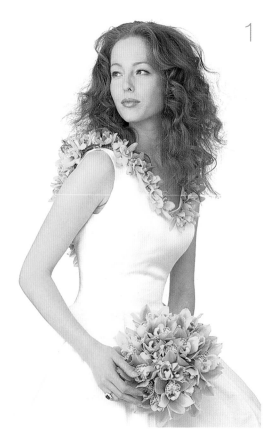

1 threaded onto wet, elongated wire Q-tips that keep them hydrated and fresh. No matter what you decide, keep in mind that beyond flowers, bouquets can also incorporate beading, silk, and ribbons, with construction that may include an intricate wire system or a painstaking hand-pulling and hand-tying process. You can add decorative accessories, such as a pearl pin in the throat of each blossom, for one more dazzling touch; you can wrap the whole bouquet in tulle or place sparkling crystals on wires between the flowers. The options are limitless. So often florists leave stems unfinished; instead, why not finish the bouquet handle as another special detail? They can be wrapped tightly in a carefully braided ribbon or a gorgeous piece of fabric that corresponds to the color scheme of your wedding.

Bouquets help complement your dress and the style of your ceremony. To me, a romantic handheld profusion of fuchsia and soft pink peonies is ideal for spring; an arrangement that trails with strands of ribbon and tiny seashells definitely says beach chic. I find that brides are often drawn to shades that reflect their personalities: Some prefer the softest pastels, while others crave the high glamour of lily of the valley in crisp white. And if you're looking for something particularly striking, Black Magic roses are my hands-down first choice for drama. Be wary of a white-on-white bouquet against a stark white dress. Although it may look beautiful in person, it won't read as well in photographs. Instead, if your heart is set on an all-white wedding, mix soft shades of cream or delicate greens into your bouquet for added texture and dimension.

1 VIBRANT AND FRESH: For added glamour, this bride wears a garland that matches her bouquet, fashioned from chartreuse cymbidium orchids.

Also, don't forget some of the most eye-catching floral accessories that aren't held in the hand at all—from a ravishing boa wrapped around the bride's shoulders to a garland delicately stitched onto the bridesmaids' necklines, or a gentle halo of blossoms woven into a flower girl's hair. Look at flowers as accessories that complement your attire and add an extra, personalized touch to your appearance.

In most ceremonies bouquets are handheld. To those brides carrying the "traditional" bouquet, I offer two pieces of advice: First is that the handle shouldn't be too long, or it'll look like another limb. Many florists design bouquets, but few carry them; so although the stems may look good on a bouquet, be sure they are short enough to look elegant and easy when you hold them. Second is—and I want you to commit this one to memory—as the processional music begins to play, take a moment to collect yourself, breathe deeply, put your shoulders back, and hold your flowers *as low as possible*. It's natural to be nervous when you're the center of attention. In response, many brides inadvertently pull their bouquets into their bellies or up to their chests—it's almost a protective mechanism. Unfortunately, this will make the bouquet look as if it is growing out of your stomach; it will cut your body in half and make you look shorter and—horrors—possibly heavier than you actually are. I've never met a bride who didn't want to be taller

and thinner, and holding the bouquet below your waist accomplishes exactly that, without skipping a single meal or adding another inch to your heels. So relax, keep your elbows straight and your hands at your waist so the bouquet sits low on your hip.

Whether a bouquet is held in the hand or wrapped in tulle and draped over your shoulders, take extra care, since flowers are fragile and can perish easily. There's a reason why most bouquets are fashioned from roses, peonies, lilies, and other more hardy varieties of flowers. That doesn't mean you need to shy away from gardenias, viburnum, lily of the

2 TIGHTLY PACKED SWEET PEAS: This bouquet of closely clustered matching sweet peas features a tropical leaf detail and a cream silk ribbon affixed with pearl pins.

valley, or hydrangeas, if they're what you love and your heart is set; just be prepared and take precautions. Hydrangeas need to be kept in water as long as possible, lilies of the valley and gardenias bruise easily and need to be kept upright and not resting on their side, viburnum need to have the ends of their stems smashed so they can soak up water and hydrate well before being fashioned into a bouquet.

Ideally, the bouquet should be made the day of the event for optimum freshness and kept refrigerated until the very last moment before the ceremony. If you'll be taking photographs before the ceremony and your flowers are delicate, ask your florist to make two bouquets. And if you're planning on tossing your bouquet, you'll probably want your florist to make one for you to carry and another, smaller, more lightweight, less expensive arrangement for you to toss (not throw) to your single girlfriends; there's a difference between sweeping people off their feet and knocking them down.

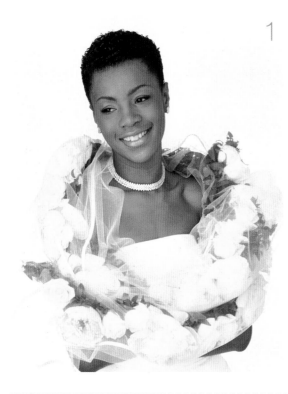

1

When figuring out all these details with the florist, bring along your supporting reference material: schematic drawings of the ceremony area, swatches of your dress fabric as well as a sketch of its design, and representations of any other major visual elements that will share the stage with you and your bouquet. Look through bridal magazines and books—even gardening books can be inspiring. The flowers should complement, not compete with, your dress; an ornate gown might cry out for a bouquet made with a single type of flower, while a simple

1 GLORIOUS GARLAND: Instead of a handheld bouquet, this bride carries a long floral boa made of smilax, peonies, and roses, wrapped in satin-edge tulle that protects both the flowers and the bride.

dress might be perfectly matched with a more extravagant arrangement studded with crystals and silk ribbon streamers.

Of course, the bridal bouquet often relates in some way to the bridesmaids' bouquets, and may also take many elements of the ceremony into consideration. Ideally, the bride's bouquet should be larger than her attendants'; you'll probably also want the maid of honor's bouquet to be slightly larger than the other bridesmaids', to signify her key role in your life.

Other members of the wedding party also deserve your attention: junior bridesmaids, ring bearers, and flower girls—the adorable little people who never fail to garner oohs and aahs when they appear at the top of the aisle, preceding the bride, carrying their floral baskets or cushioned

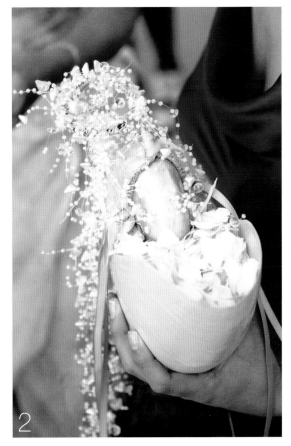

ring pillows, with wreaths in their hair and ribbons streaming down their backs. In the past, mothers and grandmothers on both sides of the aisle received corsages, but now many women prefer to have handheld or wrist corsages, so they don't have to worry about pins damaging their dresses. It's also de rigueur for the fathers, grandfathers, brothers, and of course groomsmen to be given boutonnieres— often a single flower that was traditionally inserted through the buttonhole on a lapel (hence the word *boutonniere*), but is now often pinned onto it.

2 FLOWER GIRL'S GIANT SEASHELL: For a beach-themed wedding, this giant shell is filled with rose petals and boasts a whimsical pearl garland.

All these flowers are a great way to honor your close family and friends and to make them feel like true participants in your wedding and not just passive observers or other invited guests. (The actress Lisa Kudrow took this idea one thoughtful step further: She walked down the aisle with her parents but without a bouquet. When she approached the altar, her closest friends walked up and handed her a cluster of flowers, which her mother then gathered, tied together with a ribbon, and presented to the bride. Thus her friends—including the cast of *Friends*—created a very personal bouquet.)

Now for the groom himself: Floral designers have become very clever at using flowers in a masculine fashion without sacrificing what's beautiful and delicate about them. Typically, the groom's boutonniere contains a single element of the bride's bouquet, either a single matching flower or simply a matching color. When it comes to the groomsmen, choose something distinct from the groom's boutonniere; it could be a smaller version of the bride's florals, or an entirely different blossom, depending on your preferences.

Finally, it's a good idea to have your florist make a few extra boutonnieres and corsages for people who may have slipped your mind during the planning process or in case one gets damaged accidentally. There's no need to be stressed over a flower! And do be sure to give whoever is responsible for distributing corsages the name, and possibly a brief description, of each recipient, so he or she can be located discreetly and efficiently. You don't need someone running around searching for "the bride's aunt Christina from Santa Barbara." It's also a good idea to have everyone in the bridal party arrive at least thirty minutes before the invitation time. Nervous mothers of brides tend to want the bridal party to arrive earlier, but I'm strict about this: You want people to be fresh. A half hour or so is sufficient to remind everyone of his or her role in the ceremony but not so long that the ring bearers get fussy, the bridesmaids' makeup melts, or the best man starts to wilt. With just enough time to build the excitement and not so much time that they'll get bored, your bridal party—as well as their carefully chosen bouquets and boutonnieres—will be bright, beautiful, and in full bloom.

NASCENT BUD: This ranunculus bud, bound in a tropical leaf, hasn't yet blossomed.

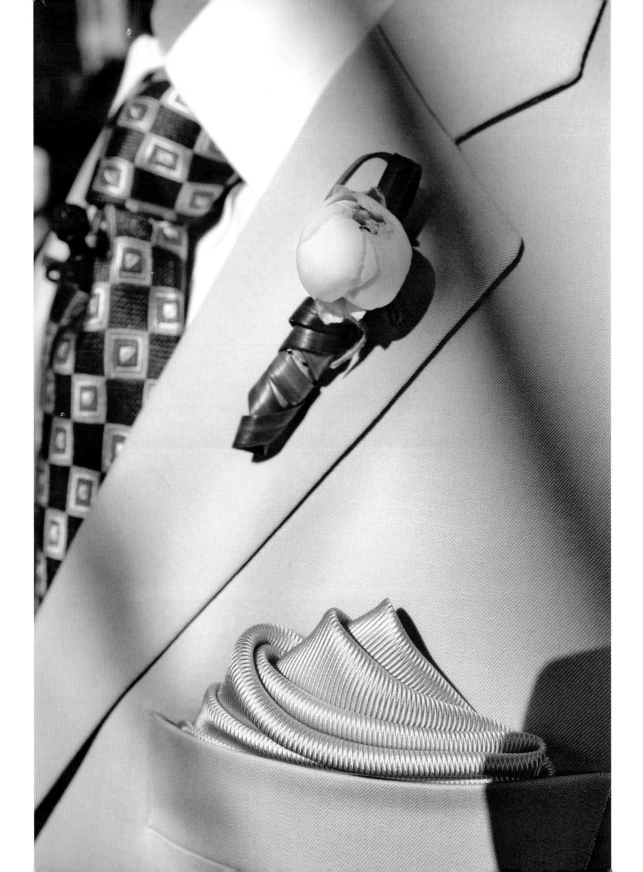

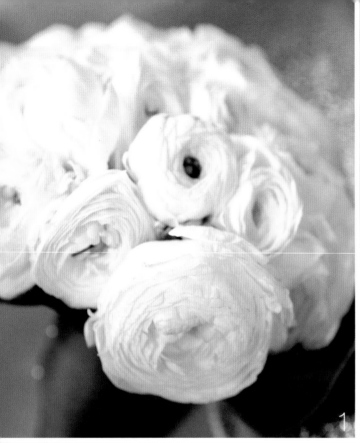
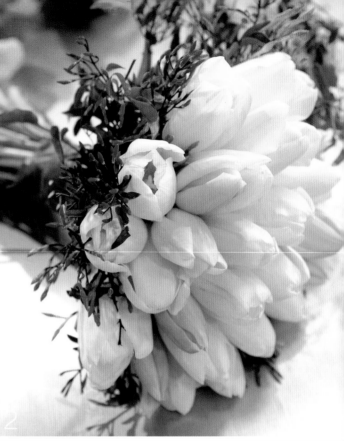

1
2
3
4

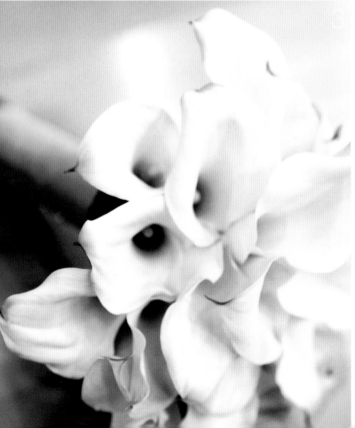
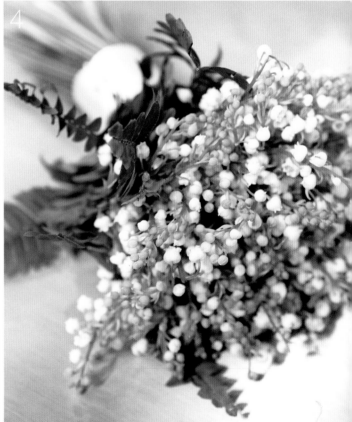

whites

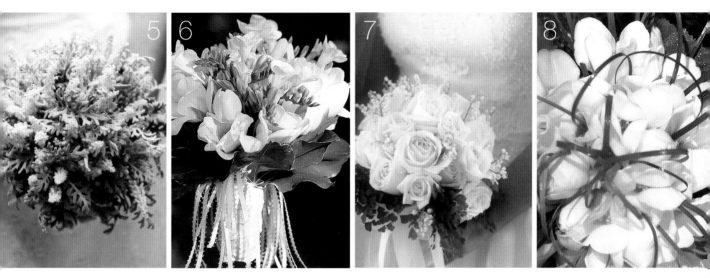

1 EBULLIENT WHITE: A gorgeous bouquet of ranunculus is bursting and ready to open, with stems barely contained in a tropical green leaf that's secured with pearl pins.

2 FRENCH WHITE: A ring of night-blooming jasmine surrounds a bouquet of tight French tulip blossoms.

3 RESTRAINED WHITE: This very pristine and elegant bouquet is fashioned out of mini calla lilies whose stems are wrapped in chartreuse silk ribbon.

4 LUXURIOUS WHITE: This tight bouquet of delicate, fragrant, and wildly expensive lily of the valley is backed with hearty Boston fern, one of the least expensive ferns.

5 SILVERY WHITE: This beautiful winter bouquet consists of white grape hyacinth sprinkled among silvery gray Dusty Miller leaves.

6 TEXTURES OF PURE WHITE: Gently folding Vendela roses are punctuated by lily of the valley and encircled by maidenhair fern.

7 RIBBONED WHITE: Fragrant white freesias are set against variegated ivy and arranged with an elegant spray of silk ribbon.

8 MODERN WHITE: A contemporary architectural bouquet is made solely of waxy white tulips that are threaded through with loops of bear grass.

pomanders

1 TRUE ROMANCE: Sari roses and stephanotis blossoms are wrapped in a veil of tulle, just like the bride. For added glamour, there's a pearl pin in the throat of each stephanotis blossom.

2 MINIATURE WHITE: The tiny stems of stephanotis blossoms are threaded using Q-tips and wires for a painstakingly handcrafted bouquet.

3 SUBLIMELY SUMMER: Yellow roses, white hyacinth, and variegated ivy leaf are punctuated with lemons for a spectacular outdoor wedding bouquet.

4 SIMPLE AND MODERN: The temperamental viburnum bloom, surrounded by scented geranium leaves, makes for a clean, contemporary, and utterly chic bouquet.

5 VARIATION ON A THEME: This pavé bouquet is made entirely of white and blush spray roses, which have multiple small blooms on each stem, tightly packed for a rich, abundant look.

6 PUNCTUATED WHITES: One of my favorite approaches is a monochromatic mixture of flowers, such as these white roses combined with white carnations and interspersed with hypericum's bright red berries and vibrant green leaves.

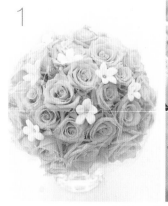
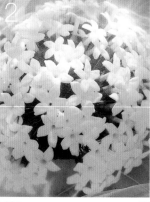
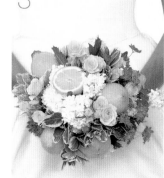
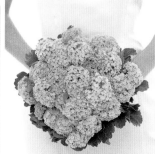
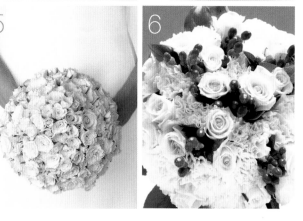

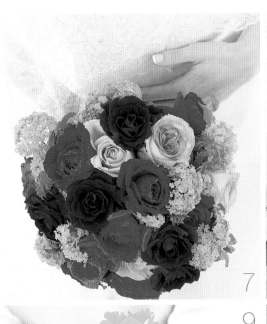

7 8

9 10

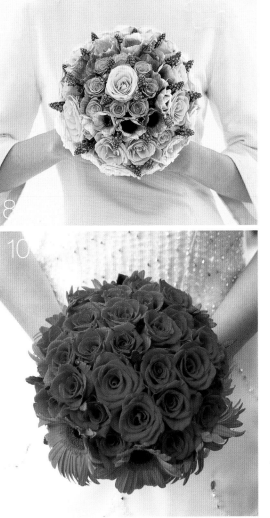

7 COLOR EXPLOSION: This combination of brightly colored roses punctuated with lime-green viburnum blossoms makes for a truly eye-catching bouquet.

8 COLORFULLY SOFT: A soft palette creates a wonderfully romantic classical posy in concentric circles of roses, anemones, and grape hyacinth.

9 SPRING FLING: For a look that's 100 percent April in Paris, inexpensive daffodils are showstopping when arranged in tight circles.

10 HOT, HOT, HOT: Lusting for bright color? Look no further than jacaranda pink roses with a collar of mango-colored gerbera daisies.

cascades

1 **WHITE ON WHITE ON WHITE:** This very romantic bouquet comprises white garden roses, lily of the valley, Eucharist lily, and Easter lily.

2 **CLASSICAL CASCADE:** Sorbet-colored roses spill into lily of the valley and stephanotis blossoms in this classic shape.

3 **HANDHELD AND GARLANDED:** This beautiful play on color is a combination of individual gladiolus blossoms and light pink astilbe, with a matching floral necklace. So chic.

4 **HIGH DRAMA:** Make a sensational statement with this pear-shaped bouquet of Black Magic roses.

5 **SHADES OF WHITE:** A thick hand-dyed four-inch silk ribbon adds the finishing touch to the subdued monochromatic bouquet of white and taupe roses.

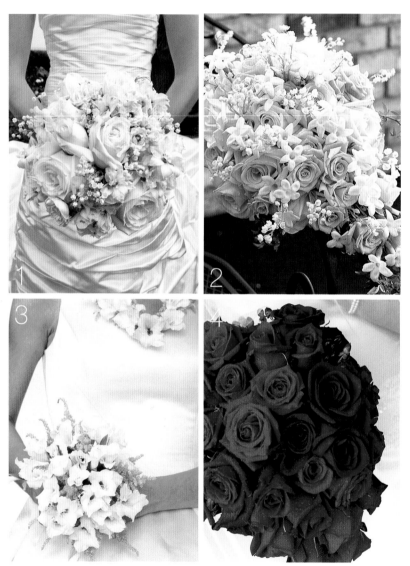

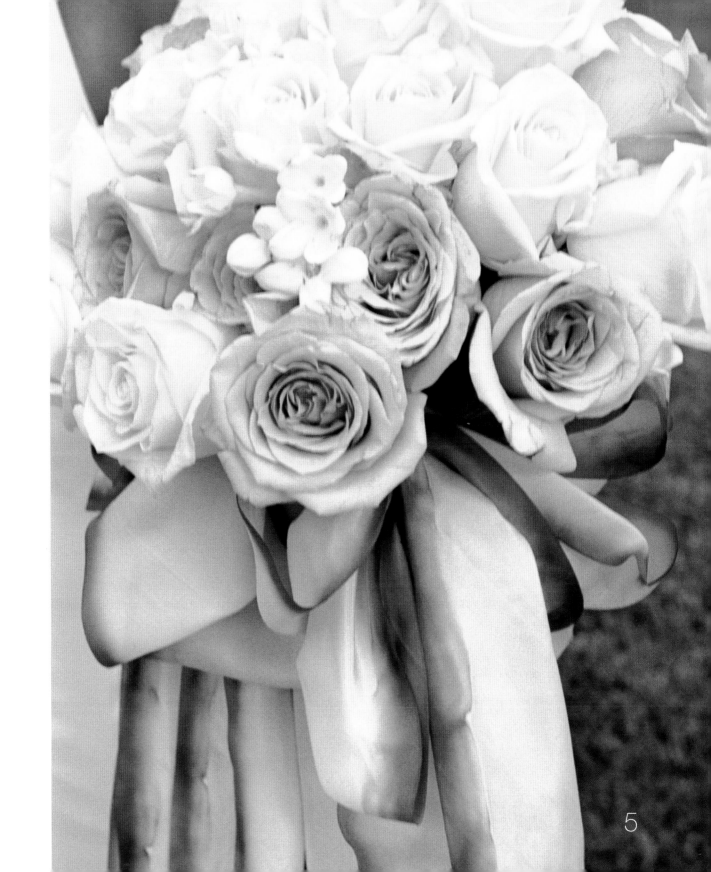

hand-tied

1 **TULIPMANIA:** This completely simple yet very striking bouquet consists of nothing more than three dozen hand-tied orange and red tulips.

2 **EFFUSIVE REDS:** A cluster of slipper orchids nestles in a bed of leaves, dressed up with soft pink ribbon streamers.

3 **PASTELS AND PEARLS:** This spring arrangement is a combination of white and lavender freesia, pink spray roses, white roses, and variegated ivy, all bound with a celadon silk organza ribbon and studded with pearl pins.

4 **FORMAL WHITE:** Beading taken from the bride's dress interlaces this hand-tied assortment of roses and stephanotis.

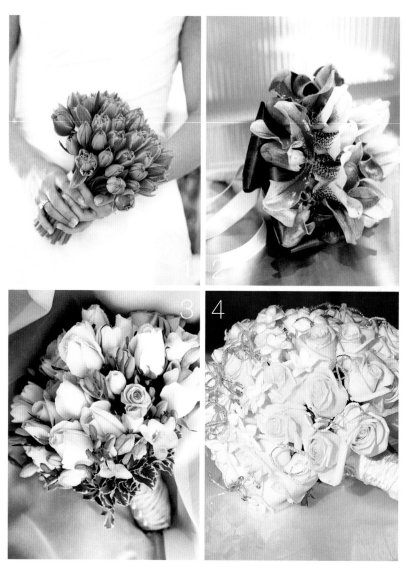

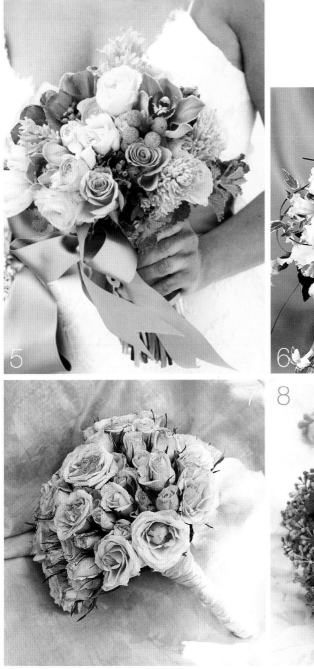

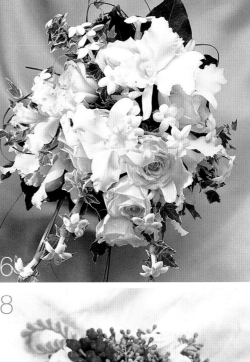

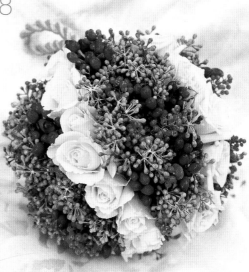

5 SHADES OF SUMMER:
This light, summery
bouquet is pulled
together with a three-
inch-thick satin ribbon.

6 CLASSIC BOUQUET:
Roses are arranged
with cattleya orchids,
stephanotis blossoms,
and variegated ivy.

7 PASTELS AND GREENS:
Soft and dusty pink
garden roses com-
bined with light pink
cultivated roses create
contrast and texture.

8 PASTELS AND GREENS
AND BERRIES: For a
winter wedding, circles
of spray roses, euca-
lyptus seeds, and holly
berries are suspended
on a gilded cord.

lilacs

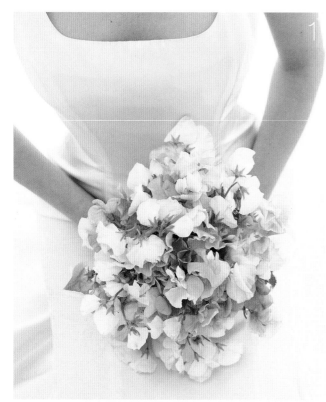

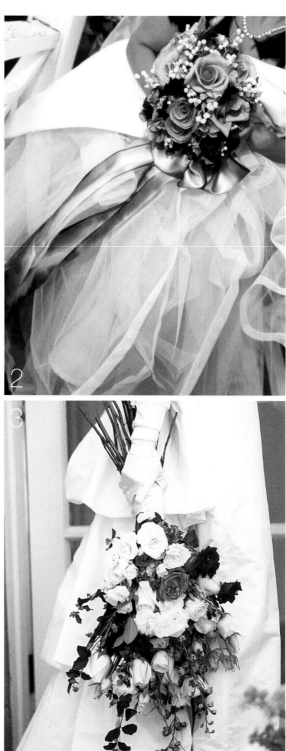

1 ULTRA FEMININE: What could be more feminine than this beautiful bouquet of lavender, lilac, and white sweet peas?

2 ONE-OF-A-KIND RIBBON: A custom-dyed silk ribbon brings together the entire arrangement and makes for a completely unique bouquet.

3 DRAMA IN THE ARM: This arm bouquet of long-stemmed hybrid delphiniums, roses, and lisianthus, which rests face-up in the crook of the bride's arm, makes for a tremendously dramatic moment when the bride walks down the aisle.

pinks

4 PRETTY IN PINK: Various shades of lush pink peonies are studded with crisp white stephanotis blossoms for a very romantic look.

5 ELEGANCE PERSONIFIED: For a restrained, traditional quality, use sterling roses hand-tied with a beautiful silk-ribbon handle.

6 THINK PINK: One of my all-time-favorite bridal bouquets is this gorgeous cluster of vibrant pink peonies.

7 BOUND AND PINNED: This stunning bouquet is made from cerise-pink peonies pulled together with a wonderful olive-green silk ribbon and jeweled pin.

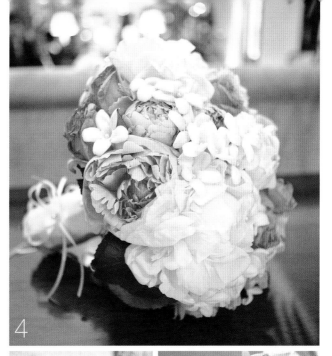

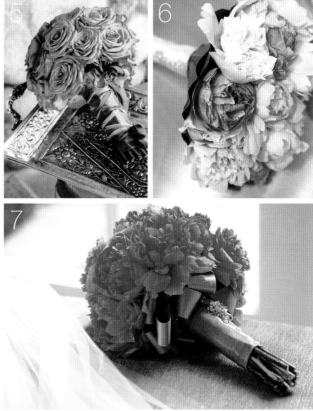

bridesmaids' bouquets

1 SHADES OF SUMMER: Tropical leaves surround slipper orchids, a wonderfully natural bouquet set against the summery hue of the bridesmaids' dresses.

2 SPRING FLING: These cheerful bouquets are all made with spring-like flowers: light green hydrangea, cabbage-patch roses, pincushion proteas, cymbidiums, and ranunculus. The bridesmaids carry these bouquets, while the bride carries the same assortment fashioned into a pomander.

3 GLOVES AND GIRLS: These glorious cascades—sterling roses and variegated ivy studded with fragrant white gardenias—achieve a new height of elegance with the bridesmaids' long gloves as a backdrop.

4 CONTRAST: Against dark dresses, this bouquet creates a striking contrast with white roses artfully combined with grape hyacinths and deep purple delphinium, all tied together and finished off with delicate maidenhair fern.

5 PERFECT PAIRING: For big drama in the wintertime, combine black calla lilies with a variety of deep red and Black Magic roses together with oiled hypericum berries.

6 DRAMATICALLY ROMANTIC: The combination of strapless dresses, posies, and Black Magic roses, all in the same tone, makes for an intoxicating combination of drama and romance.

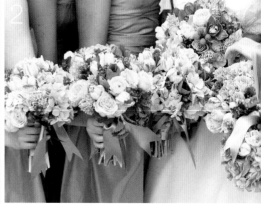
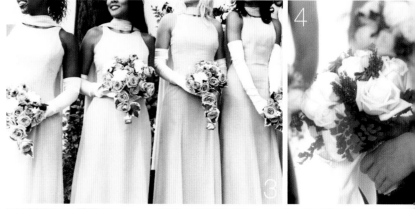
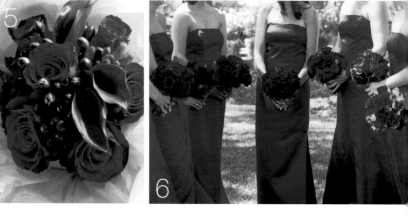

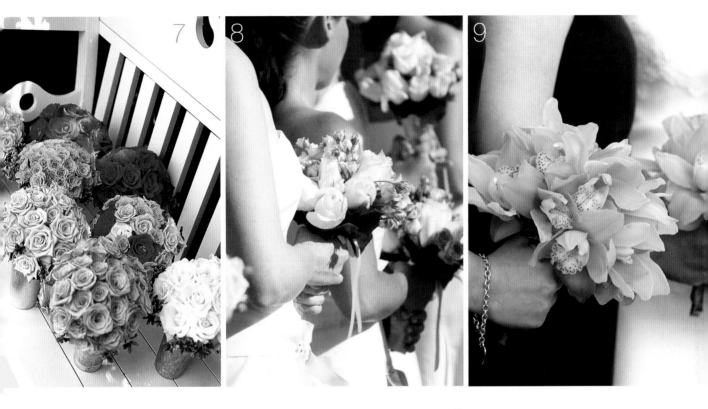

7 VARIETY IS THE SPICE: This spectacular collection of bouquets is all made up of roses, but in different colors, arranged in classical nosegays trimmed with scented geranium leaves. The maid of honor holds the combination of all the colors.

8 SIZE MATTERS: All of these bouquets are made of roses, but of different sizes: spray roses, cabbage-patch roses, and cultivated roses.

9 COMPLEMENTARY: Posies of wired chartreuse cymbidiums are the perfect complement to the aubergine dress.

mother of the bride

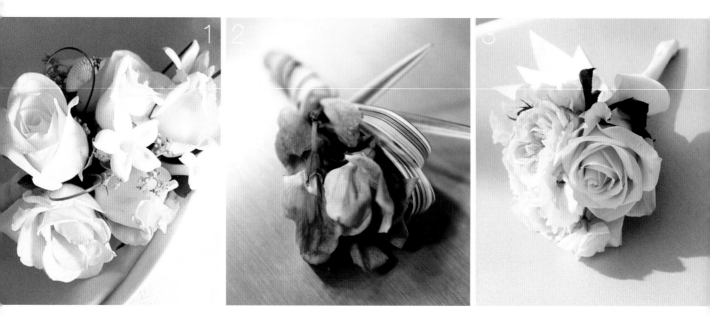

1 CLASSIC CORSAGE: This traditional combination—roses and stephanotis blossoms with a couple of seashells—is ideal for the mother of the bride (or groom) at a beach wedding.

2 SWEET PEAS: Ideal for a warm-weather wedding, sweet peas and variegated tropical leaf offer a fun, summery look.

3 ROSES: Peach roses and white sweet peas are tied with a white satin ribbon for a crisp, tight, and sweet bouquet.

hair wreaths

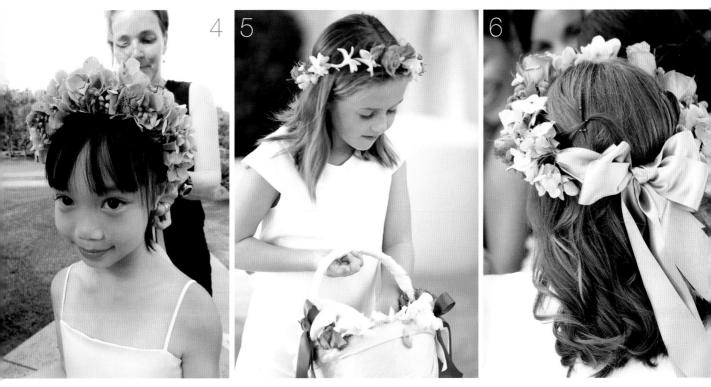

4 SHADES OF GREEN: The flower girls all wear celadon dresses that are accentuated with pistachio-colored Hawaiian hydrangeas and accented with eucalyptus berries.

5 CROWN-BASKET SET: In this totally pulled-together design, this girl's crown and her basket are both adorned with orange rose blossoms, white tuberoses, and orange silk ribbon.

6 SPRING GREENS: These green hydrangeas are paired with soft coral roses and tied with a voluminous satin ribbon for a beautiful crown.

flower girls

1 BLANKETED BASKET:
This petal-filled basket is swathed in multiple shades of pink roses that match the wreath in the flower girl's hair.

2 FLOWER GIRL'S GIANT SEASHELL: For a beach-themed wedding, this giant seashell is filled with rose petals and boasts a bundle made of a pearl garland.

3 HYDRANGEA CROWNS:
These flower girls look utterly adorable with their vibrant pink hydrangea crowns and baskets filled with rose petals of a matching color.

4 FLORAL TIARA:
Instead of wearing a traditional crown, this flower girl's hair is pulled back and orna-mented with a tiara of dendrobium blossoms.

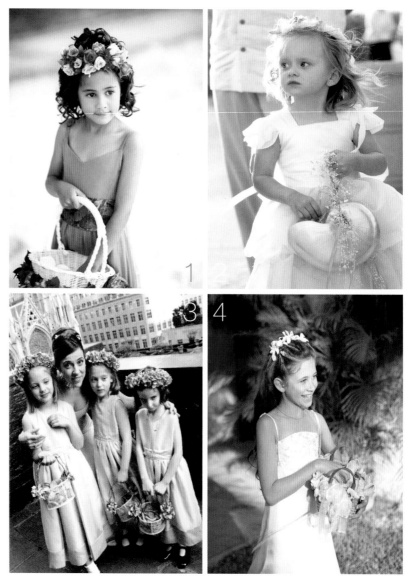

petal baskets

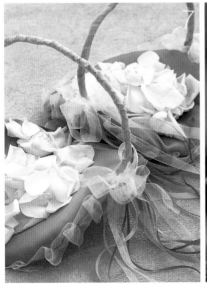

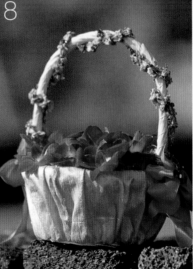

5 CASUAL COUNTRY: These oxidized copper containers are filled with Leonidas roses, and spray roses are attached to the handles for an abundant country look.

6 COUNTRY BASKETS: For a country wedding, the flower girls carry low baskets decorated with organza ribbon and dendrobium blossoms, and filled with white rose petals.

7 WISPY STREAMERS: The basket is lined in robin's-egg-blue satin and adorned with iridescent chiffon streamers for a flowing, ephemeral style.

8 WICKER BASKETS: A simple white basket is personalized by wrapping it in pink dupioni silk and cerise bows, then filling it with cerise rose petals.

baskets

1 SEASHELL PAVÉ: A bamboo-handled papier-mâché box, filled with rose petals, is accented with seashells for a seaside wedding.

2 CONTEMPORARY CHIC: This sleek bamboo basket is filled with hydrangeas and lime orchids.

3 DIAMOND DAYS: This trio of accessories—a ring box, a flower basket, and a purse—are all bound in a vibrant turquoise silk ribbon and Swarovski crystal buckles.

4 MESH MAGIC: This mesh box is fashioned into a basket by adding a handle made from curly willow and ivy, then filled with rose petals.

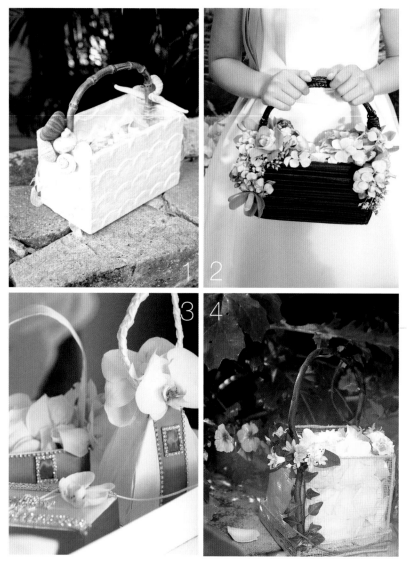

ring bearers and boxes

5 ROPE-TRIMMED PILLOW: This traditional satin pillow is adorned with rope and tassels, and garnished with sterling roses and green ivy.

6 FORMAL MOSS PILLOW: Here a clean background of natural moss is punctuated with stephanotis blossoms and satin ribbon.

7 SILVER BOX: A vintage sterling box is lined in blue card stock.

8 IVY BOX WITH SATIN: A simple box covered in variegated ivy is lined with a satin pillow.

9 SHELLS AND SAND: Nature always provides—this is nothing more than a giant seashell, filled with beach sand.

10 RUSTIC MOSS PILLOW: This moss pillow is lushly set with a variety of blooms and twigs for an eminently country look.

11 GALAX BOX: This box is covered with evergreen galax and lined with moss.

12 RIBBONED RINGS: These rings are simply tied on a ribbon and carried by the ring bearer.

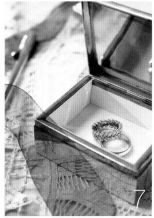

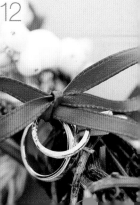

boutonnieres

1 PRIZE POSSESSION: The world's most expensive and delicate flower, the fragrant lily of the valley is so invasive that it's extremely difficult to cultivate—and, consequently, is extremely expensive. For stability, this one is backed with a sliver of Boston fern.

2 CORAL ROSE: For a shot of color at this beach wedding, the groom wears a pristine coral rose backed by a galax leaf.

3 CLASSIC COMBINATION: This very elegant boutonniere is made of a tight rosebud, a full-blown rosebud, a stephanotis blossom, and a couple of miniature ivy leaves.

4 UNDERSTATED CHIC: Two simple stephanotis blossoms, set against small ivy leaves on a curled wire, make an exquisite statement.

5 DELPHINIUMS: Several delphinium blossoms are a chic complement to the groom's navy suit.

6 HYACINTH: Instead of the traditional pure white, try a single bloom in a bright hue, like this grape hyacinth.

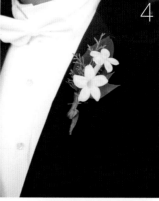
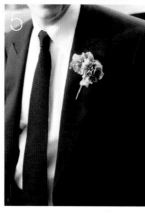

the art of the boutonniere

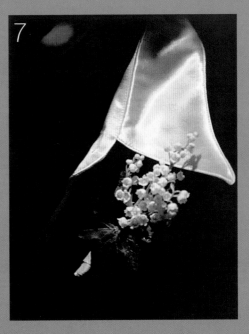

The boutonniere is all about the details—a single gorgeous bloom, the right shade of silk ribbon to bind the flower, a pearl button to secure it. The key is for it to appear masculine while also complementing the bride. So look for small flowers with a big presence. On a practical note, I suggest that every groom's boutonniere should be made twice—one version to be worn during the ceremony and through the majority of the reception. After hugging a few hundred people, the blossoms will inevitably be battered and bruised. So the newly married man should don the second, crisp new stand-in (which should be stored under the cake table, so everyone knows where to find it) right before the couple cuts the cake and makes their toasts. What could be more 007 than to still be wearing a fresh-looking boutonniere as the dawn breaks?

7 **A SPRAY:** For the added presence that comes with height, use a spray of the prized lily of the valley.

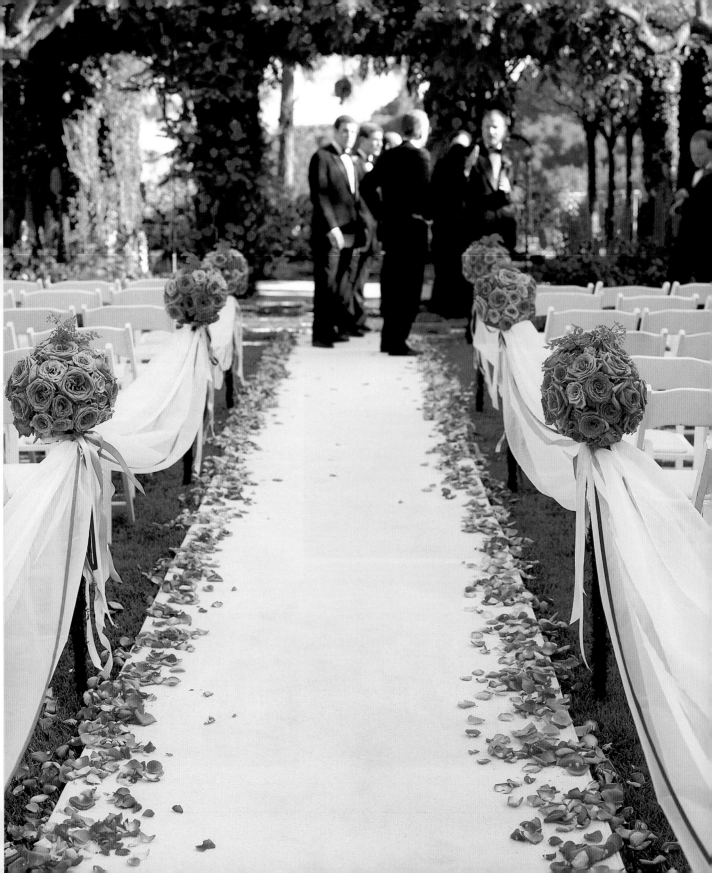

2
ceremony décor

Not long ago, nearly every wedding ceremony looked as if it had been stamped from the same cookie cutter. Whether out of respect for a religious tradition or in deference to an even higher power—one's future mother-in-law—the ceremonies all took place in a house of worship, with a long straight aisle that ended at an altar; with the same tune, "Here Comes the Bride," as the processional; with readings taken from a few select passages ("the greatest of these is love" in heaviest rotation); and, of course, with the familiar exchange of vows.

Today, however, with so many brides and grooms adhering to different religions, many of the weddings we design at Colin Cowie Lifestyle don't take place in a church or house of worship. The fact that more and more of the clergy are willing to officiate at hotels or ballrooms, vineyards or beaches is tremendously liberating—it means the bride and groom can choose spaces that not only hold special, spiritual meaning for them, but can also be decorated in whatever style they choose. I tell each bride, whether she wants to take over a winery in Bordeaux or re-create Peter the Great's Amber Room in her own backyard, the ceremony is the most significant part of her wedding and should be set in an environment that's meaningful to her.

The one constant over the years is that almost every bride has a vision of what she wants her ceremony to look like and how she wants to make her entrance.

WHITE CARPET RUNNER WITH PETALS: This basic white aisle runner is bordered organically with lavender rose petals.

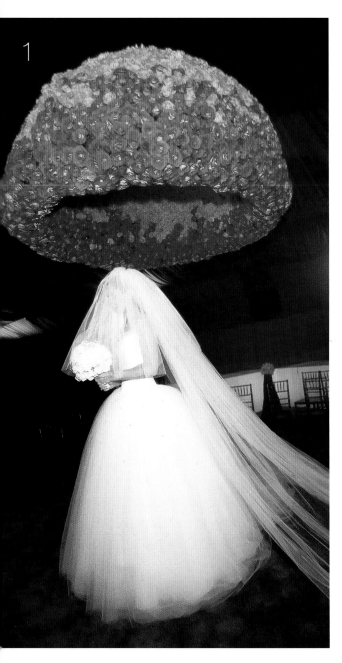

She might desire a fairy-tale drama with a horse-drawn carriage delivering her to the steps of a cathedral; walking a path raked in the sand on a beach in the Bahamas; or meandering down a serpentine aisle fashioned out of flower petals in her mother's garden. No longer restricted to rigid rows of straight pews, you could walk down a curved aisle flanked by upholstered foam pods leading to a cliffside ceremony; you could seat the guests on white benches in a contemporary space with a minimalist look; or you may get married in the round, surrounded by guests seated in concentric circles, or on garden chairs arranged around a gorgeous oak tree.

After you've decided upon your aisle, the next decisions have to do with how you and your attendants are going to get down it. As the bride, you may decide to be escorted on the arm of your father, or have him meet you halfway down the aisle; or you might walk alone, illuminated only by a pool of light. As you reach your groom, there should be a focal point or some frame for the ceremony: an arbor, a backdrop, an altar, a chuppah, or an arch. Whether your ceremony is fifteen minutes long or a full hour, the exchange of vows is your big moment—this is when all eyes are on you and the groom, as

1 ROSE-COVERED DOME: For major drama, this dome is pavéd on the outside with Leonidas and sari roses, and for added texture the inside is covered with carnations—in all, sixteen thousand flowers.

you pledge your love and allegiance. The spot where you exchange vows draws the collective energy in the room to one point and should be pleasing to look at, conducive to photography, and designed to frame the event and hold your guests'

attention. If you'll be building a structure, it shouldn't be so tall as to distract or so wide that you'll look like minuscule cake toppers, but at the same time it should not be so compact that it will obstruct your guests' views. There should be no more than two to three feet from the top of your head to the lowest flower in the structure—if it's any higher, your photographer is going to have to be at the very back of the church to compose a good picture.

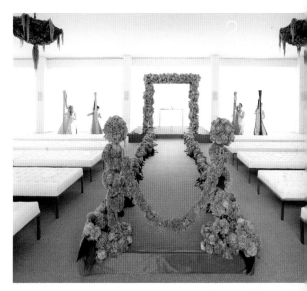

Light is also a key component of the ceremony. Most people don't realize how important lighting is until they're looking at blurry photos of the "I now pronounce you man and wife" moment. Make sure there's enough natural light so you're well illuminated and can be seen by everyone; as an added bonus, hire a lighting company to ensure lighting that highlights your best features. The sun might come out or the clouds might roll over, so a wash of soft ambient light will go a long way.

Almost every ceremony includes flowers. I always take into account how those arrangements relate to the other florals used in the celebration—the bridal bouquets, reception centerpieces, boutonnieres—and I encourage brides to weave a thread of style throughout. You don't necessarily have to match all the blooms used that day, but staying within a color scheme brings a sense of uniformity to the look and feel of your wedding.

Your décor needn't revolve entirely around expensive cut flowers—there are many ways to mix flowers with other elements that are just as interesting and beautiful (and often more cost-effective) than a typical arrangement in the urns provided by the venue or the use of one type of flower in only one color. Depend-

2 PEONY-COVERED ARBOR: The bride and groom exchange their vows under a rectangular arbor that is massed with bright pink peony blossoms.

ing on the location and your vision, you may decide to cover your arbor or chuppah with materials such as shells, moss, and vines, or even white gauzy fabric that will billow gently in the wind. For something unique, I *love* fashioning hanging crosses out of hundreds of crystals suspended on monofilament so the end result appears to be a cross floating in thin air. This really looks spectacular at a sunset ceremony when the sun catches the crystals. Again, have some ambient light to make sure you don't lose that moment if the weather changes.

Try to rely on local floral offerings—they're more readily available and usually dramatically less expensive than imported or out-of-season flowers. The savings in cost may allow you to take approaches you'd otherwise never dream of, such as beheading thousands of roses and using their petals to create a mesmerizing

aisle border. If you're working with a tight budget, be creative with your entire floral scheme; many arrangements can be designed to be portable, so the same flowers might be used for the ceremony and during cocktails, then moved to the reception area or even the bridal suite. Imagine if the petals from every luscious rose used in the ceremony were layered four inches deep on the bed in your honeymoon suite and surrounded with dozens of votive candles—what a romantic way to end the evening and begin the next chapter of life together.

1 CRYSTAL CROSS: Crystals hanging from monofilament in the shape of a cross form a dramatic backdrop to the ceremony. 2 FOLDING CHAIRS: In this spectacular mountaintop setting, an open, lofty feeling is maintained with the natural teak folding chairs.

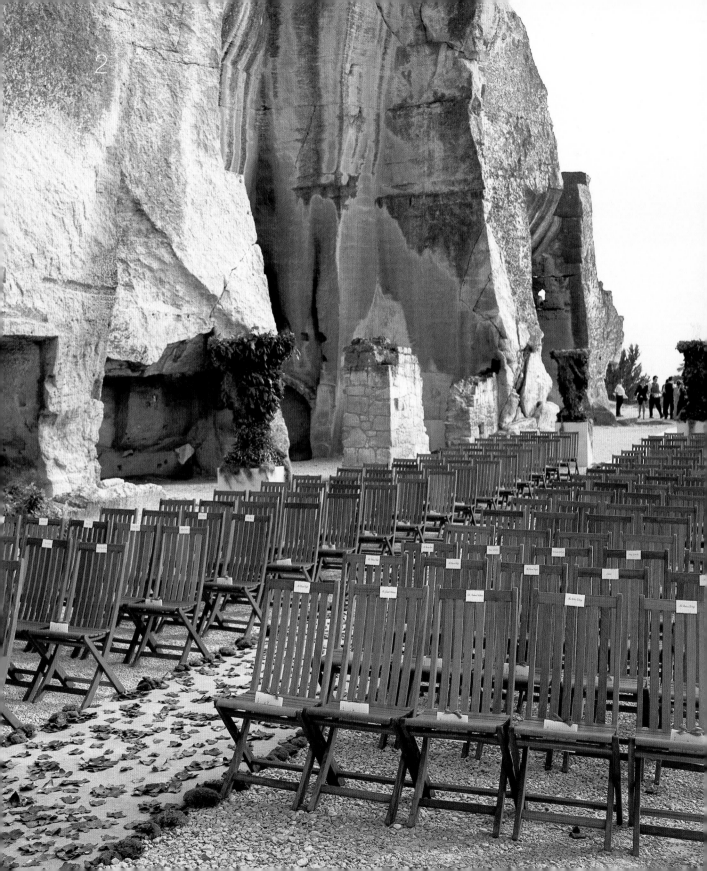

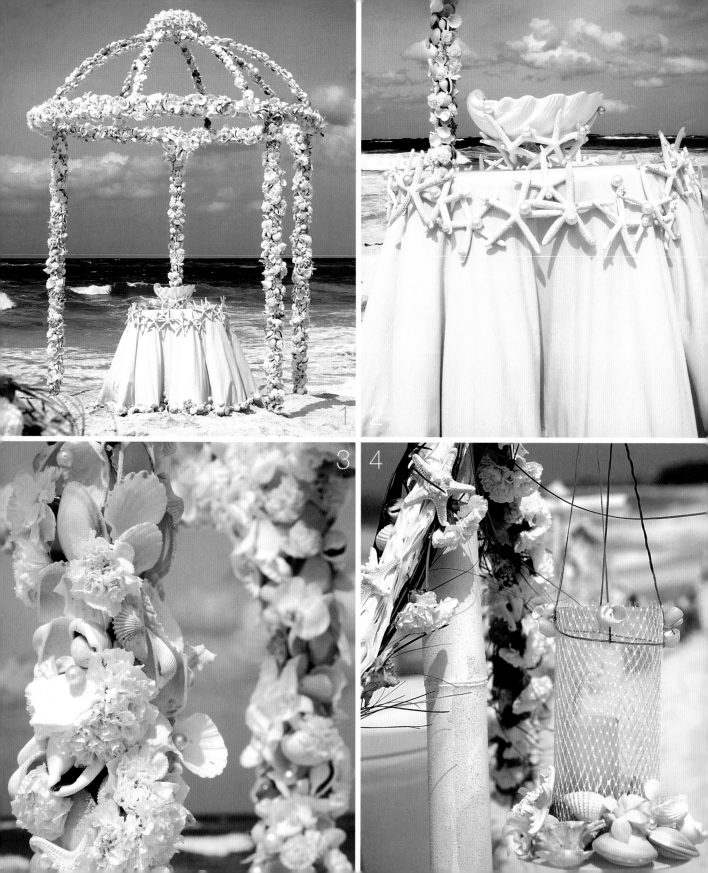

on the beach

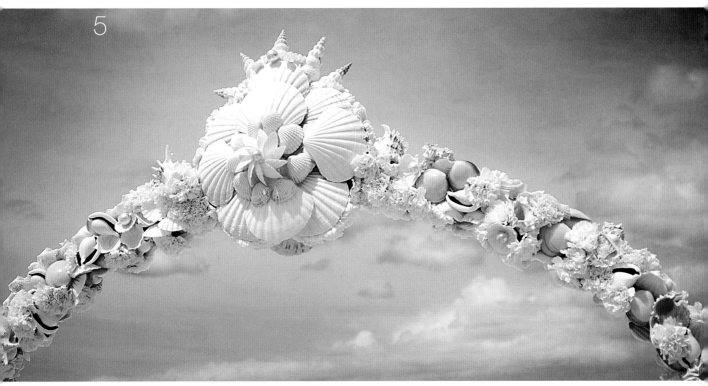

5

1 **OPEN WHITE ARBOR:**
The simple structure rises organically from the sand, and doesn't distract from the gorgeous setting.

2 **HAND-WASHING CEREMONY:** This table is draped with ecru linen and hemmed with seashells to weight it; its top is cuffed with white starfish and overscale pearlized ornaments. The hand-washing ceremony uses the scalloped bowl that's set into a starfish base.

3 **ARBOR OF SEASHELLS:** Dried moss, white carnation heads, and pearlized holiday ornaments evoke the idea of water bubbles.

4 **SEASHELL AISLE STANCHIONS:** White-painted bamboo posts are hung with candles in hurricanes to line the aisle, and garlanded with shells, sea grass, carnations, and painted holiday ornaments.

5 **SEASHELL CROWN:** An ornately constructed combination of seashells makes a powerful statement atop the arbor at the head of the aisle.

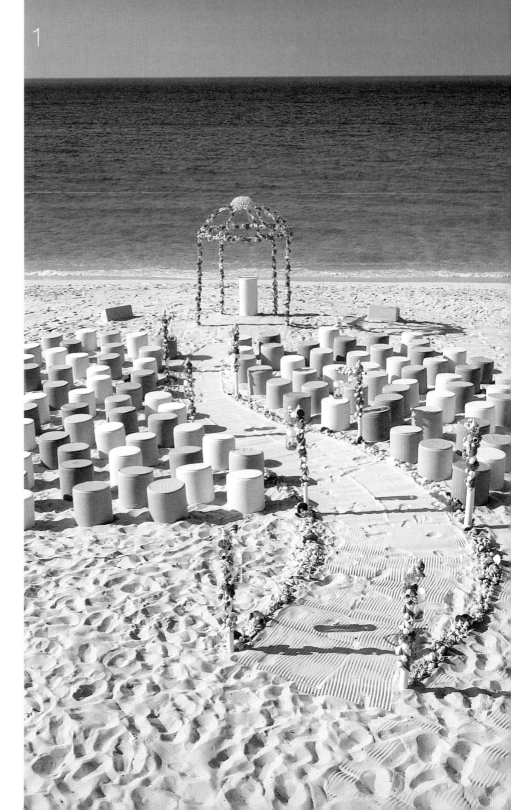

1 S-SHAPED PATH: Breaking with tradition, this organic, curving aisle creates a natural flow for the walk to the altar.

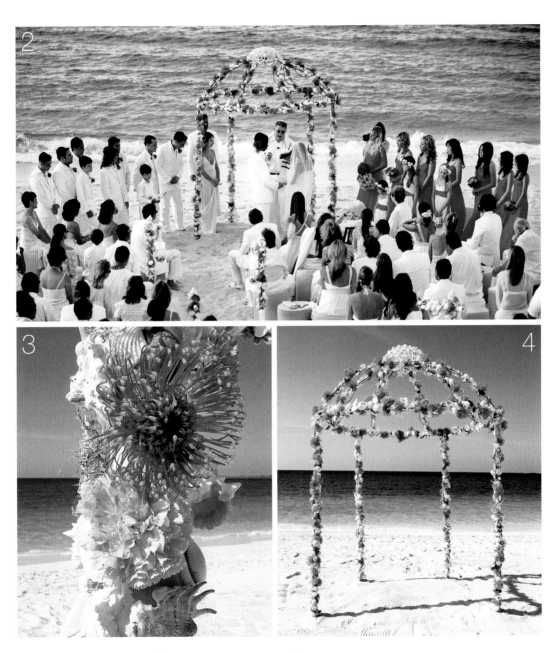

2 SEASIDE ARBOR: This framework is covered with seashells, adorned with coral flowers including proteas, carnations, and roses, and finished off with orange silk ribbon.

3 ARBOR MADE OF NATURAL MATERIALS: including moss, shells, peach carnations, and coral pincushion proteas.

4 OPEN ARBOR: With a spectacular backdrop, you don't want an arbor to take up much visual space. Note that the two front tent poles are positioned farther apart than the rear two; the wider front spacing allows for an unobstructed view of the action from many angles, while the narrower rear spacing ensures that the action doesn't include a tent collapse.

1 BRIGHTLY BLOOMED AISLE: Leading to a thatched *palapa* on the water's edge, this aisle is fashioned from the heads of gerbera daisies, grading from darkest to lightest as you proceed along the aisle—with white at the very front.

2 RUSTIC AISLE STANCHIONS: These stanchions include simple votives fashioned out of glass cylinders, filled partway with sea sand and decorated with white dendrobium.

3 SPARKLING SHELLS: This rustic wood structure is topped with latticework and a profusion of monstera leaves, Casablanca lilies, white cascading dendrobium, and white anthurium, then finished off with garlands of translucent shells that sparkle when backlit.

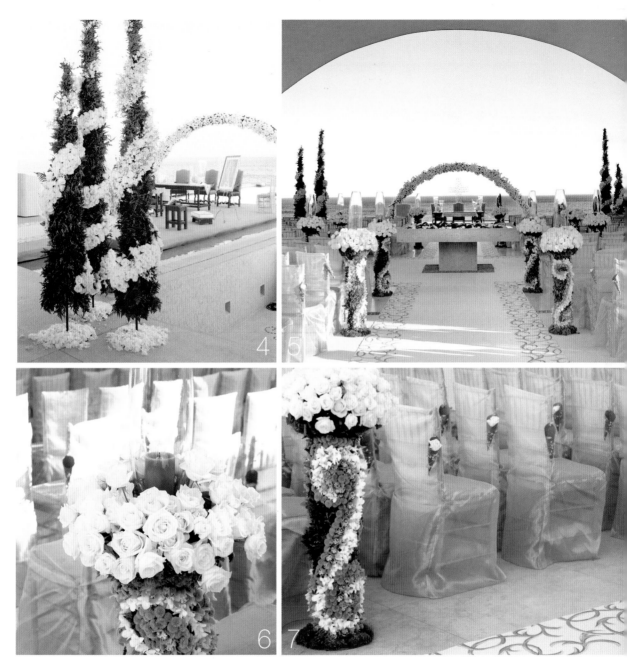

4 TOWERS OF LEAVES: For an element of height, thin spindles are pavéed with greenery and then garlanded with assorted white flowers.

5 HAND-PAINTED RUNNER: A customized aisle runner leads to a rose-covered arbor and a cross, fashioned from crystals hanging on monofilament.

6 HURRICANE-LANTERN-TOPPED STANCHIONS: These elegant aisle stanchions are topped with rings of white roses and hurricane lanterns.

7 ORGANZA-COVERED CHAIRS: The sheerness of the organza allows the silhouette of the chair to show through, creating a breezy, romantic look.

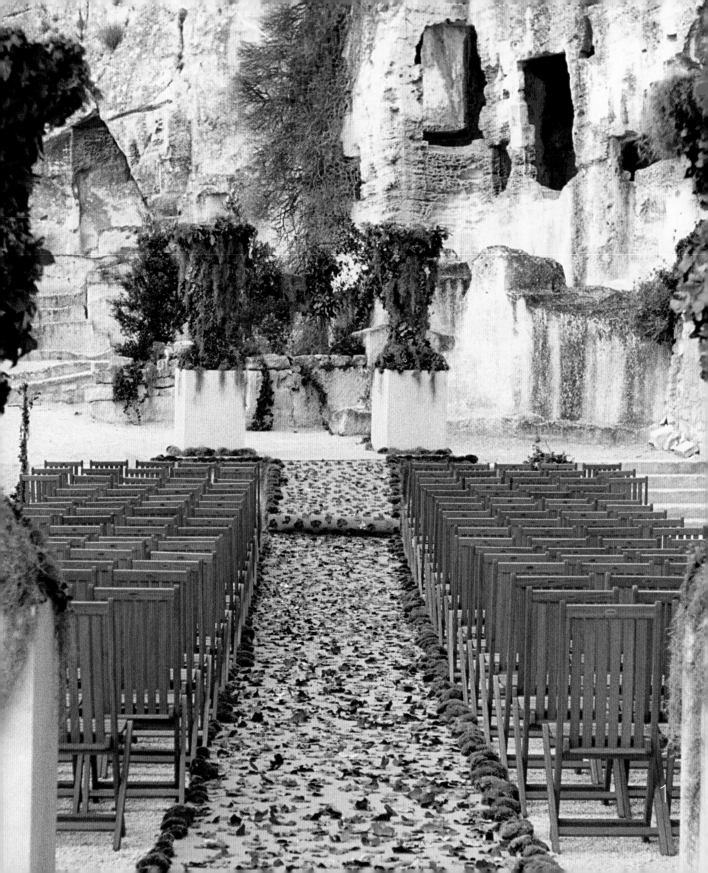

garden

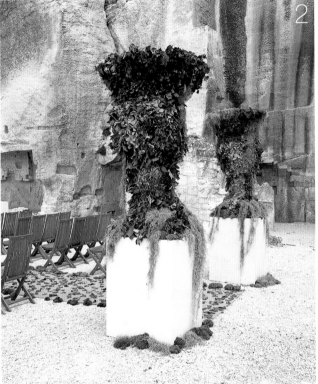

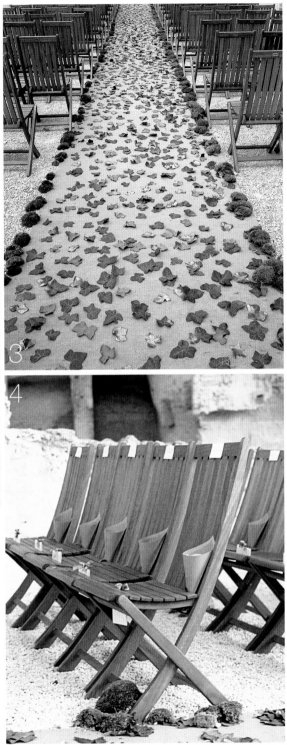

1 SET INTO THE SITE: In a unique location, I like to ensure that design fits the natural surroundings, such as this stunning installation in an ancient citadel in Provence.

2 DRAMATIC AISLE HEADS: Overscale urns covered with greens mark the beginning of the aisle.

3 RUSTIC AISLE RUNNER: This runner, made from brown craft paper to mimic the color of the stone that surrounds this site, is bordered with clump moss and scattered with ivy leaves.

4 CONES OF ROSE PETALS: These elegant cones are placed on every chair, so guests can shower petals upon the bride and groom.

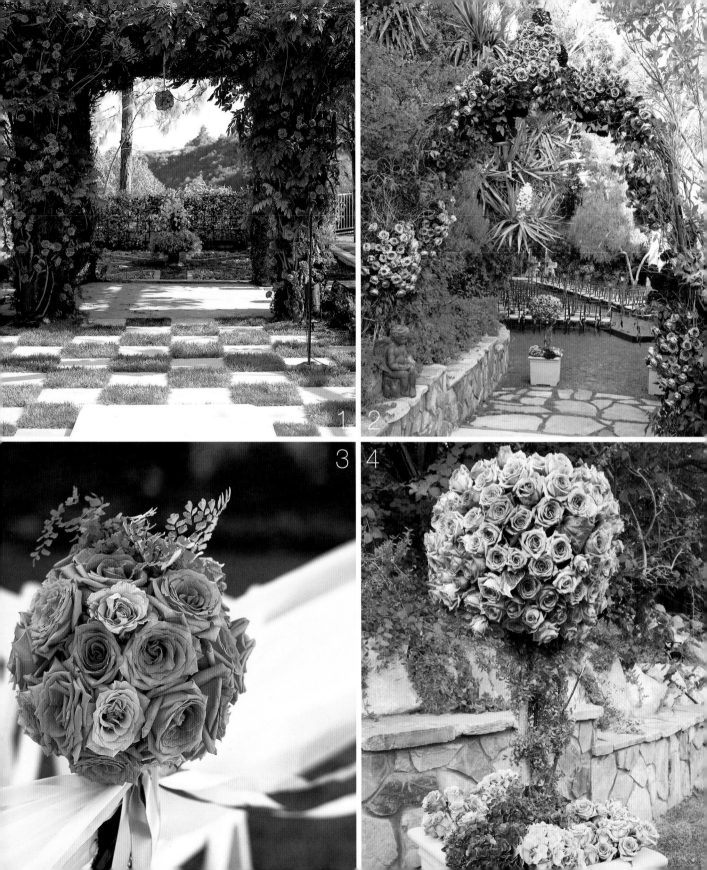

1 ROMANTIC ARBOR WITH ONE BLOOM: A profusion of just one type of bloom—bluebird roses—makes a striking statement for this arbor, with a single refined pomander that hangs above the bride and groom.

2 AGE-OLD ARBOR: These vines seem as if they've been in this spot for hundreds of years, and just happen to be in full, perfect bloom on the day of the wedding—but of course that's not entirely the truth of it.

3 POMANDER WITH CROWN: A pomander of lavender and sterling roses is attached to garlands of white tulle, as well as lavender and lilac ribbons, and crowned with maidenhair fern.

4 POMANDER WITH BASE: To demarcate the beginning of the aisle, white garden boxes are planted with tall pomanders of bluebird and sterling roses, and packed with a surfeit of different shades of purple hydrangeas around the base.

5 ROMANTIC ARBOR WITH MULTIPLE BLOOMS: Roses, vines, ivy, and hydrangeas lend an overgrown arbor a natural, abundant look.

6 LAVENDER RUNNER: Columns of curly willow topped with vases filled with purple hydrangeas flank the carpet.

7 UNADORNED POMANDERS: These elegant, simple pomanders of deep purple, sterling, and bluebird roses, along with clumps of moss, sit on a ceremony table whose legs are wrapped with dried twigs for a rustic feel.

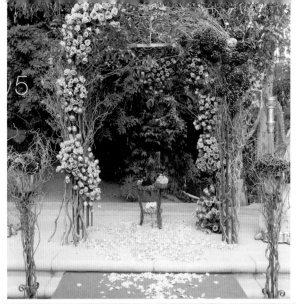

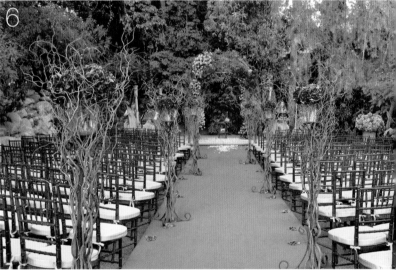

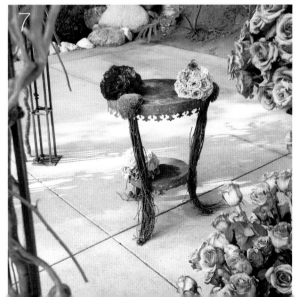

1 POMANDER WITH HANGING TRAIL: A pair of rose pomanders, studded with white stock and hung with amaranthus, marks the heads of the aisles.

2 CRISP WHITE LINEN RUNNER: This serene aisle runner is left bare leading up to the elegantly understated arbor.

3 AND 4 GARDEN ARBOR: This beautiful structure is covered in a garland of greens, including magnolia leaves and boxwood, punctuated with clusters of white roses and hanging amaranthus.

5 MODERN ARBOR: For this wedding in the round, with plenty of front-row seats and an intimate feel, the arbor is relatively bare—to afford unobstructed views for every guest.

6 CHERRY BLOSSOM FESTIVAL: This ceremony site for sixty people is made intimate with a pair of gates at the top of the serpentine aisle that ends at an arbor; both structures are decorated with cherry blossoms, a very inexpensive and effective way to decorate— but only in season, in spring.

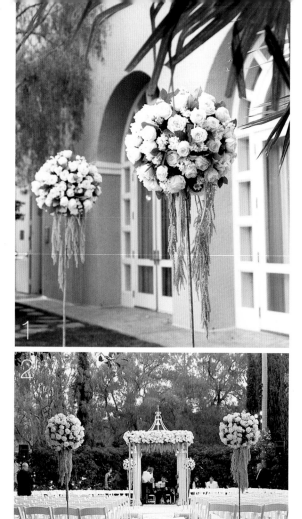

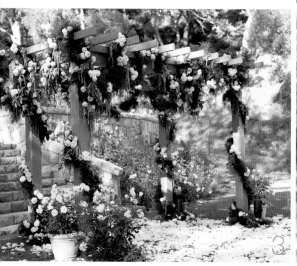

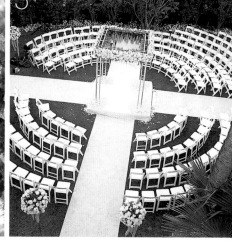

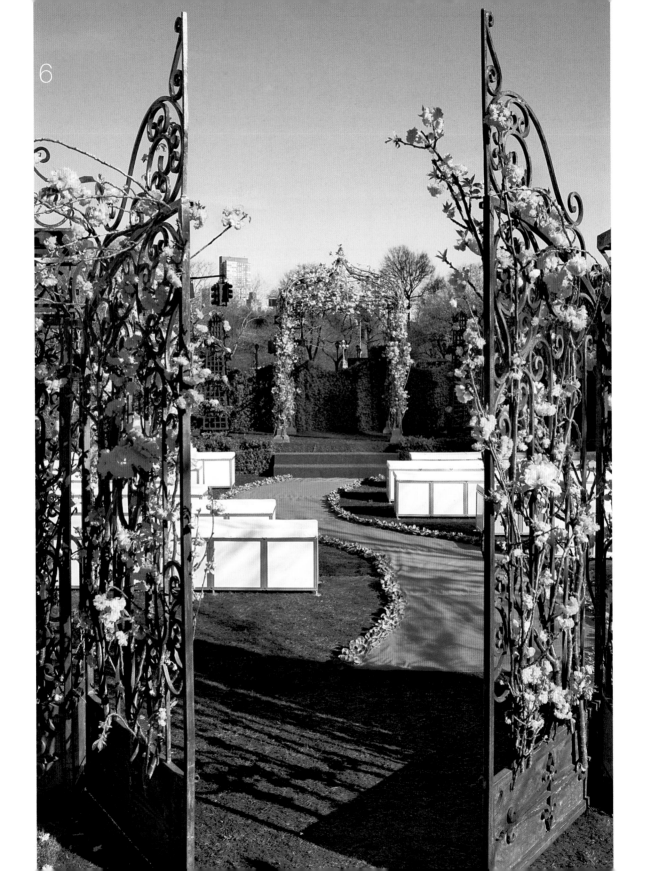

1 SHOCKING-PINK AISLE: This winding aisle runner in a show-stopping Schiaparelli pink is bordered with succulents, creating a fantastic contrast between the pink fabric and green grass.

2 GARLANDED OBELISKS: These formal garden obelisks are garlanded with boxwood.

3 HANGING PEONIES: Garden obelisks are adorned with clusters of large blooming peonies.

4 SWORDPLAY!: These ice buckets are swimming in a lavish quantity of rose petals, a soft counterpoint to the utilitarian object at the end: a saber that will be used to decapitate the tops from the Champagne bottles.

5 FLOATING GARDENS: For a magical effect, create large islands loaded with mosses, roses, greenery, and even candles. Islands like these can be anchored to the bottom of the pond and fixed where you want them, unlike individual floating blooms, which invariably end up clumped along the shoreline.

6 FLORAL ARCHES: These lovely structures are densely covered with roses in autumnal browns, deep oranges, and ochers together with garlands of magnolia leaves.

7 FLOATING BLOOMS: Pre-ceremony drinks are served under the trees, with sari roses suspended upside down on monofilament for an ethereal, floating effect.

8 PETAL-ONLY PATH: This path to the ceremony is fashioned solely from white rose petals and flanked with light coral roses.

9 AISLE STANCHION LANTERNS: Stanchions created from rustic, rusted metal lanterns are topped with garden moss and studded with orchids, then finished off with a votive candle lit from within.

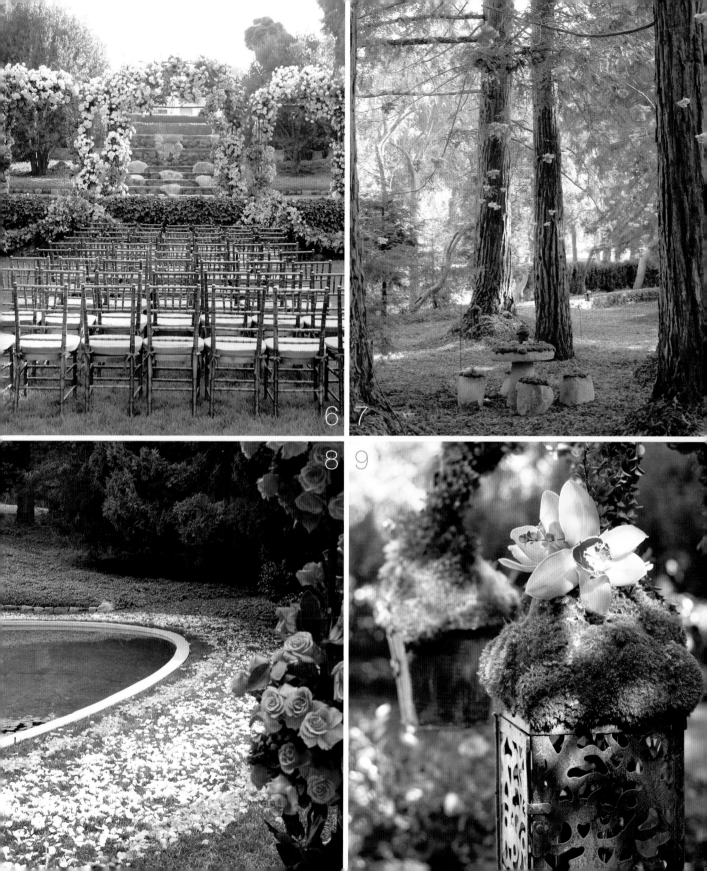

tented ceremonies

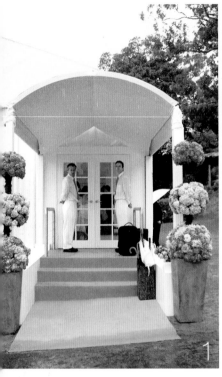

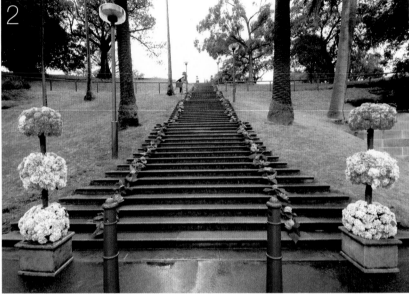

1 SUMMER DRAMA:
For this entrance to
the ceremony area,
the color pink sets a
summery stage, right
down to the waiters'
matching ties.

2 GRAND STAIRCASE:
Leading to the cer-
emony tent in Sydney,
Australia, the Fleet
Steps are decorated
with succulents and
leaves and a pair of
topiaries at both the
top of the stairs, where
guests are dropped
off, and the bottom,
at the ceremony site
overlooking the harbor
and the opera house.

3 CLEAN TENT: A white
tent is decorated using
very clean lines and
a complete palette of
white and sisal carpet-
ing, punctuated by a
vibrant splash of bright
Schiaparelli pink.

4 BUILT-UP BORDERS: A
pink silk aisle is flanked
with glorious tropi-
cal leaves and gar-
landed with peonies,
roses, carnations, and
succulents.

5 INVERTED UMBRELLAS:
The ceiling is deco-
rated with inverted
umbrellas that are
covered with roses,
peonies, and carna-
tions, and adorned
with tassels fash-
ioned from hanging
amaranthus.

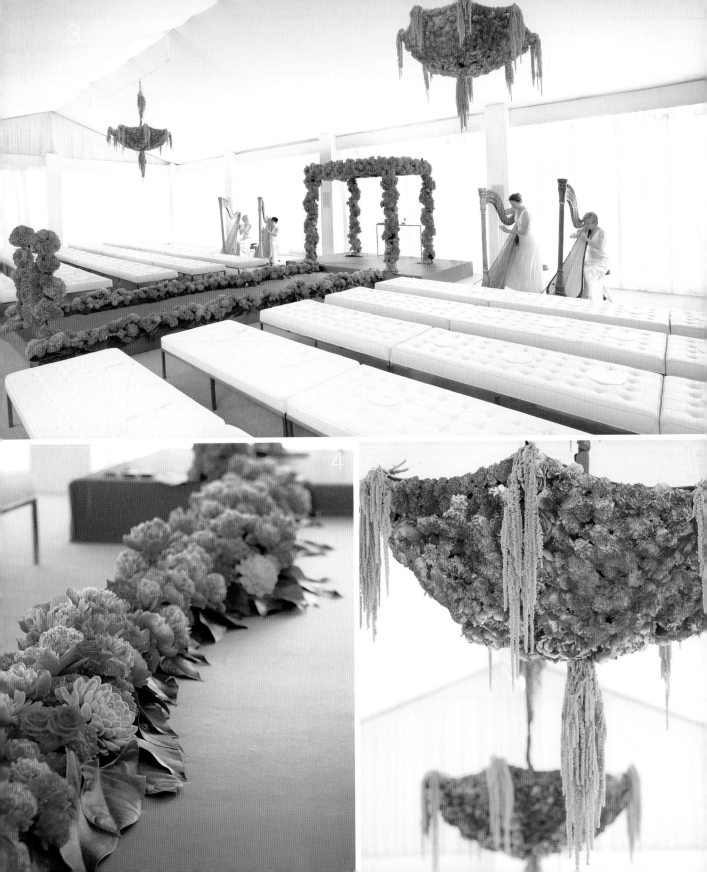

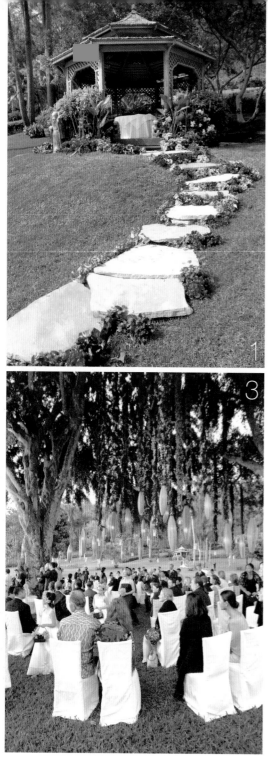

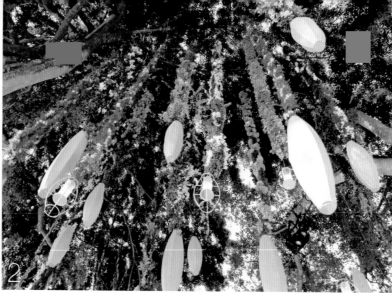

1 FLOWERS AND FLAGSTONE: The bride makes an elegant and dramatic entrance down this flagstone pathway, which is lined with flowering geraniums to integrate the path with the surrounding garden.

2 GLOWING PODS: These lampshades are fashioned from illuminated pods that are suspended from garlands up to thirty feet long.

3 ALTERNATING CHAIRS: For this seating arrangement in the round—allowing every guest an intimate view of the ceremony—half the chairs are covered in sheer fabric and the other half in cotton, adding depth and variety to the ceremony area.

4 MAGIC LANTERNS: These hanging lanterns are covered with moss and adorned with brown cymbidium orchids.

5 CLASSIC ARBOR: The ceremony arbor is clustered with a profusion of white and Leonidas roses.

6 SEASONAL SEATING: In keeping with the fall theme of this wedding, fruitwood Charivari chairs are completed with cognac satin cushions.

7 AISLE DÉCOR: The aisle is demarcated with a bed of white rose petals and with metallic crooks hung with moss-covered lanterns.

8 SEATING-AREA ACCENTS: The ceremony site is adorned with rose blossoms suspended from monofilament and lace-trimmed glass vases that are fashioned into hurricane lanterns.

9 PRESIDING PRESENCE: This stone cherub presides over the ceremony.

10 MATE FOR LIFE: At a wedding ceremony, there's nothing quite as romantic as swans, which are monogamous and mate for life—how's that for perfect symbolism?

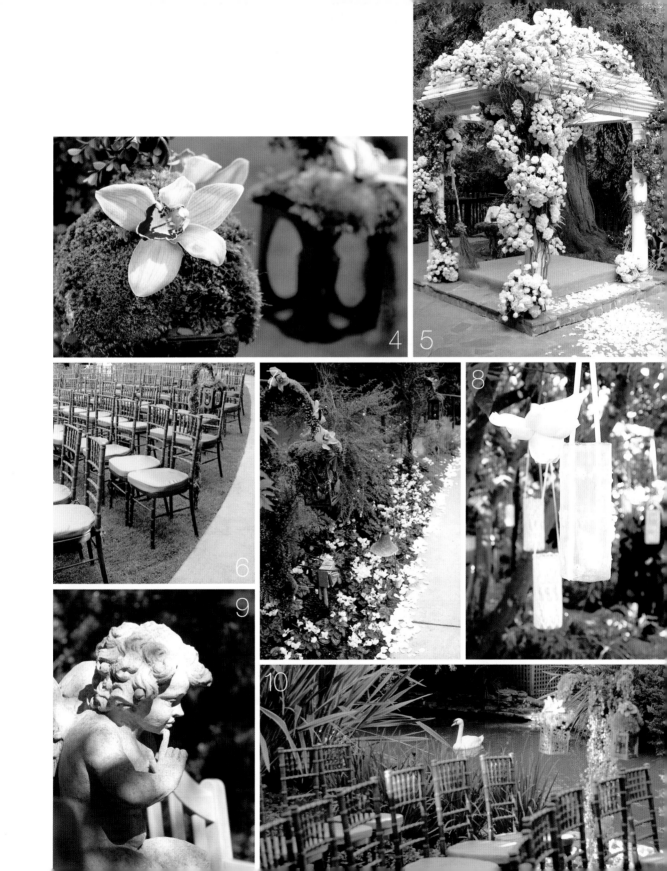

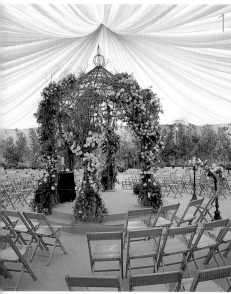
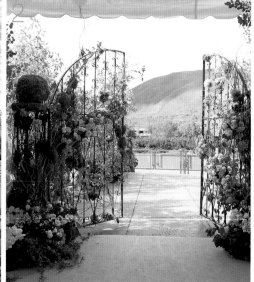
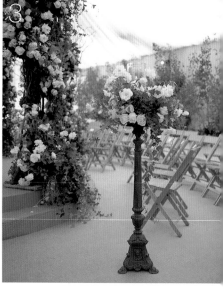

1 GAZEBO IN THE ROUND: Breaking with tradition and providing a front-row view for everyone, the seats are arranged in the round, with the wedding gazebo in the center, cloaked with a surfeit of roses.

2 FLORAL GATES: The romantic entryway to this tent is a pair of garden gates, decorated organically with curly willow, ivy, and coral and white roses.

3 TOWERING CANDLE-STICK: To demarcate the aisle, this tall vintage candlestick is crowned with a hurricane lantern and adorned with ivy and a variety of white roses.

4 WINTER DRAMA: For this winter wedding in Beaver Creek, Colorado, where ice was the theme, a dramatic entry is fashioned with arrangements of red tulips placed in urns of ice atop columns also made of ice. Wow.

5 FLORAL GATED ARCH: At the top of the aisle, this low, elegant garden gate features an arch swathed in smilax vines and white roses, to add drama to the arrival of the bridal retinue.

6 GARDEN ABUNDANCE: For a dramatic entrance to the ceremony canopy, this wrought-iron table is completely covered with moss, then topped with an oversize garden urn overflowing with tulips, roses, hydrangeas, dahlias, and magnolia leaves; flowering paperwhites bloom directly out of the moss tabletop.

7 RED ARBOR CROWN: Suspended over the bride and groom, this wreath is constructed of boxwood strung with hypericum berries and seeded eucalyptus, studded with Fire and Ice roses, and streaming with red silk and suede ribbons.

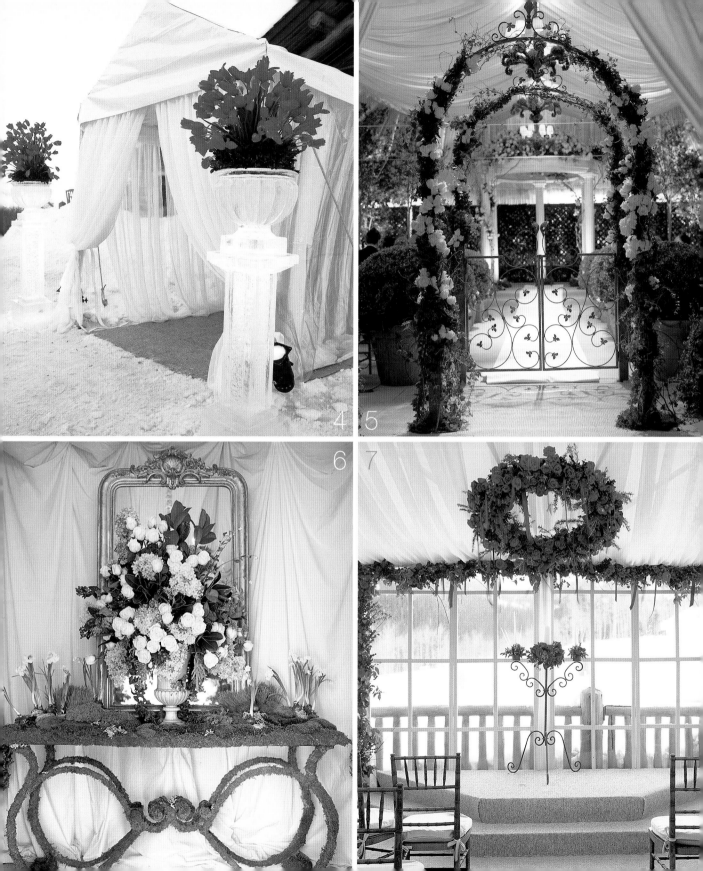

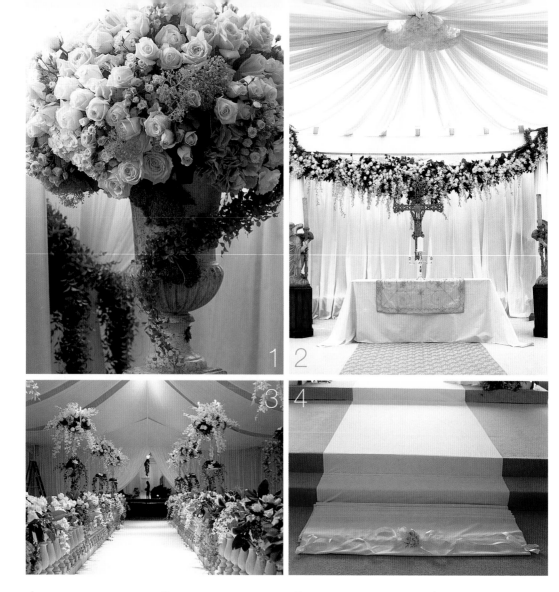

1 DENSELY PACKED URNS: On either side of this aisle, stunning arrangements amass multiple types and varieties of roses, ranging from small spray roses to large garden roses, all in shades of sorbet, in aged garden urns.

2 CROSS IN A TENT: For this at-home wedding, a gorgeous decorative cross is placed at the altar, flanked on either side by angels holding candles.

3 BALUSTRADED AISLE: For a very formal wedding, stone balustrades festooned with fragrant gardenias, cascading orchids, stephanotis blossoms, and yellow message roses line the aisle.

4 UNFURLED AISLE: Once all the guests are seated, ushers walk to the head of the aisle and unfurl this runner all the way to the altar, paving the path for the bride's arrival. To ensure that the runner is straight, tape is affixed to the bottom, so the runner adheres when pulled taut on the floor.

church

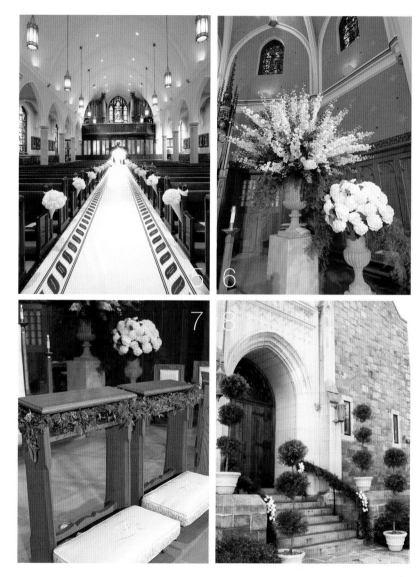

5 PERSONALIZE THE AISLE: Each guest's name is hand painted into this aisle runner, which is fashioned to look like a rope to fit in with the seaside town, bringing a personal touch to the very public space.

6 TALL BLOOMS IN AN URN: Alongside the ceremony area, one stone urn is nearly bursting with tall stems of white and purple hybrid delphiniums with asparagus-fern towers, and the lower urn is filled with large blossoms of French white hydrangeas and asparagus fern.

7 MONOGRAMMED EMBROIDERY: To personalize the wedding experience in a church, these kneeling cushions are monogrammed with the bride's and groom's initials.

8 ADORN THE STEPS: The church exterior comes alive with an assortment of cement pots filled with topiaries, and garlands fashioned from mixed greens, including smilax and boxwood.

BRADFORD WG LIBRARY
100 HOLLAND COURT, BOX 130
BRADFORD, ONT. L3Z 2A7

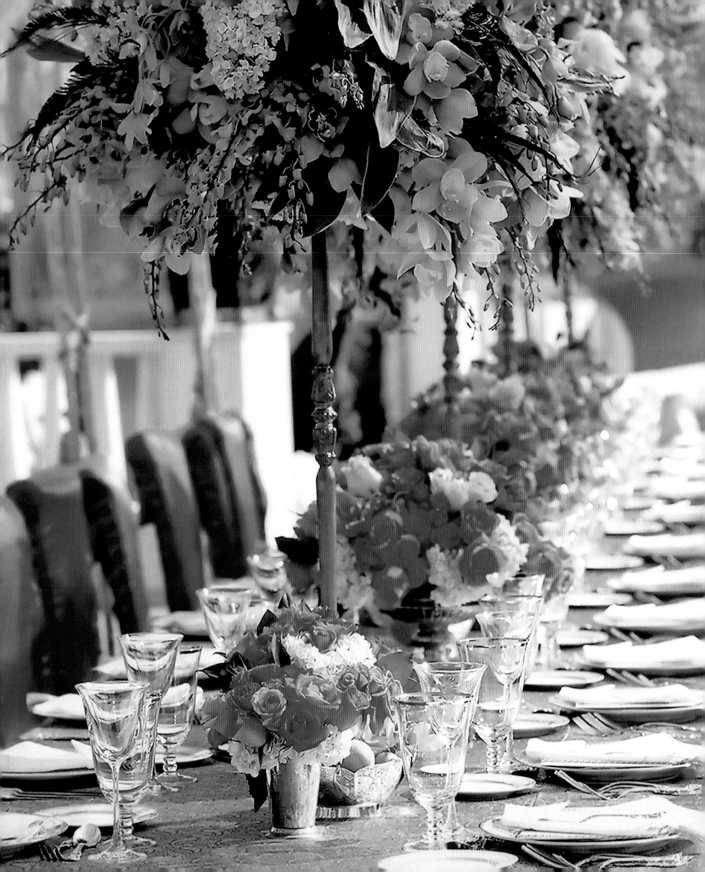

3
centerpieces

Bright blooms, showstopping greens, stunning vases—what's more beautiful than a ravishing centerpiece adorning the dining tables at your reception? One of the most common questions brides ask me is: "How should I decorate my tables? What should I use for my centerpieces?" I completely understand—after all, the very word *centerpiece* evokes a focal point. Your guests will probably spend more time around the table focusing on the centerpiece, while dining and toasting in your honor, than anywhere else at your wedding. But so often the tabletop arrangements are utterly predictable—roses in a glass bubble bowl, duplicated without variation throughout the room. It's as if one arrangement were mass-produced for the entire sea of tables. Without any variation of height, color, and materials, the eye can't help but glaze over.

It doesn't have to be this way. Gorgeous centerpieces bring a sense of drama to even the most basic room. For instance, instead of two dozen matching centerpieces for two dozen tables, I prefer a more personalized look of two or three different designs—maybe one-third are a single low arrangement, one-third are tall topiaries, and one-third are a combination of smaller low pieces, artfully grouped together. Varying the selections not only makes the décor appear more thought out, it also gives a visual rhythm to your space, drawing the eye from the near tables to those across the room, from one table of guests to friends at the next.

SPRING CANDELABRAS: The tall green arrangements—composed of foliage, limes, dendrobium and cymbidium orchids, and feathers—are anchored with roses in footed pedestals and julep cups.

Because you'll most likely spend a large portion of your floral budget on your tabletop arrangements, I urge you to consider seasonality—choose flowers that will be in season for your event and, if possible, grown locally or at least domestically. I say this not only for cost purposes, but also for peace of mind. Ninety-nine percent of the time things go according to plan, but customs delays, torrential rains in another part of the world, or just happenstance can derail the best-laid plans for imported flowers. Counting on a shipment of dahlias from South Africa,

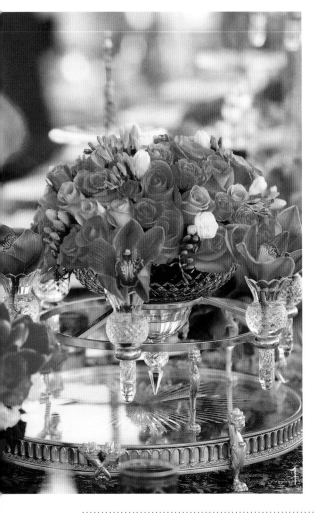

which will require multiple modes of transportation across numerous time zones, may put you at risk of sending your mother running to the florist to buy out their entire stock of whatever they have in your color scheme. It's true that in most major cities your florist can shop the flower markets and find almost anything and everything, at any time of the year, but last-minute rushes mean extra stress and expense.

I also advise brides to consider mixing several different kinds of blooms in their floral scheme. Flowers can be unpredictable. If your local peonies come in smaller than you had hoped or the color isn't exactly what you'd dreamed, it's much easier to replace a few stems in each arrangement than to start from scratch. If you've selected an all-peony design, be sure your florist or flower market can deliver. And no matter what you're guaranteed and by whom, it's a good idea to have a backup plan.

For a wedding overseas, to be safe, rely on what's local. When working out of town, especially out of the country, I almost always

1 FORMAL FLORALS: Coral roses, freesia blossoms, and cymbidium orchids are arranged in a formal gold vase.

fashion a floral scheme composed at least in part of flowers that will be in season in the event's area. So if I'm working with blooms that are being shipped in, and can be found only in Ecuador (or even if they can be found only in Santa Barbara, but the event is in Mexico), I'll often incorporate local flowers that are guaranteed to be in season and available for the event. This means that if those precious stems don't make it in from Latin America or California, no one will be the wiser.

Let me add that you don't necessarily need to rely on flowers alone, especially if you're keeping to a strict budget. Fruits and vegetables, beautiful greens, and other nonfloral elements can provide great shape, texture, color, and dimension to the table. A glass or ceramic bowl packed abundantly with limes and punctuated with blackberries and fuchsias and a couple of dendrobium orchids in bright green sets a lovely garden mood, with no fear of wilting in the heat. A low pedestal urn filled with sugared fruits that have been dipped in egg white, rolled in sugar, and allowed to crystallize will create an opulent nineteenth-century look at a fraction of the cost of cut flowers. If you have the budget, add smaller arrangements of lush blossoms along with some carefully selected foliage to the sugared fruits, for a truly sumptuous centerpiece.

For a more formal feel, the elegant tone can be echoed in the tabletop details. Architectural elements—spheres, obelisks, even basic glass vases—can be covered with leaves or fabrics, or just spray-painted and gilded for that over-the-top effect. And don't stop there—your tablecloths and runners can be adorned with flowers and greens, too.

2 AND 3 RANUNCULUS IN A BOX: These sterling silver boxes are filled with bright orange ranunculus; this is just one component of a multi-element centerpiece.

While I encourage my clients to be as imaginative and ambitious as possible when it comes to their centerpieces, remember that the most important function of the arrangement is to complement the décor of your celebration and add to the experience of your guests at the table. So be sure that everyone can make eye contact, engage in conversation across the table, and easily connect. As a rule of thumb, your arrangement should never be taller than twelve or at most thirteen inches. The exception is a topiary, which needs to be thin at the base so it doesn't block your guests from seeing one another. With topiaries, the florals should ideally start at about thirty inches above the table; otherwise, as beautiful as the arrangement may be, it may create a physical barrier that will inhibit conversation. You definitely don't want to find one of your guests removing a center-

piece from the table and placing it on the floor in a last-ditch effort to make contact with the person across from him. (I've seen it happen many times—not at any of my parties, however!) If the topiaries or other tall arrangements are meant to look top-heavy, be sure they not only have a sturdy, anchored base, but also have been professionally constructed to withstand any gusts of wind or a tipsy uncle who may bang into the table accidentally. In addition to the height of your centerpiece, consider fragrance: You wouldn't want gardenias to overpower the rack of lamb. One or two sweet-scented blooms will be fine, but avoid constructing an entire centerpiece from very fragrant varieties. And I prefer never to place scented candles on a dinner or buffet table—beef Wellington and Tahitian vanilla essence don't mix.

You can add interest with the containers for your centerpieces. There are hundreds of options beyond the commonly used glass bowl or the simple square glass container. Whenever possible, I like to add a unique touch—for example,

1 MOSAICS: For this beachside wedding in Mexico, we used glass-mosaic containers filled with tropical flowers in bright colors.

vases or urns from the families' collection, or even mismatched vintage coffee-pots, ice buckets, and other serving pieces I've found after scouring flea markets. Look for these types of items on your own treasure hunt. They'll be ideal for a shabby-chic or country look at a garden wedding. To make a contemporary

statement that's strong but simple in style, try covering inexpensive wood boxes with silk or other fabrics that coordinate with the tablecloth and your tabletop color scheme, or even a remnant from the bride's dress; or line glass containers with fresh leaves. For something striking and totally different, you can dispense with containers entirely and set pomanders of flowers directly on the tablecloth. Roses and carnations, used separately of course, work very well in pomanders, since they are hardy and won't spoil.

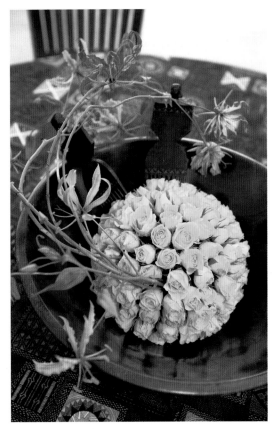

If you want your guests to take the flowers home with them, make sure you're not using expensive rented containers that will be charged to you if not returned. Instead, have the florist construct inexpensive containers that can be hidden within the outer containers, then easily removed and taken with the flowers. Tell the wait staff or your wedding planner if the containers need to stay. They can then show guests how to remove the inner glass vase and arrangement—and you won't have to spend the last part of your reception as the petal police. A thoughtful alternative is to have the centerpieces delivered afterward to a local hospital, hospice, or senior center, where they can be enjoyed for a few days after you've left for your honeymoon. Just alert the facility in advance, especially to make sure there's no policy prohibiting your floral donation.

...

2 YELLOW POMANDER: For an African theme, this pomander of yellow roses nestles inside a carved wooden bowl with a pair of wooden serving pieces, all surrounded by a garland of gloriosa lilies emanating from the pomander.

winter

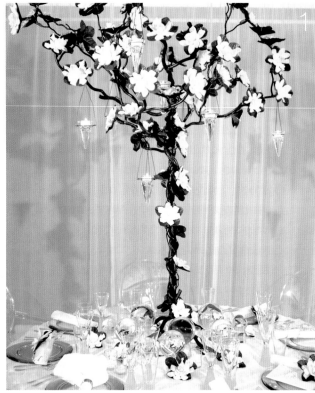

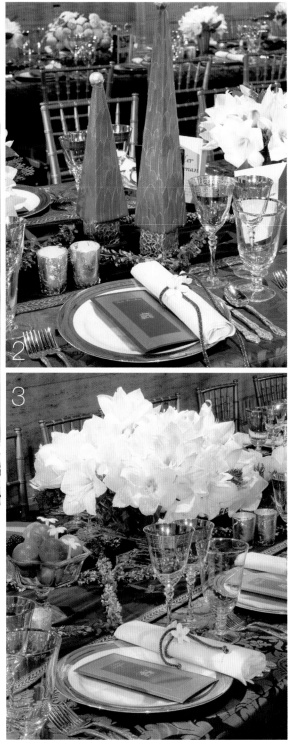

1 METAL TREE: For height, elegance, illumination, and fragrance—real multitasking!—this metal tree is hung with conical votive candles and dozens of mesmerizingly fragrant gardenia blossoms set just far enough away that their smell won't disturb the palate.

2 FORMAL ELEMENTS: Polystyrene pyramids pavéed with fresh bay leaves and topped with a holiday ornament provide a formal element between the flowers and the bowls of fruit.

3 AMARYLLIS: Large blossoms of white amaryllis punctuate this long table, with small accents of stephanotis blossoms on the napkins. At a table like this, it's fun to alternate bowls of fruit along with flowers.

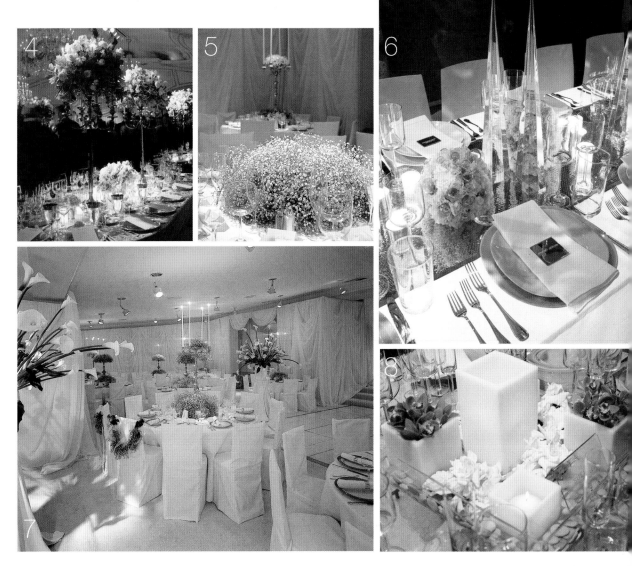

4 HIGH CANDELABRAS: These very tall candelabras are packed with tulips and roses against a background of velvety Dusty Miller for a wintry motif.

5 BABY'S BREATH: A dense nest of white baby's breath, sitting alone in the center of a table surrounded by candles, makes a simple, clean, and contemporary statement.

6 TIGHT POMANDERS: For a winter look, pomanders of white carnations, silver balls, and white roses are placed down a sequined silver runner that's accentuated with dramatic Lucite obelisks and frosted votive candles.

7 CLOUDS OF BABY'S BREATH: There's great charm (and cost-efficiency) in selecting one flower and using a lot of it en masse, such as this gypsophila—commonly known as baby's breath—in the middle of some tables, alternating with candelabras that are surrounded and filled with the same flower.

8 SQUARED IN: For a very modern wedding, these Lucite squares are filled with rose petals, wax candles, and small arrangements of green cymbidiums.

CANDELABRAS: Black Magic roses, Fire and Ice roses, and deep red dahlias stud this series of tall gilded candelabras; low bowls of fruit and small julep cups of roses accent the tall elements.

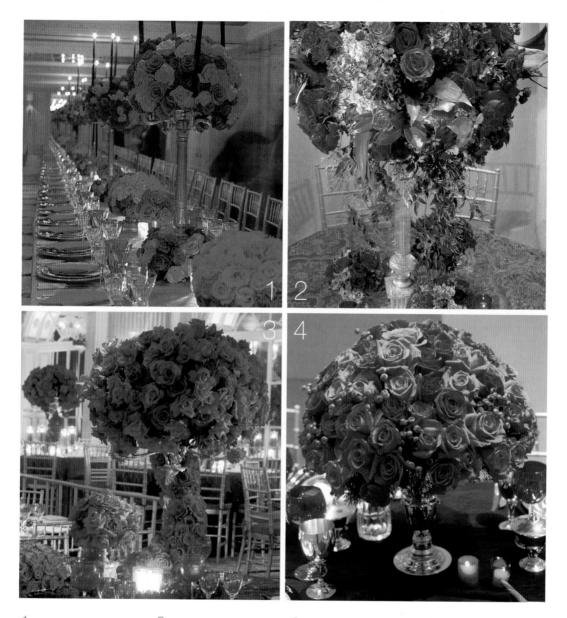

1 MORE CANDELABRAS: Create a sense of warmth with thin, tapered black candles that rise from the already tall candelabras, which are filled with coral, red, and Black Magic roses.

2 VARIETIES OF RED: Opulence and drama are front and center in this gilded-and-crystal pedestal blooming with a variety of red roses, coxcombs, hydrangeas, calla lilies, and jasmine vines.

3 AND YET MORE CANDELABRAS: A tray serves as a base for candelabras that are lavishly covered in pomanders of red roses, with smaller satellite pieces at lower levels.

4 MIXED ROSES: This pomander of mixed red roses, interspersed with holiday greens and holiday berries, is amassed in a beautiful family-heirloom Christofle silver vase.

1 CORAL ROSES: Borrowing on an African theme, a black ceramic dish is lined with coral roses and punctuated with osprey feathers, with the whole arrangement sitting in an eye-catching cuff of black ostrich feathers. Cha-cha-cha.

2 QUILLS AND EGGS: The top of this rose arrangement is crosshatched with porcupine quills and surrounded by lacquered ostrich eggs that also hold roses—fabulous for the African or ethnic look.

3 RED ROSES: A profusion of roses, vines, and a few pieces of fruit in a small urn create a nineteenth-century tableau.

4 STUNNING SCHIAPARELLI PINK: By contrast, this candelabra is topped with a pomander of hot pink roses that's surrounded by black tapered candles in glass hurricane lanterns, while the base is a pudding of matching pink roses with a cuff of red.

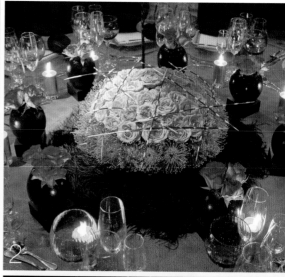

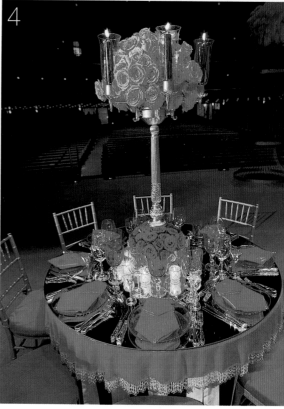

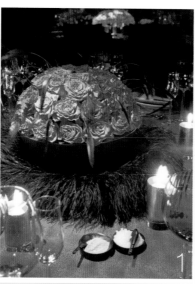

5 STUNNING SCHIAPARELLI PINK, REDUX: For a look of pure opulence and decadence, these tall gilded arrangements are anchored on the bottom with Schiaparelli pink roses, surrounded by red roses, and set on a gilded mirror top, while the top is an inverted cone of cerise peonies with huge plumes of matching Schiaparelli pink ostrich feathers. Hallelujah.

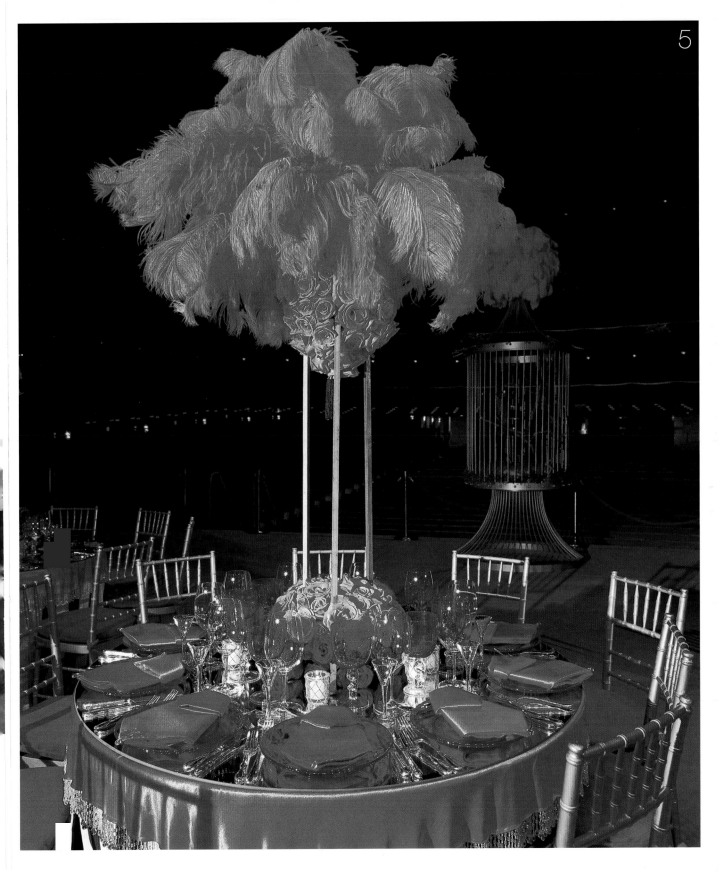

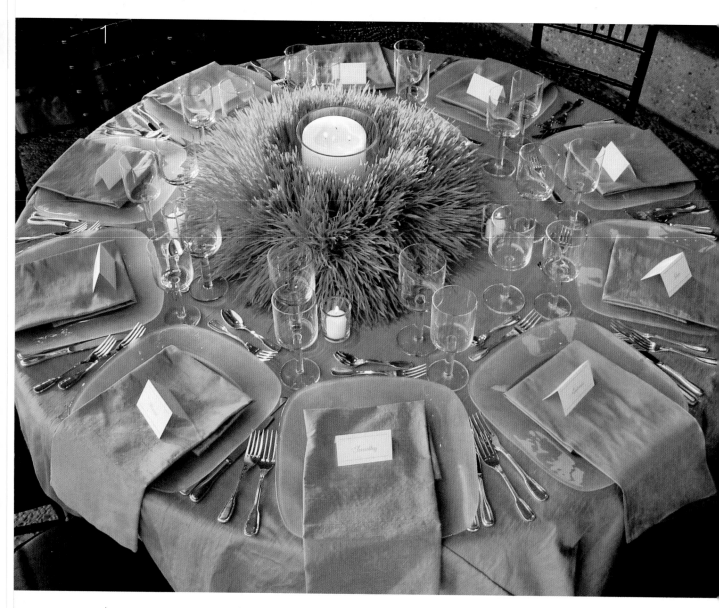

1 WHEATGRASS: For a simple, inexpensive, chic, and fresh look for a spring wedding, wheatgrass is allowed to grow four or five inches tall, then used to surround a multi-wick candle in a hurricane lantern.

2 CHRYSANTHEMUMS: The lime-green dupioni silk runner is bordered with galax leaves, while chrysanthemums are arranged tightly in a ceramic vase that's lined in a matching silk.

3 VIBURNUM: A rectangular glass vase is filled first with branches of curly willow to provide an anchor for stems of bright green viburnum.

4 CHARTREUSE: For contrast, one container is covered in chocolate-brown silk while others are treated to green silk. The chocolate vase is packed abundantly with chartreuse cymbidiums.

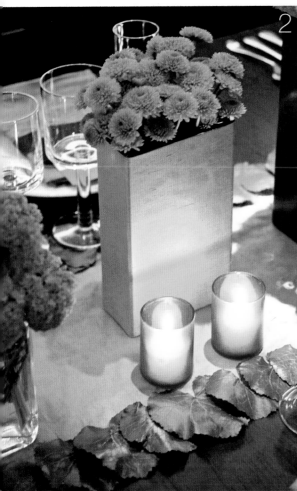

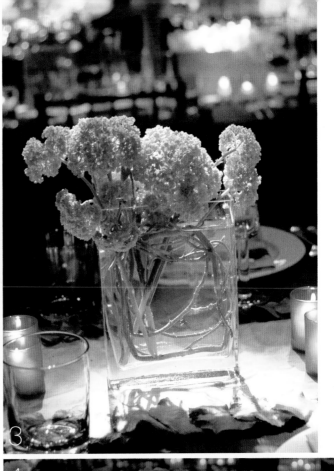

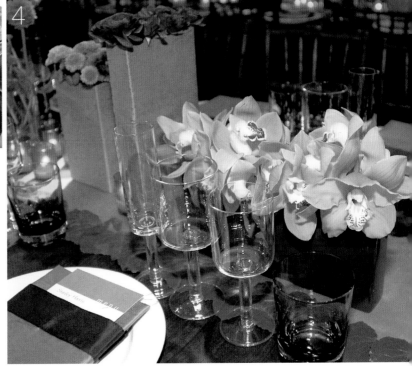

1 PAVÉD BALL: A very simple oasis ball is pavéd with small golden chrysanthemums and wrapped with a halo of curly willow, then is finished off with a tiny accent of African beading for a more ethnic look.

2 SCULPTURAL STEMS: Orange pea gravel secures the long stems of California poppies in these rectangular containers.

3 SCULPTURAL STEMS, A DIFFERENT WAY: For a whimsical look, square containers of wheatgrass play off the sculptural stems of California poppies.

4 JULEP CUP: One of the elements in this grouping is a traditional sterling silver cup that's loaded with sari roses for an utterly romantic vision.

5 PARROT TULIPS: A geometric vase makes a striking statement when packed to capacity with deep-purple parrot tulips.

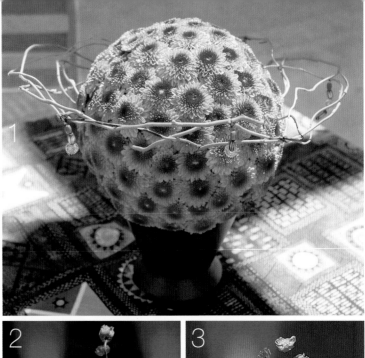

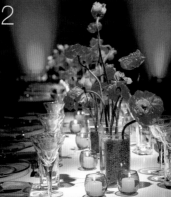

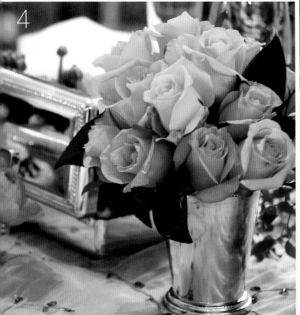

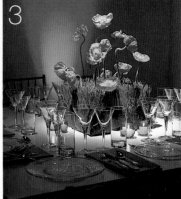

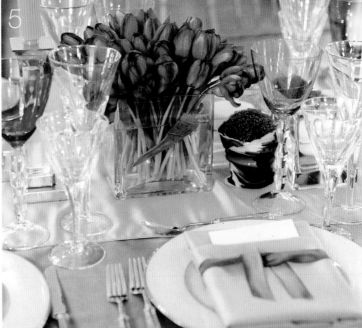

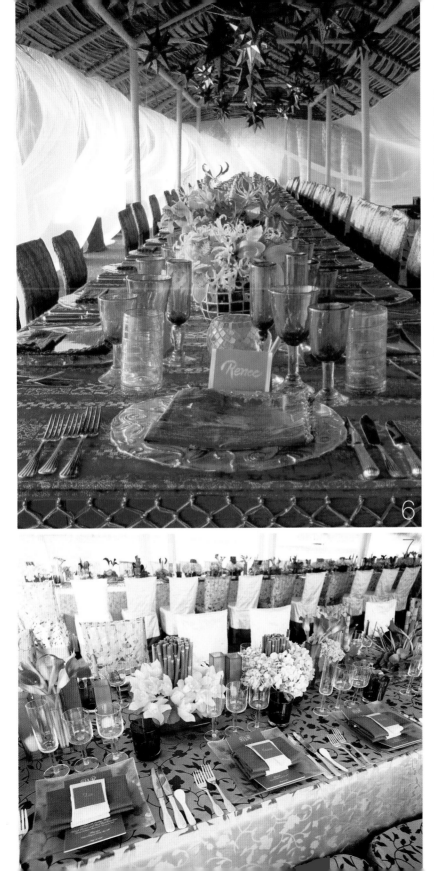

6 LOCAL ARTISANS: Whenever I stage a destination wedding overseas, I try to embrace as much local flavor as possible—in this instance, we bought all the glassware and china from artisans in the nearby craft markets of Guadalajara.

7 PLAYING WITH TEXTURE: For an utterly modern look, glass vases and Lucite troughs encase shaved horsetail, arrangements of chartreuse cymbidiums, mini lavender calla lilies, and variegated hydrangeas, all scattered amid a sprinkling of tall square lavender votive candles.

summer

1 **WHITE TULIPS:** There's nothing quite as pristine as a beautiful bunch of freshly arranged white tulips, here arranged into the form of a bouquet with the stems wrapped in a tropical green leaf and placed in a clear glass cylinder.

2 **MIXED WHITES:** French white hydrangeas, freesias, miniature calla lilies, and star of Bethlehem are each tied into a tight bouquet, placed in clear glass, and scattered around the table for a crisp, white summery look.

3 **STAR OF BETHLEHEM:** This arrangement of star of Bethlehem looks great when each stem is exactly the same length, twisted to create a spiral pattern that's tied and secured with a tropical leaf.

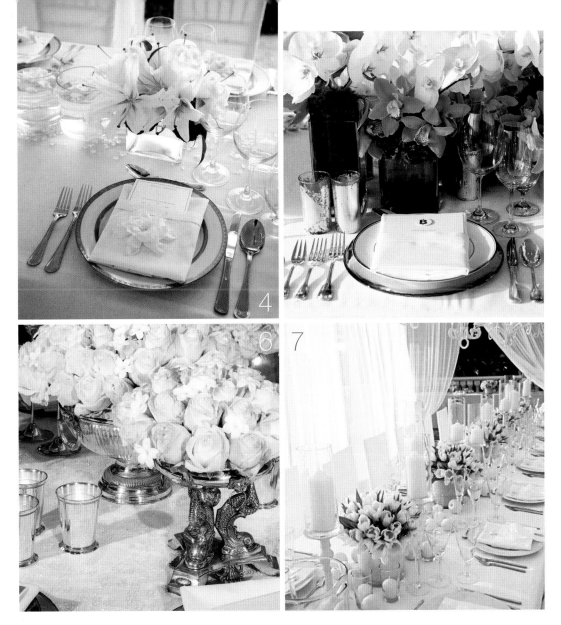

4 CASABLANCA LILIES: A fantastic look for a seaside wedding, here glass containers are filled with water and Casablanca lilies along with gardenias, a fresh gardenia at each setting for a dose of fragrance.

5 ORCHIDS: Geometric glass containers are lined with dark leaves then filled with moss and studded with chartreuse green cymbidiums and elegant fronds of white phalaenopsis.

6 ROSES AND STEPHANOTIS: White roses and stephanotis blossoms are amassed in heirloom silver containers, which are illuminated with silver candlesticks and votive cups.

7 TULIPS: For an element of whimsy, apples are spray-painted white and laid down the table to alternate with the white tulips amassed in white-glass vases.

1 VENDELA ROSES: Placed directly in front of the bride, a silver family heirloom overflows with Vendela roses and proud blossoms of lily of the valley.

2 SUSPENDED IN WATER: A water-filled glass cylinder magnifies nature's every wondrous detail of these white orchids.

3 TOWERING CANDELABRAS: This classic arrangement consists of white carnation with maidenhair fern in the tall candelabras. A huge pudding of white roses marks the bride and groom's spot.

4 PHALAENOPSIS: Thousands of blossoms of white phalaenopsis are placed in a faux lizard–covered trough along the center of the table, which is illuminated from below with votives and from above with candles floating in amber water.

5 PHALAENOPSIS AND CYMBIDIUMS: For a serene, summery look, white phalaenopsis orchids are interspersed with contrasting green cymbidiums.

1

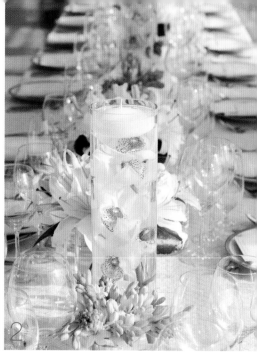

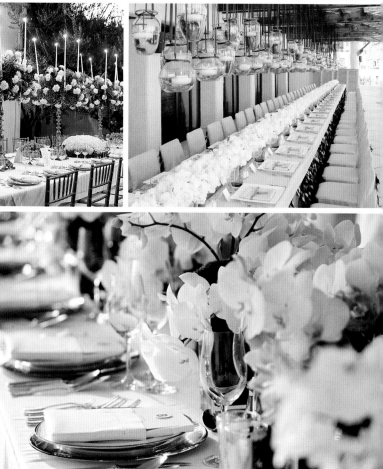

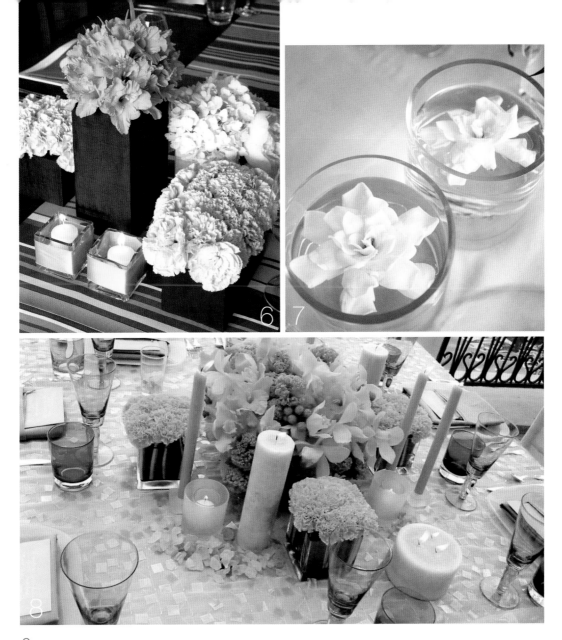

6 SILK-COVERED CONTAINERS: This bar-code runner in lime, olive, white, and chocolate is topped with wooden boxes covered in brown dupioni silk, then filled with flowers that include white hydrangeas, peonies, carnations, and gladiolus blossoms; two votives wrapped with lime-green ribbon finish the grouping.

7 FLOATING BOWLS: For a simple, clean, contemporary look, blooming fragrant white gardenias are suspended in bowls of water that are just large enough to fit the diameter of the blossoms.

8 ORCHIDS AND CARNATIONS: For an early-evening wedding at the river, a garden urn spills over with mosses, pods, green orchids, and green carnations; at four points are small glass containers lined with tropical leaves and filled with more green carnations.

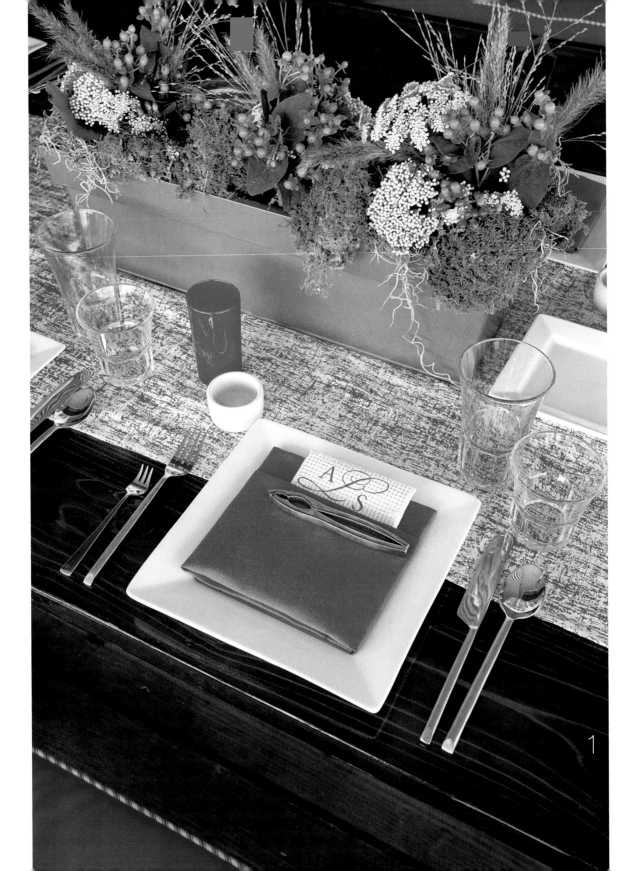

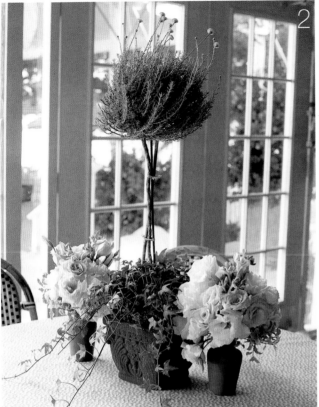

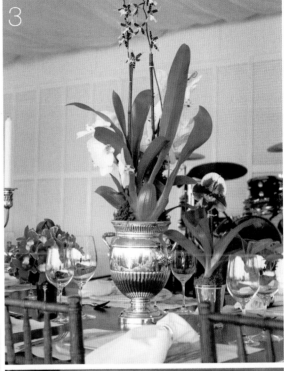

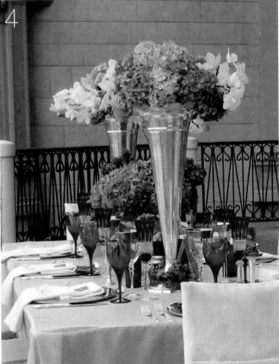

1 PLANTERS: A casual look is achieved via copper boxes planted with hypericum berries, mosses, and wild grasses.

2 HERBS AND IVY: For a garden wedding, fragrance abounds in large containers of fresh herb topiaries with ivy on the bottom as well as in little arrangements of lisianthus, roses, freesia, and more fresh herbs.

3 ORCHIDS: Flowering orchids are placed in ice buckets and silver serving pieces along with cymbidium blossoms in small horn containers to create a breezy, colonial feel.

4 HYDRANGEAS: At this long table, tall trumpet vases alternate with a lower arrangement, creating a unified palette of shades of blue and green hydrangeas, accentuated with white phalaenopsis blossoms.

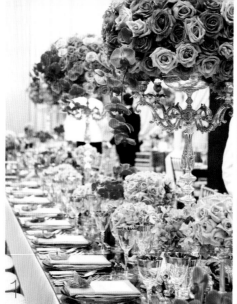

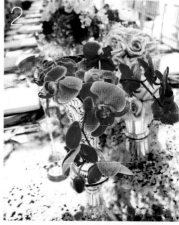

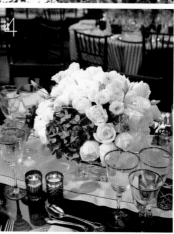

1 MOSTLY ROSES: Phalaenopsis, hydrangeas, and lisianthus pair with roses in the tall candelabras, while the low pomanders are arranged in julep cups.

2 PHALAENOPSIS: Just one or two stems of purple phalaenopsis look particularly glamorous when set in a silver julep cup on an antiqued mirrored surface.

3 SILVER TRAYS: Floral groupings of hydrangeas, lily of the valley, lisianthus, and lavender roses with candles on silver trays suggest intimacy and abundance, and the mirrored top adds a strong dose of glamour.

4 CRYSTAL URN: On a wooden table atop a crisp white runner, a crystal urn holds white Vendela roses, lisianthus, and hydrangeas.

5 MIRROR IMAGE: For added depth, a full-length mirror sits at the end of the table, doubling the majestically towering arrangements of hybrid delphiniums in silver trumpet vases between pomanders of white roses.

6 COBALT DIFFUSION: White peonies spill from miniature silver trumpet vases, and cutglass cobalt-blue votives illuminate the table and cast a romantic violet hue over the entire room.

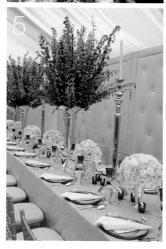

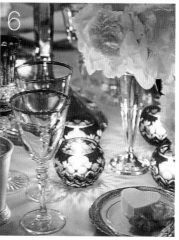

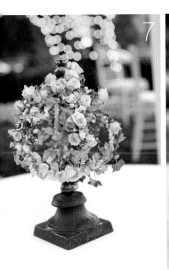
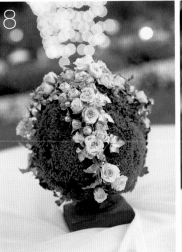
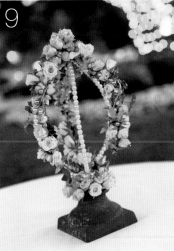
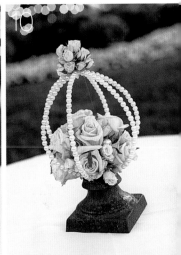
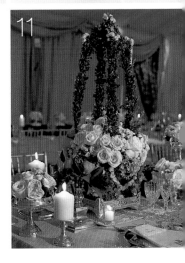

7 SPRAY ROSES: Spray roses among gilded leaves and crystals create a jewel-like effect.

8 MOSS AND SPRAY ROSES: Spray roses, pearls, and gilded mini-ivy leaves cascade on four sides from a sphere of moss.

9 CAGE OF ROSES: This combination of pearls, roses, gilded berries, and ivy is meant to look like a cage made from tautly strung pearls.

10 MORE ROSES: Classically formal shapes are created with pearls, crystals, and small roses for a majestic theme in the form of a royal scepter.

11 GARDEN BASKETS: For a very rich nineteenth-century look, formal garden shapes are covered in boxwood and then filled with a profusion of roses, and enthroned majestically in silver trays.

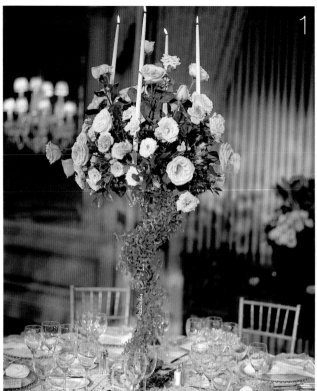

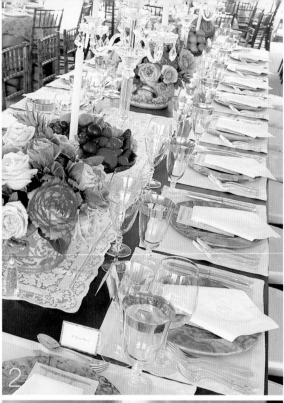

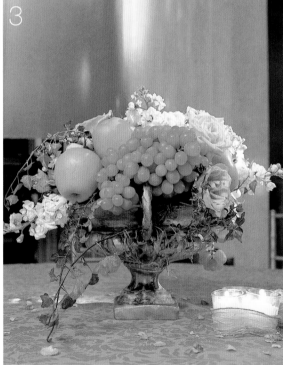

1 ROSES WITH SMILAX: The candelabra is designed in a 1950s fashion. Roses are used sparingly, with a lot of air between blooms, and a beautiful garland of smilax anchors the flowers to the table, with long tapers extruding from the top. Big effect without such a big expense.

2 MIXED ROSES: California garden roses and waxy camellia leaves are grouped in Chinese urns for an elegant colonial look.

3 FRUIT WITH FLOWERS: For opulence without breaking the bank, large pieces of fruit are arranged in this pedestal urn; ivy, stock, and just a few rose blossoms fill the negative spaces.

4 COMBINATION BOUQUET: For this family-style dinner, a handful of arrangements—a combination of roses, hydrangeas, and ranunculus—is placed simply down the center of the table, leaving gaps for the food platters.

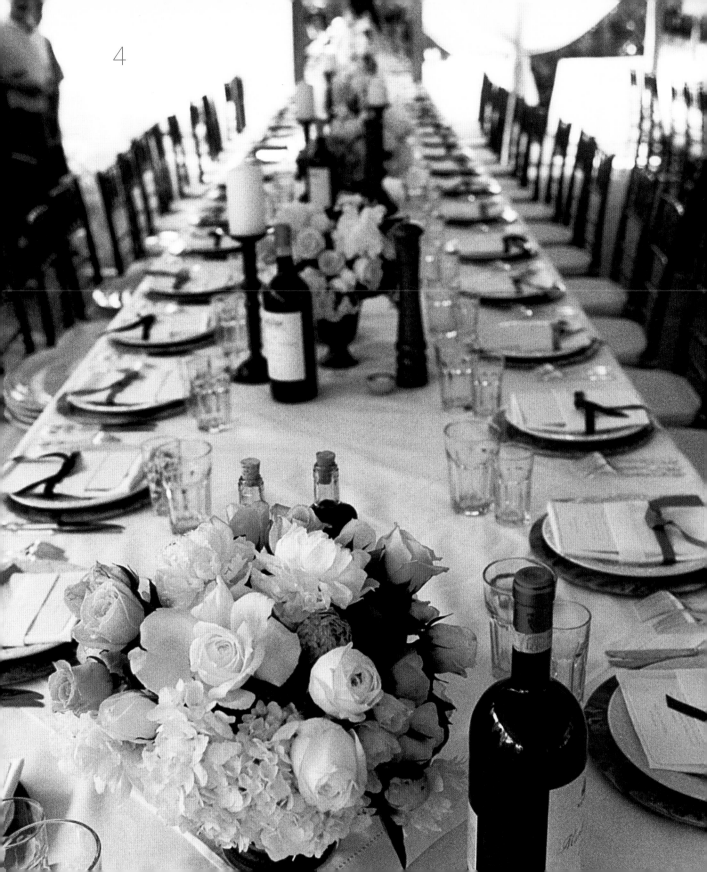

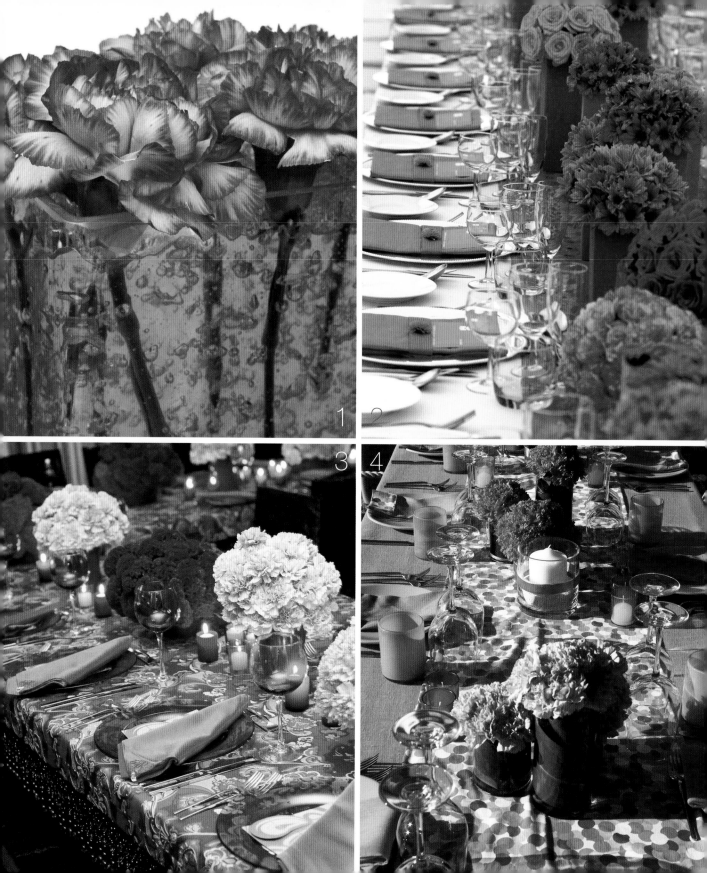

1

2

3 4

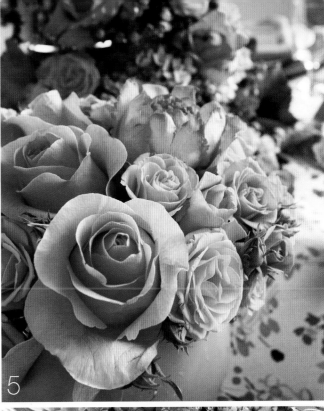

1 COLORED GEL: This extremely inexpensive arrangement is nothing more than carnations in a clear glass vase that's filled with colored gel.

2 SILK BOXES: On two very long tables, flowers are arranged in a series of simple silk-covered boxes, the perfect complements to the daisies and roses in shades of orange and pink.

3 RED CARNATIONS: Two colors of always-reliable carnations fill these short ceramic vases.

4 CARNATIONS: A great approach for a beach wedding, these glass vases are lined on the inside with tropical green leaves; then variegated carnations, a simple and hardy flower that works well in hot climates, are bundled inside.

5 AND 6 ROSES: In vintage celadon vases, mango and cerise roses alternate with green hydrangeas, which are the same colors used in the tablecloth.

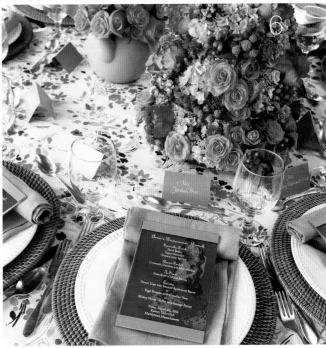

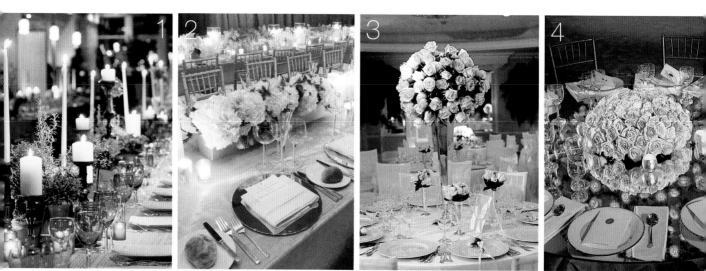

1 **TUSCAN TERRA-COTTA:** Live herb topiaries, placed organically down the center of the table and offset with votive, pillar, and taper candles, fill these small terra-cotta pots.

2 **HYDRANGEAS:** A warm, romantic effect is achieved with a low trough, covered in matte ecru stain, that's loaded with white hydrangeas and green orchids.

3 **ROSES AND SPRAY ROSES:** The tall silver trumpet vase offers a profusion of creamy white roses, and is encircled by a trio of mini trumpet vases filled with smaller spray roses, for a déjà-vu-in-miniature effect.

4 **PUDDINGS OF ROSES:** A warm, harmonizing assortment of yellow and peach roses is arranged into a pudding and placed on a mirrored tabletop, creating the reflected impression of a complete rose pomander.

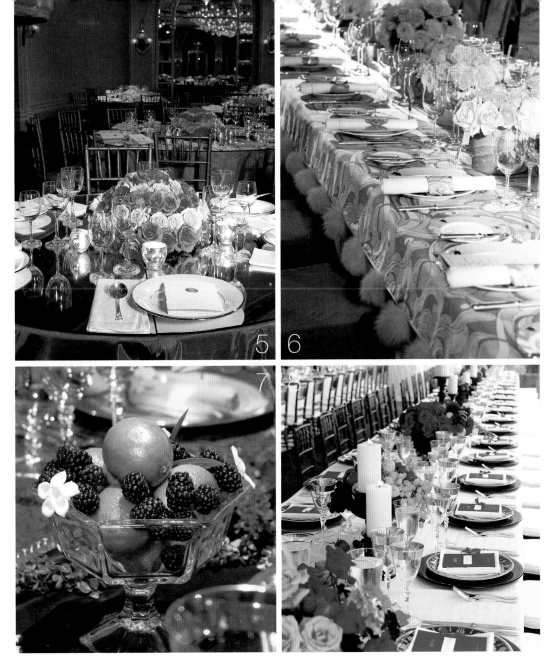

5 CONCENTRIC REDS:
Circles of autumnal-shaded roses—deep reds, corals, and browns—appear like a sphere on top of this elegant mirrored table.

6 POM-POMS: You may not often use the words *pom-pom* and *tablecloth* together, but here's a vibrant Pucci tablecloth with fox fur pom-poms to match the roses.

7 FRUIT BOWL: To create abundance without using a lot of flowers, fill a simple glass bowl with limes, blackberries, and just a few stephanotis blossoms.

8 ROSES AND FRUIT:
Orange, red, and coral roses are combined with urns cascading with grapes, apricots, and plums; thick pillar candles stud the center of this long table.

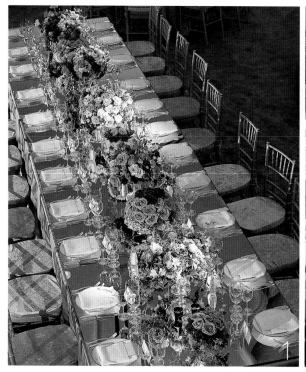

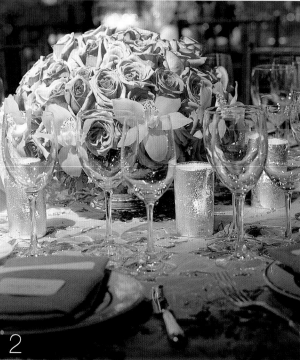

1 GILDING THE ROSES:
For a sumptuous, romantic feel, silver-leaf votive candles illuminate the gilded vases, which are filled with sterling roses, deep purple lisianthus, and maidenhair fern and centered on this elegant main table.

2 ELEGANT POMANDER: This tight cluster of fragrant sterling roses is placed in an urn, trimmed with maiden-hair, and accented by lime-green cymbidium blossoms around the sides.

3 PHALAENOPSIS: For a look of abundance, two different types of grapes in different silver urns surround an arrangement of white phalaenopsis, offset by pillar candles in match-ing silver stands.

4 TOWERING MUMS: For an element of height on the table, balls of Oasis are covered completely with small chrysanthemums next to a lower piece made of concentric circles of chrysanthemums, roses, and berries.

5 ROSES AND CHRYSANTHEMUMS:
Dueling pomanders of roses and chrysan-themums in comple-mentary pale colors run the length of this jewel-toned table.

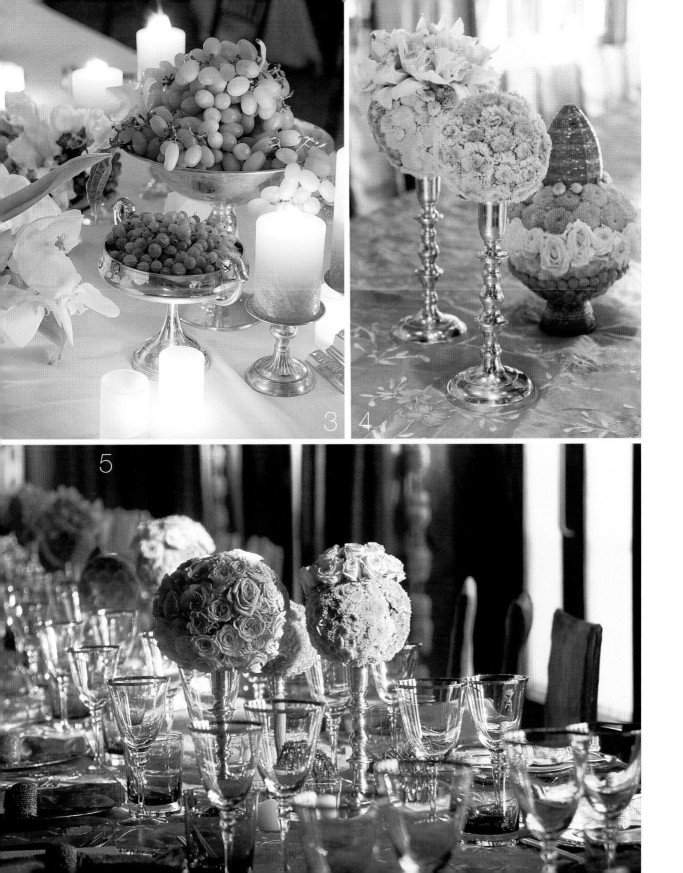

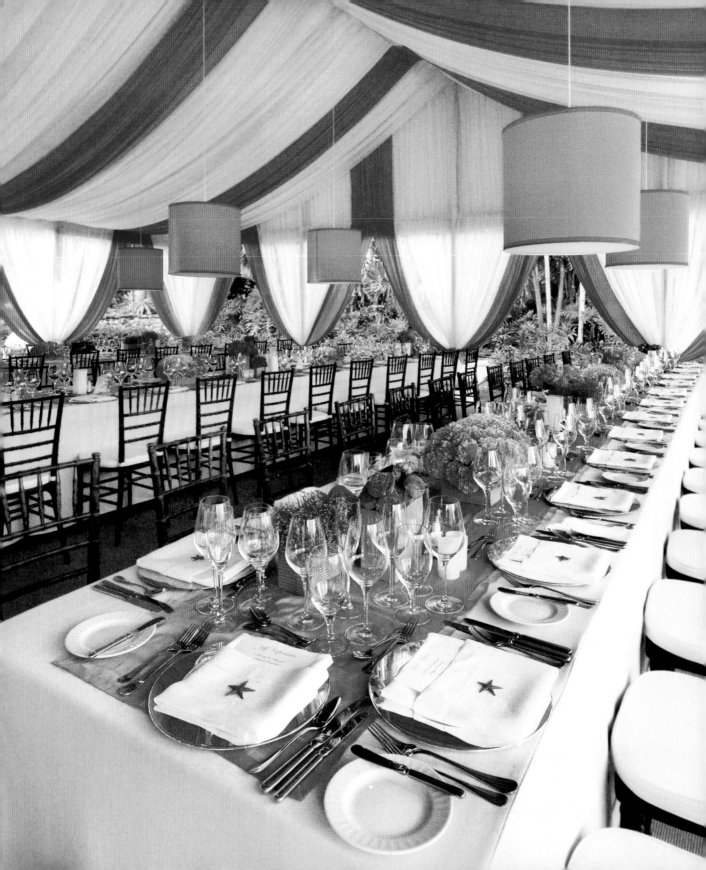

4
reception décor

When I started in the special-events business, the options available to party planners were somewhat limited: white plates, possibly with a shiny gold rim; an array of primary-colored linens loaded with polyester; two kinds of folding chairs; and sixty-inch round tables. I am happy to report that the industry has grown in leaps and bounds, and today vendors specialize in every detail of the business. Some offer spectacular linen collections with corresponding chair covers and napkins, some house dozens of china patterns from formal to French country. Your local neighborhood rental company is no longer the only option. With overnight shipping and Web sites to satisfy any taste, the choices are literally limitless.

Naturally, this is great news for you and your reception. With the ceremony behind you, it's time to celebrate, let down your hair, and dance the night away while toasting each other with flutes of chilled Champagne or signature cocktails. And with all the décor choices that are available, it's easy to think out of the box: Maybe you'd like an early-evening reception in a winery with dancing until midnight, or an elegant dinner in your home with guests seated at one long table, or a barefoot barbecue on the beach with everyone dressed in white around huge bonfires. Your reception can be as formal as you've always dreamed it would be or as casual and informal as you wish.

DRAPED CEILING: Embracing a coral-and-white theme, this ceiling is draped in ivory fabric and punctuated with coral streamers, dividing the banquette-filled room.

Create a wedding binder for everything from swatches to contracts, and keep the information separated by vendor. Be honest with yourself and straightforward with your vendors as to what you like, what you don't like, and what you are willing to pay. Take the entire binder with you whenever you go to vendor meetings so that you'll always be able to paint a visual picture to anyone who needs to understand and interpret your vision.

Whatever your vision, I strongly encourage you to reconsider the traditional approach of a roomful of matching tables that all look the same. Instead, try to divide the tables into different design scenarios that complement one another while sharing something in common. For example, you might consider dressing all the tables with the same underlay cloth, or the same napkins, or the same cushion covers, with each table topped with a different overlay and accented as variations on a theme: beading on one, embroidery on another, tassels on a third. You'll get to tell a more personal story in a room that looks as if consideration had been given to the little touches, instead of a room that seems decorated without careful thought. Also, whether you're using long tables, round, square, or a combination of all, which I encourage, it's crucial that you position them with the proper degree of intimacy. You want enough space between tables for the guests and staff to navigate, but *just* enough space, and no more—about two feet between the backs of the chairs once guests are seated. This sense of intimacy allows all your guests to play off one another's energy as the party goes on.

Your marriage celebration is about you, your fiancé, and your guests, so spend your money on the things that all of you will get the most enjoyment from. If you can

1 MANE OF MARIGOLD: This sumptuous orange-and-gold damask curtain is trimmed with strands of horsetail and bright orange marigolds, a flower traditionally used in India for garlands.

afford a knockout party, and love caviar and vintage Champagne, then host that black-tie sit-down evening of decadence filled with all your favorites. If you and your families adore the great outdoors and barbecue, consider a reception in a mountain lodge with a jaw-dropping view and fantastic Texas-style chicken and ribs.

Since your wedding celebration will most likely be your first statement of style as a couple, pick five things and do them properly rather than do ten things on a shoestring. If you love food and wine, but you're working within a tight budget and it's not possible to shave your guest list any lower than 150, you might have to forgo the sit-down dinner to avoid compromising on a wine you don't love or an entrée you won't enjoy. No matter how much you spend, or how big your budget, there will always be compromises. So maybe instead of that over-the-top dinner, host a cocktail party and pair your favorite wines with a selection of tray-passed heavy appetizers, hire a great band, and serve a slice of delicious wedding cake. As long as you're happy with the result, your guests will focus on the highlights, and will never know what was cut to stay on budget.

One of the most commonly overlooked aspects of reception décor is lighting. Many people don't realize just how critical it is, partly because nearly all wedding planning takes place during the day—but most receptions take place at night, when whatever is lit seems to pop and whatever isn't falls into a black abyss. Lighting doesn't mean simply flooding the room with brightness; it means manipulating the colors of light and their intensity in the room to highlight what you want seen and hide what you don't. I'm a self-confessed ambience junkie, and I think ambience is all-important; you'll want to be able to adjust the lighting from elegant and subdued for dinner to seductive or mirrored-ball sparkly with red gels for dancing if

2 **DRAMATIC DINING:** Sheer drapes and sexy lighting create an intimate, unforgettable setting.

that's your vibe. It's amazing how much you can transform a space without moving anything other than a few switches and controls. After all, why spend money on centerpieces when they can't be seen in a dimly lit room? Instead, spend a portion of your flower budget on some dramatic pin-spot lighting that's focused on the center of your table and the flowers. In most hotels you can have fixtures installed that attach to the hotels' existing lighting along the ceiling and cast an eight-degree cone of light directly on your flowers, illuminating them like glistening, multifaceted gemstones. It's particularly striking to pin-spot flowers from two opposing angles or sides, or tall centerpieces from both the top and the bottom. Pin-spot the cake table, bars, and buffet arrangements, too. And don't forget the band! Use people-friendly colors—pink, lavender, and amber—anywhere guests will be. (Avoid aiming very skin-unfriendly tones—blues, greens, or yellows—directly at people.) And I've said it a million times: Nothing flatters the skin like candlelight, so use votives to cast a flattering glow from below and pillars or tapers for illumination from above. There is no such thing as too much candlelight.

A week in advance of the event have a dress rehearsal where you can set up a table with the linens and the plates, the glassware and the flatware, the flowers and the menu cards. Eat the food. Drink the wines. I know some brides shake at the thought of (a) attending yet another meeting and (b) writing yet another check. But this is a chance for you to see how all your ideas will come together—what works, what absolutely doesn't—and to ensure that your florist, caterer, and planner all understand how the event will proceed without their having to ask you for instruction all night on your wedding. After you've taken care of all these details and confirmed your vision with your team, my last piece of advice is to give yourself over to the party.

I hope that the food is heavenly and those wines have their effect. I hope you dance till the early hours of the morning and take home memories that will last forever.

HOT TENT: This Bedouin-style tent (very easy to erect—no kidding) absorbs the light wonderfully, bathing within a beautiful shade of pink, bathing without in 100 percent high drama.

chair backs

1 **COTTON UNDER MUSLIN:** A thoroughly elegant chair is created by first covering the traditional Chari-vari ballroom shape in a white cotton slipcover, then capping it in muslin with frayed edges for a fun detail on the bottom, and tying at the sides with a suede shoelace for an unexpected touch.

2 **DUPIONI SILK UNDER SILK ORGANZA:** For a modern, tailored look, the ballroom chair is first given a three-quarter-length slipcover of ecru dupioni silk, which is then adorned with a loose sheath of silk organza for a flowing, romantic effect.

3 **RIBBON-TIED MUSLIN:** The most casual, easiest—and least expensive—way to reinvent the classic ballroom chair is to secure a length of muslin on the sides with a simple silk ribbon.

4 **LINEN WITH PIPING:** For the ultimate in summer chair décor, a white linen slipcover—with a tailored waist-down kick pleat—is finished with coral linen piping.

5 **SATIN AND ORNAMENTATION:** Here a chair is given an elegant white satin cap that's detailed with four covered buttons and a flowing organza skirt.

6 **SILVERY BLUE:** The classic ballroom chair is fitted in a silvery satin slipcover with an inverted velvet-lined kick pleat, which is secured halfway to the top with a velvet-covered square button.

7 **DRAMATIC BLUE:** Wow! Teal silk slipcovers feature back panels of patent leather for a very modern, very sexy look.

8 **SOFT BLUE:** The robin's-egg-blue skirt at the bottom of this organza slipcover mimics the tablecloth.

1 VARIETY IS THE SPICE:
Punch up a sea of
simple white slipcovers
by interspersing a few
chairs in a selection of
different fabrics; these
feature a botanical
pattern that's replaced
at the base with a
solid-colored linen
fringe.

2 GRADATIONS OF
GREEN: For this
garden-themed
wedding, three differ-
ent colors of velvet
create variations
among the cushion
covers, which boast
matching toppers
complete with floral
appliqué.

3 POPPING WITH PINK:
The principal pattern
for this wedding is
a bamboo weave of
chocolate brown and
white, a palette that's
brought to vibrant life
by Schiaparelli pink
piping along the joints
of the ivory canvas-
slipcovered chair.

4 ORGANZA WITH A
VOLUMINOUS SATIN
BOW: A fitted organza
slipcover boasts an
oversize satin bow; yel-
low, coral, and white
roses trim the top of
the chair.

5 HYDRANGEAS AND
STERLING ROSES: For
a garden wedding,
Versailles chairs are
ornamented with gar-
lands of blue hydran-
geas and sterling roses
secured with white
ribbons.

6 CITRUS AND LEAVES:
Completing the look
of a classic country
wedding, these chair
backs are garlanded
with lemons and limes
set into mixed leaves
and raffia.

7 A WELL-DRESSED
TABLE: Instead of
setting a table, I like
dressing a table: over
an emerald-green
dupioni silk underlay,
we lay a rich brocade
top fabric, which is
bordered with a thirty-
inch fringe of mac-
ramé. And note that
the back of the chair is
grommeted to look like
a corset. How's that for
table dressing?

1 BOLD PATTERNS: This velvet camel slip-cover is capped with eye-catching Pucci silk affixed with a yellow faux-diamond button.

2 DEEP COLORS: These chair covers are made from a deep purple stain trimmed in red with toggles in the rear, allowing you to see the inside of the red-lined kick pleat. The key to good slipcovers is to make sure they're well fitted; when not tight, slipcovers can end up looking like Grandma's under-wear. Nobody wants that.

3 FEATHERS: For drama at a winter wedding, the backs of the chairs are cuffed playfully with red feathers.

4 SILK FRINGE: In this opulent reinvention, a rental chair is padded with upholsterer's batting, then fitted with a royal-blue satin slipcover, backed with velvet, and finished with a custom-dyed seven-inch silk fringe, creating an über-glamorous transformation of the classic ballroom chair.

5 SAFFRON AND GOLD: For an Asia-themed wedding, these chair backs, intricately embroidered in India, are distinguished by a gold-thread pattern against an orange organza slipcover.

6 SEASHELLS: At this beach wedding, simple folding chairs come alive with clusters of seashells and streamers of coral ribbons.

7 ROSE TEARDROPS: For a formal wedding, the slipcovers are garlanded with teardrops of roses and vines.

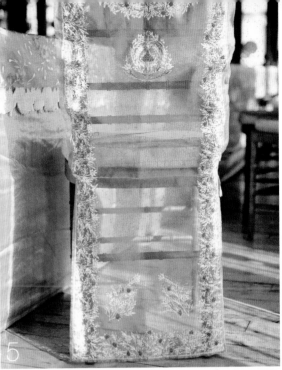

linen themes

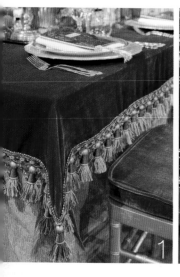
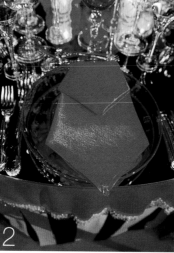

1 VELVET WITH ALL THE TRIMMINGS: To create a nineteenth-century look for this very opulent wedding, ornate fringe and tassels are placed on a burgundy silk-velvet overlay, which sits atop a gold damask underlay; the chairs are given coordinating piped burgundy velvet cushions.

2 RED ON PINK ON RED: The pink satin napkin features embroidery in red thread, a red linen lining, and a red ruby bead for trim. And it sits on one of the all-time over-the-top tables, with a crinoline overlay topped with a black-and-white striped cloth decorated with a slit every eighteen inches; this cloth is in turn topped with a Schiaparelli pink overlay fringed in Swarovski crystals; finally, this overlay is topped with a gold mirror. Now *that's* a table.

3 LONG CUT CRYSTAL: The heavier the fringe you use, the better the cloth will drape, as evidenced by this fringe, made from a cut crystal that hangs three inches from the edge of the cloth.

4 HEXAGONAL CLOTH: Going beyond the square, I created hexagonal tablecloths, so at each setting a pointed flap hangs down, with the beading just touching the top of the chair.

5 DAMASK OVERLAY: On the alternating tables, the overlay is gold damask trimmed with burgundy and gold tassels, while the underlay is a burgundy velvet cloth, which is matched by the cushions.

6 INTERLOCKING RUNNERS: Square tables present interesting geometric opportunities to create treatments such as these interlocking runners. A six-inch overhang finished with luxurious fringe and thick tassels rests atop a fitted striped cloth.

7 WINTRY NOTES: Citrine beading, a sage underlay, and a rich brown velvet overlay create an elegant winter look.

8 MATCHING BANQUETTES: In this terraced ballroom, the tables are given a more interesting treatment than normal: They are outfitted with tablecloths in the same fabric as the banquettes' upholstery.

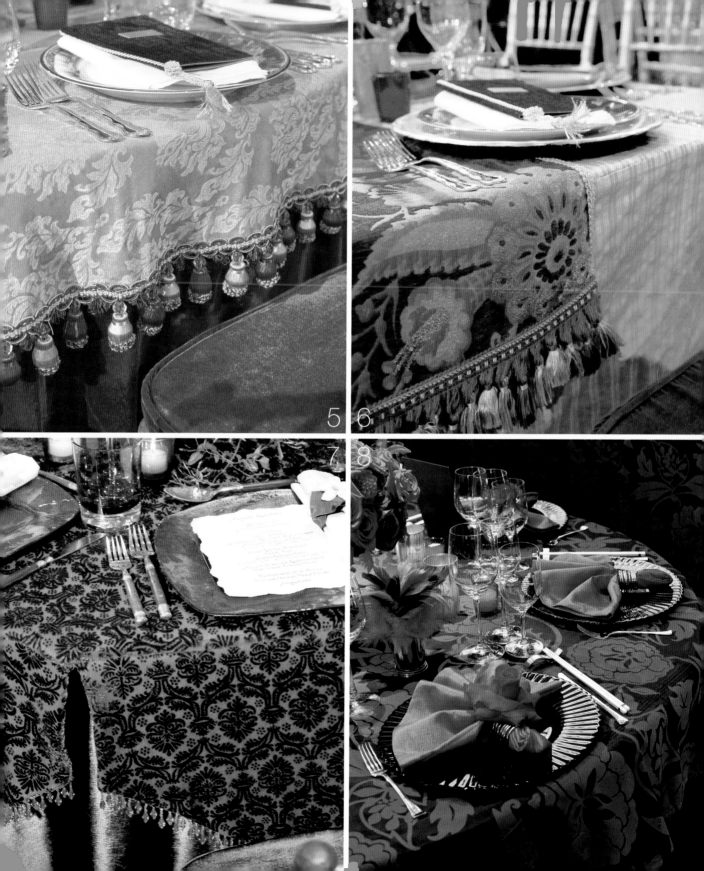

5 6
7 8

1 **SUBTLE PLAID:** This table is covered in dupioni silk cloth with a plaid tone-on-tone overlay, trimmed with a fringe made from coconut shell. For a final dash of glamour, a lantern underneath each table creates a wonderfully warm glow while also making the table appear to be floating.

2 **BAMBOO FRINGE:** At this beach wedding, we drape the tables in oyster dupioni silk, then top them with an Indian beaded overlay trimmed in a thoroughly unexpected bamboo fringe.

3 **RIBBON-TIED:** The top cloth on the table at this beach wedding is made from Irish linen tied at the corners with suede ribbon.

4 **ROSETTES:** At this very formal wedding, the overlay is feathered in the corners and middle, creating an elegant scallop. At each spot where the cloth gathers, a silk rosette with a pair of tassels affixes the overlay to the underlay to the table, all of it in a rich monochrome.

4

1 GREEN CITRINE: For this summer wedding, the base cloth is an olive satin topped with an embroidered and beaded Indian vine overlay; green citrine beading and satin trim finish the cloth. A complementary white hemstitched napkin, tipped with the same bead, completes the picture.

2 BURNOUT PATTERN: Here the overlay is an organza burnout, with the pattern showing clear against the colored underlay. Note the generous twelve-inch flange along the bottom of the overlay, which is echoed in both versions of the chairs.

3 ASSORTED TEXTURES: For a Venetian-inspired wedding, this woven lamé underlay is drawn up with a quilted lavender overlay trimmed in vintage Venetian brocade.

4 VINES: A well-ironed pistachio silk-satin tablecloth is the underlay, which is topped with a vine-patterned embroidered organza overlay trimmed in the same satin as the underlay, which, not coincidentally, is the same fabric used for the seat-cushion covers.

5 RENAISSANCE EFFECTS: For this Tuscan-themed wedding, a Renaissance pattern is embroidered with brick-colored and black thread onto crisp Italian hemstitched linens.

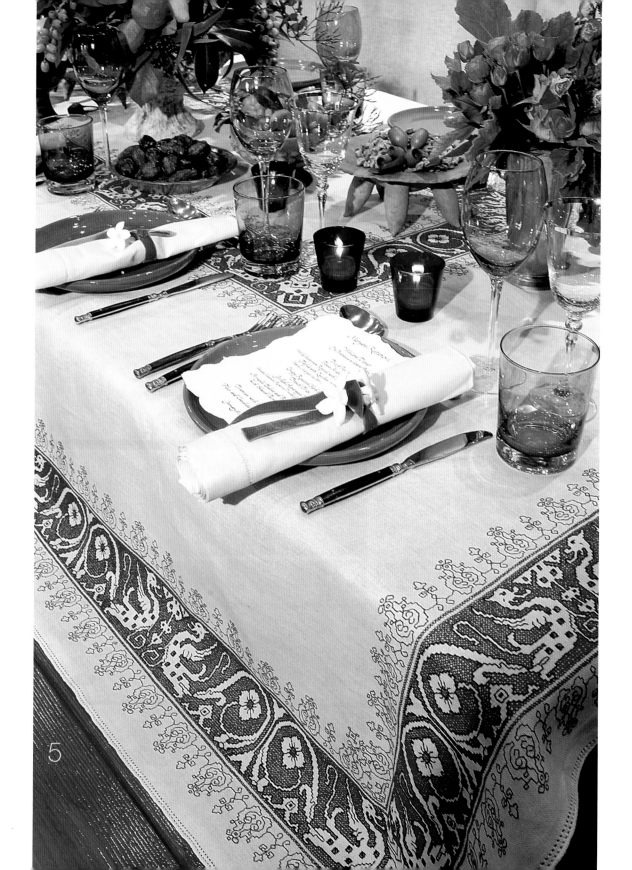

1 SOUP SERVICE: For a family-style meal, I prefer to leave the dishes at each setting and bring the food to the table in platters, such as at this soup course. Note the napkin used as a liner under the bowls.

2 DOWNWARD TINES: On the American table, our fork tines usually face up; but in the European style, they're positioned downward.

3 COLORED GLASSES: These days it's possible to rent glassware in all different shapes, sizes, and colors to help complement your theme. Alternatively, mass merchandisers such as Home Shopping Network make it possible to *buy* all your glassware at what may not be much more— or any more—than rental costs.

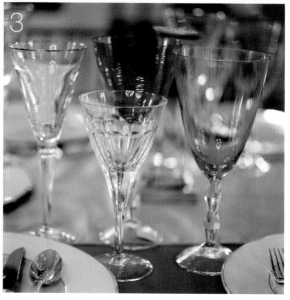

entry arrangements

4 HELLO, SEXY: For a very sexy look, pomanders of carnations orbit over silver candlesticks on either side of a tall cylinder filled with red water and a floating candle. The whole arrangement is punctuated with votives.

5 WARM WELCOME: This welcome table is topped with a metallic tree fitted with hundreds of curly willow branches, from which are suspended clusters of red pepper berries and hanging candles.

6 AUTUMNAL CORNUCOPIAS: For a fall wedding, this entrance is decorated with cornucopias filled with grapes, gourds, and pumpkins that set the perfect seasonal stage for the meal.

7 FLOATING CANDLES: Lotus blossom–shaped candles float in a gilded bowl, bringing life to the arrangement of variegated yellow and red carnations studded with cymbidiums.

8 SEGREGATED STEMS: The general principle here is to collect each type of flower in its own vase, and these deep purple calla lilies look extremely sexy arranged in their glass cylinder.

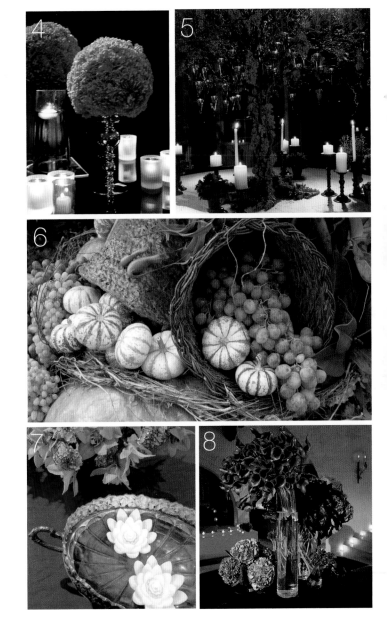

bar arrangements

1 CHERRY BLOSSOM FESTIVAL: The focal point of this bar is an arrangement of large branches of cherry blossoms punctuated with bright green viburnum.

2 BIG STATEMENTS: To fill the air in a large space, these gigantic elephant ear leaves provide a visual anchor to the bar.

3 RETRO CHIC: For a fun and quirky bar, this glass cylinder is covered in fake white fur and filled with shiny white gerbera daisies.

4 MIXED BAG: For a springtime luncheon, this interesting assortment contains a profusion of colors, textures, and scale, featuring bells of Ireland, papyrus, cobra lilies, cymbidiums, tropical leaves, Japanese eggplants, and limes arranged in a wooden box covered with a rattan matchstick blind.

5 SMALL FOOTPRINT: When decorating the bar, try to use a tall element that doesn't take up much surface space, such as this sculptural combination of two mercury-glass balls with miniature calla lilies that have been fashioned into shape with copper wire.

6 COCKTAIL TABLES: For a beach-themed wedding, the tables are decorated with glass bubble vases covered in moss with appliquéd seashells, then filled with bunches of white roses.

7 BAR BACKS: Tucked between the glasses and the back of the bar, small arrangements of roses packed tightly into glass vases punctuate the setting.

8 FABRIC BUCKETS: These floral buckets are wrapped in white fabric, then filled with white hydrangeas and freesia as well as monstera leaves to create a striking pair of bar installations.

9 TROUGHS: The centerpiece of this buffet reception is a trough filled with water, floating candles, and goldfish, with white gravel both inside and outside the trough.

10 MERCURY VASES: For a warm look to a cocktail reception table, bright smiling yellow calla lilies with deep orange throats are packed into orange mercury vases and surrounded by amber votives.

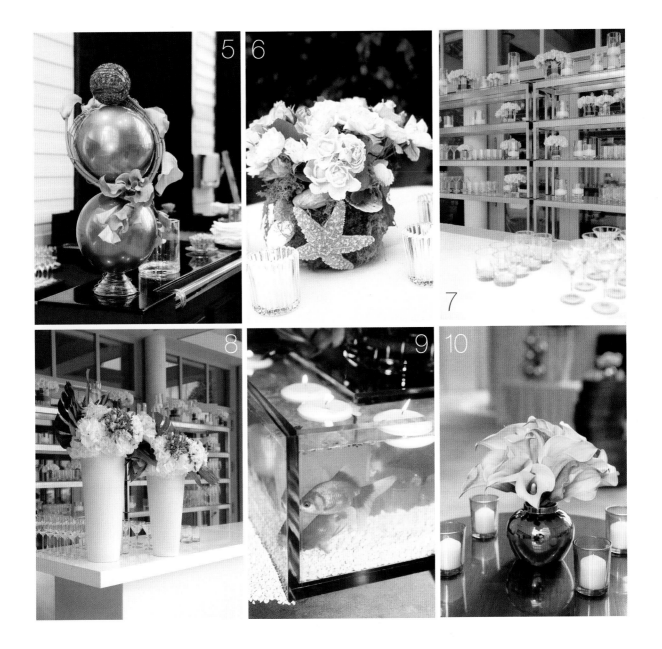

floral tiebacks and architectural elements

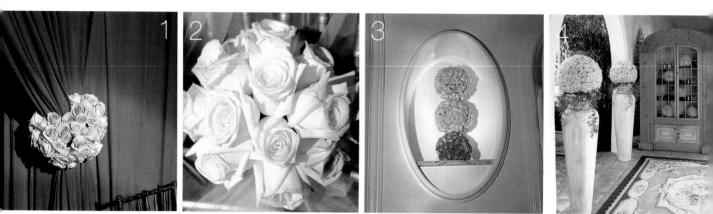

1 SARI CUFFS: For a fall wedding, the drapery tiebacks are fashioned out of large circles of sari roses, creating a wonderful contrast against the chocolate-brown velvet.

2 PRISTINE: This very simple bouquet is made exclusively of white Virginia roses.

3 NIFTY NICHE: An architectural niche becomes a stunning focal point with three rose pomanders—Leonidas on the bottom, sari in the middle, and message on top.

4 REGAL ENTRY: Flanking the entrance to this dinner tent, tall stone urns cradle large rose pomanders; also note the pomanders that sit inside the cabinet.

5 CORAL TIEBACKS: An ethereal entrance is created by using very large tiebacks made of multicolored coral roses and hanging smilax for the sheer chiffon drapes.

6 MARIGOLD GARLAND: Marigolds twined onto sections of horsetail are the garland for the drapes of this Indian-themed soiree.

7 TRIMMED DRAPES: These draperies are trimmed with garlands of tuberoses and crystals.

8 MAGIC MOMENT: These draperies—made from garlands of white dendrobiums, white tuberose, and Swarovski crystal beading—create a truly magical look.

9 BILLOWING SILK: For an Indian-style wedding, a large bolt of tangerine silk is suspended from the ceiling; the gazebo-like structure that sits on a stair landing is adorned abundantly with garlands of crystals, tuberoses, and orchids.

10 GARLANDS OF GREENERY: The dramatic tieback to this drapery is fashioned from variegated greens and boxwood brought to vivid life with autumnal-colored roses and peony blossoms.

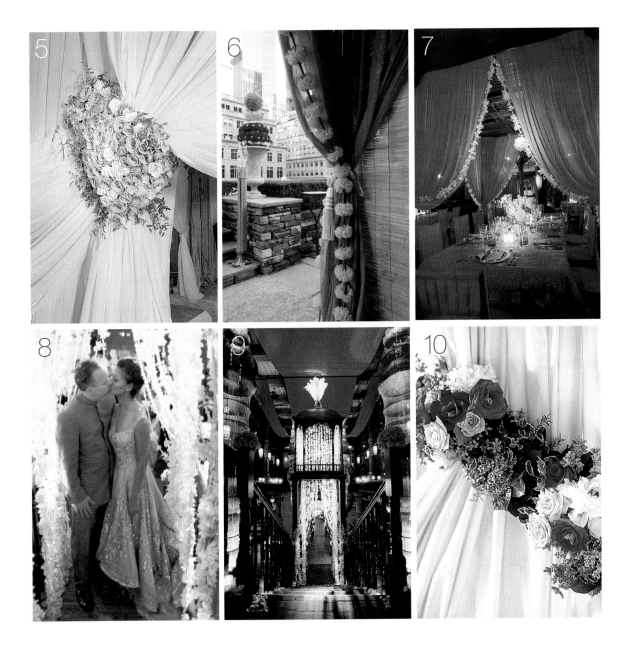

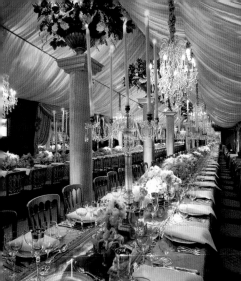

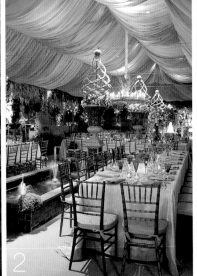

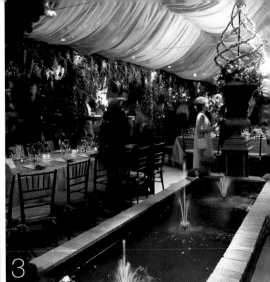

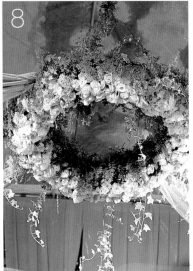

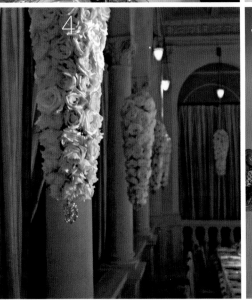

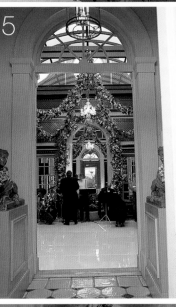

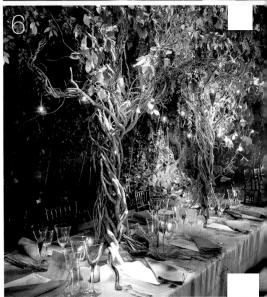

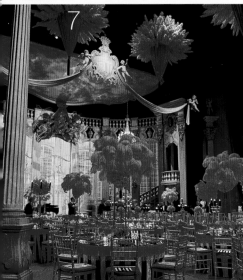

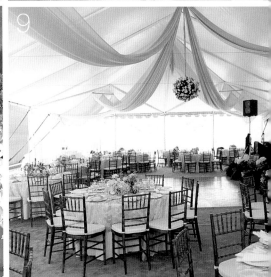

ceilings and walls

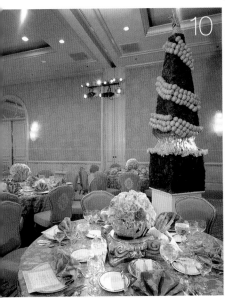

1 CLIMBING TO THE CEILING: Tall columns are crowned with gilded urns of magnolias, cascading euphorbia, and white French hydrangeas.

2 SPIRALING SPINDLES: Four tall spindles, fashioned out of garlanded curly willow and moss balls, are set into trellised urns threaded with white Iceberg roses.

3 SMALL PONDS: Under barrel-vaulted ceilings, two reflecting ponds, each with three fountains filled with goldfish, create beautiful focal points.

4 TEARDROPS OF ROSES: Densely arranged yellow and cream roses with a crystal pendant hanging from the bottom of each.

5 GARLANDS: The architectural elements are elevated by garlands of mixed greens, twinkle lights, and sterling roses, with a pomander hanging under the fringed crystal chandelier.

6 MAGIC GARDEN: Metal trees, placed on the tables, appear to support an arbor of latticework covered with greens and thousands of hanging dendrobiums.

7 CONICAL CHANDELIERS: For drama at one hundred miles per hour, chandeliers are filled with papyrus fronds that have been spray-painted pink, with black silk tassels.

8 ROSE-COVERED BOA: A ceiling is brought to life by a swag of celadon silk and a boa covered in pink and white roses and adorned with hanging tendrils of variegated ivy.

9 SIMPLE POMANDER: To soften the lines of a tent, this canopy is treated to a partial swag with a hanging pomander at the center.

10 OBELISKS: Whenever I work in a large room, I always like to punctuate the space with architectural elements to provide anchors, such as these obelisks fashioned by using florist's moss with oranges and gilded magnolia leaves.

11 FLORAL ARBOR: To mask wires and equipment, our truss system is wrapped in fabric, then in greens, and finally is studded with flowers to create a beautiful focal point instead of an eyesore.

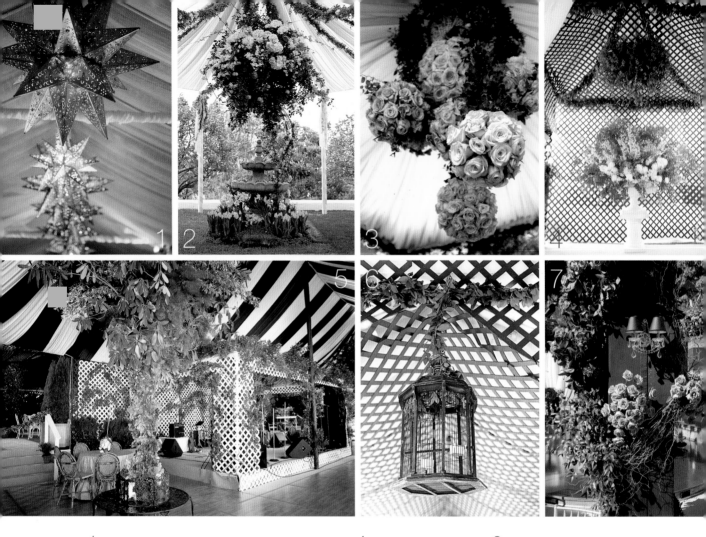

1 **HANGING LANTERNS:** For a Mexican beach-side wedding, inexpensive three-dimensional starbursts are painted and filled with amber lightbulbs, creating a very dramatic ceiling effect over a single long dining table.

2 **STRIPES AND GARLANDS:** For a daytime wedding, this ceiling is draped festively in large stripes of yellow and white, centered with a huge hanging garden above a beautiful fountain. The water feature is encircled by daffodils and narcissus paperwhites that are planted directly into the ground.

3 **MULTIPLE POMANDERS:** For an eye-catching focal point above the dance floor at this garden wedding, a series of rose pomanders is suspended on ropes covered in smilax.

4 **LATTICE HUNG WITH FLOWERS:** This entrance is clad in latticework and then outlined with garlands with a large flowering plant suspended from the apex and a dramatic arrangement set in an urn.

5 **OVERGROWN TENT POLE:** This support pole is wrapped with greens and large magnolia branches to resemble a tree in full bloom instead of a utilitarian structure.

6 **LATTICE HUNG WITH BIRDCAGES:** This canopy entrance, also covered in latticework, is treated to a touch of whimsy with an antique birdcage populated with a couple of—you guessed it—lovebirds.

7 **LAVENDER WALLPAPER:** These walls and columns are garlanded with curly willow, smilax, boxwood, and clusters of lavender roses.

ceilings

The space overhead is the most often overlooked focal point in weddings, and I always like to create something special above the guests, not just a hole in the sky. The ceiling draws the eye, and you should bring attention to it instead of ignoring it. And luckily, given that it's so very far away, it's permissible to use faux or silk flowers as the basis of your décor. In fact, for most installations it's advisable to avoid fresh flowers in the sky, because not only are they heavy, but they also need water, which is almost impossible to provide. Not to mention that it's always very hot right below the ceiling, which is not ideal for flowers. If you are going to use real flowers up there, by all means use hardier varieties like roses, and intersperse the blooms with mixed greens.

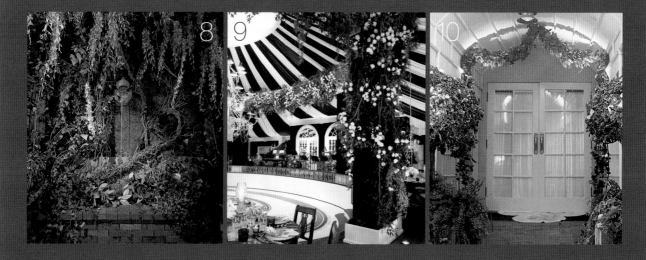

8 **SPECTACULAR SECRET GARDEN:** In the wall of this secret garden—wild rose-bushes, curly willow, hanging dendrobiums—nestles a suspended fountain dripping into a pond at its base.

9 **TO-DIE-FOR TENT:** Believe it or not, this really is a rented tent; its columns and dance-floor boa are heavily frosted with greens and vines interspersed with roses in various stages of bloom.

10 **TREAD THROUGH THE TOPIARY:** The entrance to the Bel Air Hotel is transformed with topiaries of ficus trees, mirrored by ficus garlands studded with hot-pink roses.

lighting

1 **CUT CRYSTAL:** There's nothing quite like the glamour of a full-size chandelier hanging over a dance-floor ballroom.

2 **MULTIPLE EXPOSURE:** This chandelier, lit from both inside and outside, creates a magical effect.

3 **COPPERIZE:** The chandelier at the Beverly Hills Hotel, normally a flat white light, has been transformed by hand dipping every single bulb in copper lighting ink, creating a gorgeously glowing gold fixture.

4 **COUNTRY CANDLE CHANDELIER:** For a whimsical entrance, this simple metallic chandelier is wrapped with branches of curly willow and simple tapers.

5 **PINK SPANDEX:** This large, tall ceiling is made more intimate—and infinitely more interesting—by hanging spandex light fixtures fitted with pink lightbulbs for a dash of added glamour.

6 **LENGTHWISE LIGHTING:** I designed this chandelier to be placed above a long banquet table, not only to provide light from above but also to highlight an interesting architectural element.

7 **COPPER BULBS:** For an autumnal-colored wedding, all the lightbulbs for the floral chandelier are dipped in copper ink, bathing the room in warm light.

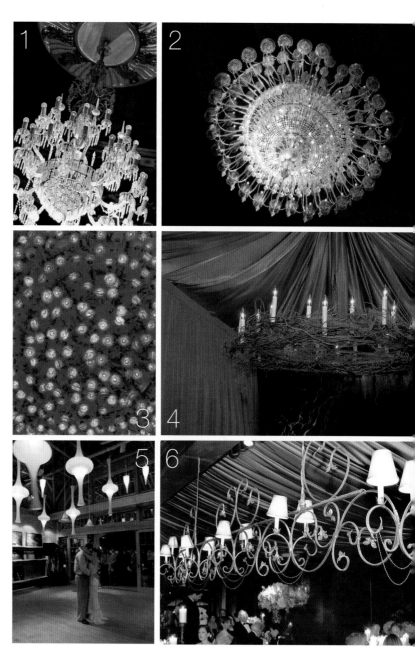

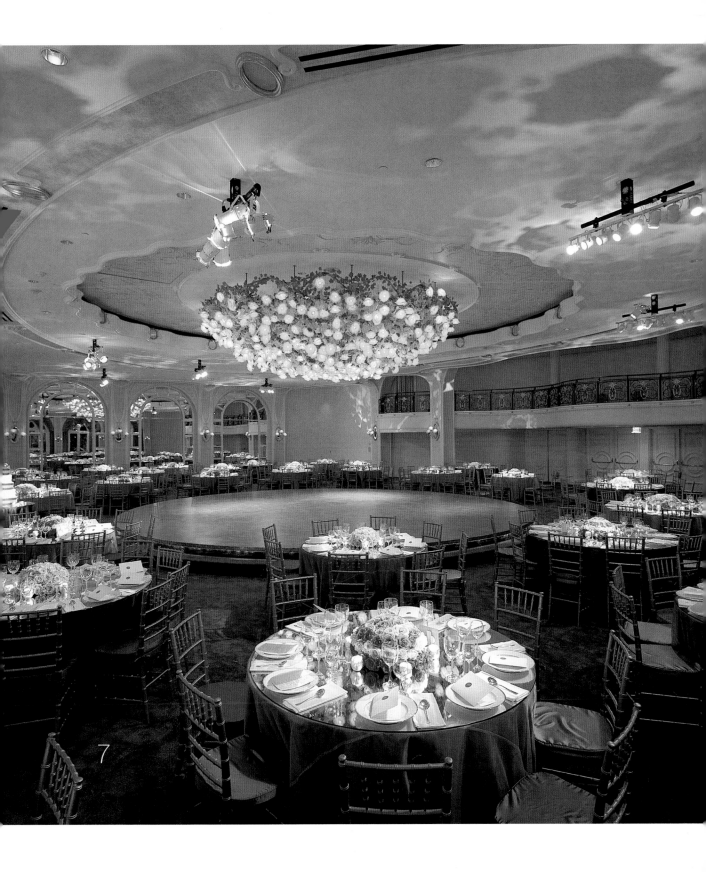

1 HANGING JARS: This long table is illuminated by hanging jars filled with amber water and floating candles, all suspended from chocolate-brown silk ribbon; be sure to use tempered glass.

2 CHINESE LANTERNS INSIDE: A simple, effective, and inexpensive way to decorate a ceiling is to intersperse different-size Chinese lanterns at varying heights, some fitted with amber lightbulbs to give added depth to the arrangement.

3 LAWN PATTERNS: By projecting a gobo pattern onto the grass, this lawn becomes a carpet.

4 FESTIVE TREES: For any evening event, check the sunset time and the status of the moon for natural sources of light, and be sure to provide electric lighting that's not only sufficiently illuminating but also attractive. Here both the uplit trees and the lanterns lead guests toward the reception site.

5 MEXICAN LANTERNS: For a beach wedding in Mexico, a series of Mexican lanterns snakes its way above the long table, creating wonderfully dappled light.

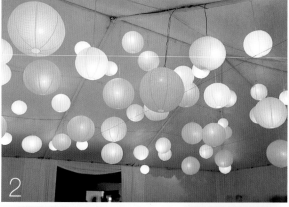

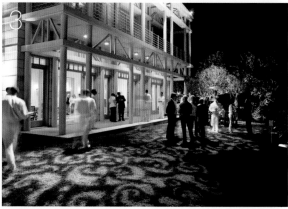

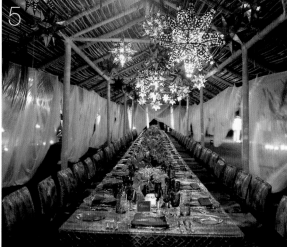

6 AMPLE FIRE: If you're going to exclusively use open flame to light an outdoor space, make sure you have plenty of it. Here both the high torches and the low lanterns light the walkway, but neither would do the job on their own.

7 OUTDOOR LANTERNS: This walkway to a beach after-party is lit with Moroccan-style lanterns that protect the wicks from the wind.

8 LARGE CANVASES: Today's advanced techniques in lighting allow you to create multiple effects and colors on floors, walls, even lawns, turning any surface of any size into a canvas for your vision. One important note when choosing colors, though: Reserve the blues and the greens for lighting water and foliage, and use only skin-friendly tones, such as lilac, lavender, and amber, for people.

9 WHITE CANVASES: White—whether for walls, ceilings, or floors, such as this dance floor—provides the most flexibility, because it can accept any color or pattern freely.

10 SURROUNDING THE CENTERPIECE: With an assortment of containers for the flames, the candles themselves become an element of the centerpiece.

11 ABOVE THE BAR: These inexpensive lanterns hang like pendants, doing double duty by providing attractive light at the bar—always a plus—while also filling the negative space and drawing the eye.

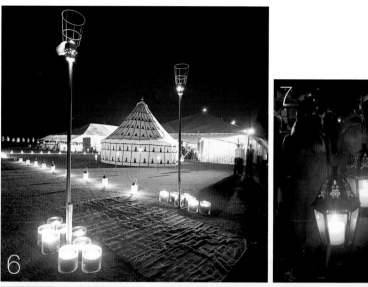

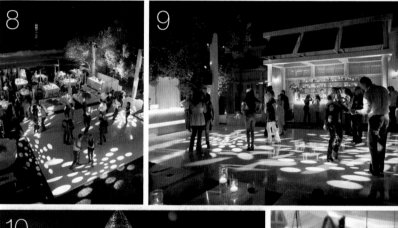

LUCITE LIGHT BOX:
A similar but more dramatic effect is achieved by under-lighting this coffee table with a flashlight, in this case with a workaday Coleman lantern, which should last at least five hours on fresh batteries, without any need for cables and outlets.

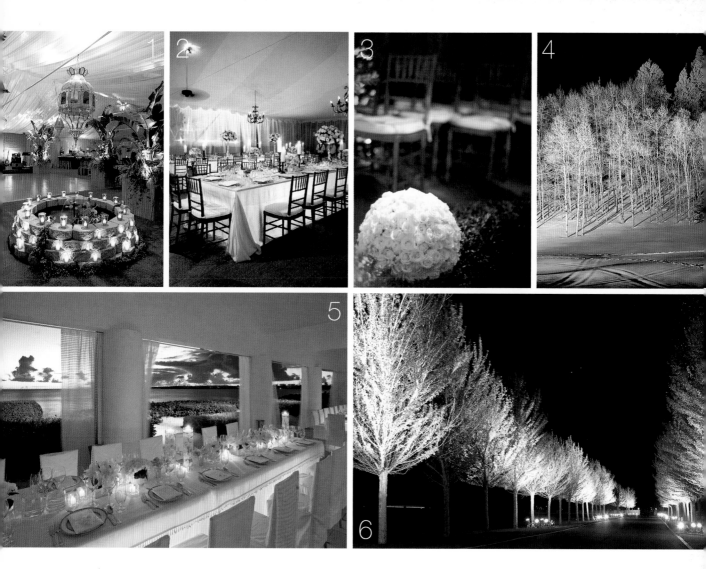

1 **BETWEEN THE SHEETS:** A great way to provide intriguing light in a tent is to place the lighting instruments between the tent's structure and the fabric ceiling, causing the ceiling to glow from within.

2 **CLOTH-COVERED LIGHT BOX:** Use lighting under the table, paired with a sheer cloth, to produce the appear-ance of a giant light box.

3 **PIN-SPOTTING:** A classic example of how pin-spotting can highlight one discrete element of your décor, in this case a beautiful rose pomander.

4 **LIGHT UP THE MOUN-TAIN:** One of the great-est lighting feats of my career was for this wedding in Colorado. When the bride and groom exchanged vows, we ignited the lights on the entire mountain, using two miles of cable and seven generators bur-ied in the snow—and creating an indisput-ably magical moment.

5 **INDOOR-OUTDOOR:** Overhead lights should always be on dimmers, allowing you to bal-ance the indoor light-ing with the changing outdoor light to keep the two in harmonious balance.

6 **DRAMATIC DRIVE:** For a grand sense of arrival (and departure) on this country property in Southampton, we uplit all the trees.

reception vignettes

1 MIRRORED BALLS: For a tremendous dose of glamour, suspend multiple mirrored balls, an inexpensive touch with a big effect.

2 LONG TABLES: A great sense of energy is created when you seat people at long tables.

3 FAMILY-STYLE: Flowers and candles in tall hurricane lanterns are arranged in clusters, leaving areas of space in between to allow the food to be served family style for a fun, chic, and informal dinner. Each guest's name is handwritten on the personalized menus.

4 BEACH MENU: Every menu has a shell glued at the twelve-o'clock position, and is tucked into a hemstitched napkin.

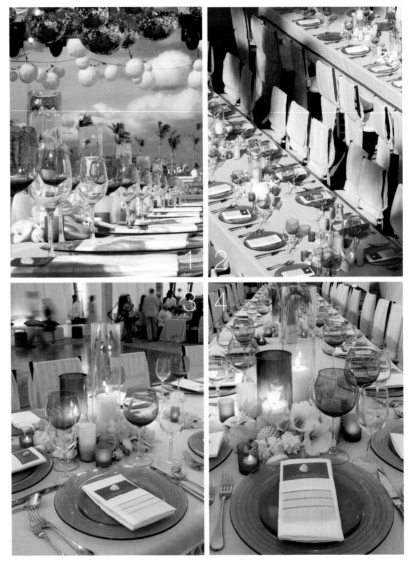

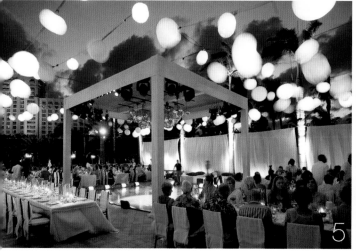

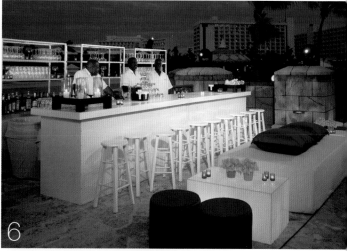

5 **CHINESE LANTERNS OUTSIDE:** An abundance of these similar ball lanterns are strung using aircraft cable, bringing a sense of décor to the great outdoors.

6 **BIG BAR:** This bar is constructed by adding extension legs to rental tables, then wrapping the tables in white linen, then adding a four-inch-thick bar top in two sections, imparting a permanent, architectural look to this rented furniture. We added large beds and ottomans in front of it, to create a lounge feel—another dose of permanence in the borrowed space.

7 **SEDUCTIVE SIGN-IN TABLE:** Blossoms suspended in water within glass vases take on a magnified look—a simple yet effective way to decorate an accent table. I especially like the idea of putting water-suspended flowers side by side with the same blooms suspended in air.

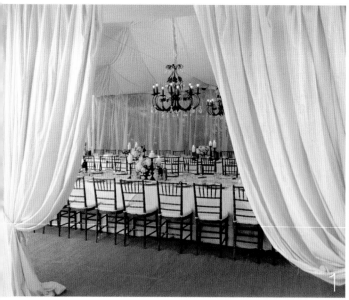

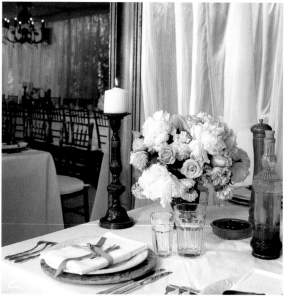

1 **DOOR DÉCOR:** The door is adorned with a pair of drapes, drawing guests into the reception area, and creating a warmer, more residential entrance.

2 **MIRROR MAGIC:** By placing tall, thin mirrors at either end of a long table, we create the illusion of a table that stretches to infinity. The center of the table is decorated with large bottles of wine, bowls of olives, urns of grapes, and cruets of oil and vinegar; and in true Italian style, guests drink their wine from tumblers instead of stemmed glasses.

3 **HIDDEN LIGHTS:** To infuse the ceiling with a soft glow, lights are installed between the tent top and the fabric ceiling liner.

4 **WAITERS IN WAITING:** Thinking out of the box, we dressed these waiters in tangerine silk saris, and topped them with tall plumes of feathers.

5 **INSIDE PAVILION:** This pavilion, created inside the restaurant, is draped first in silk, and then its edges are garlanded with strands of marigolds.

6 **BANQUET TABLES:** Since we took over an entire restaurant, we could do whatever we wanted with the tables—which in this instance meant removing all the round tables in favor of long banquet tables, on which the dinner was served family style.

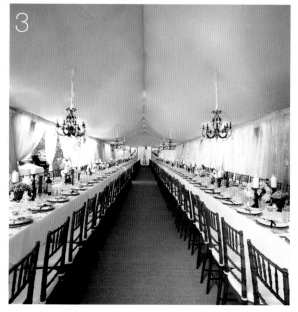

7 **IMPORTED LINENS:** These gold-trimmed tablecloths—silk-screened and embroidered in India—prove that sometimes it's advantageous to look afar for the ideal table settings.

8 **WARM SETTING:** Carefully placed atop each brass charger is a personalized menu card and a tangerine silk napkin.

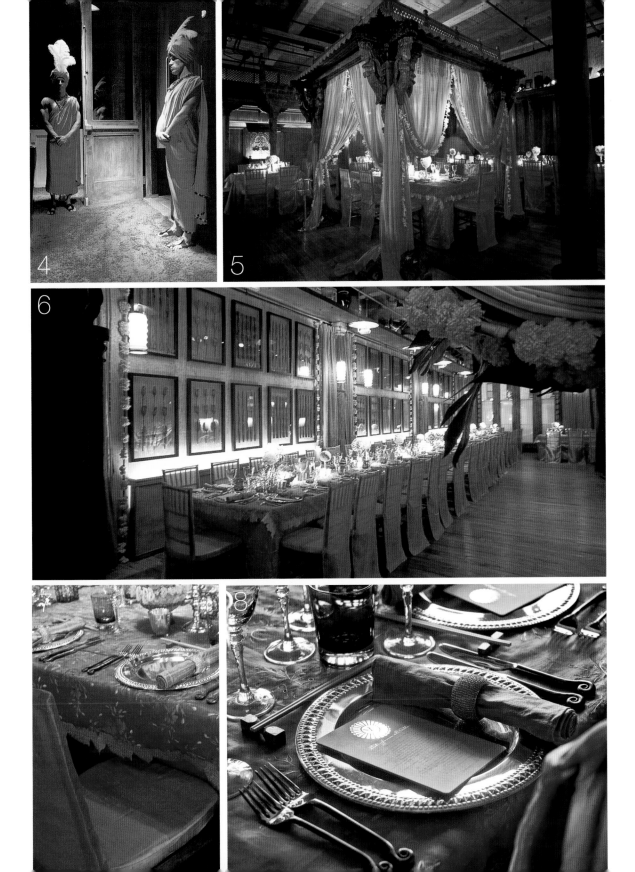

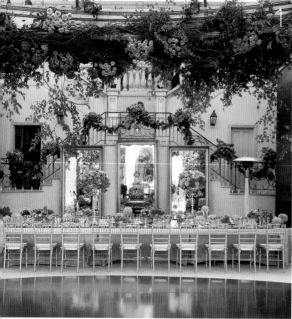

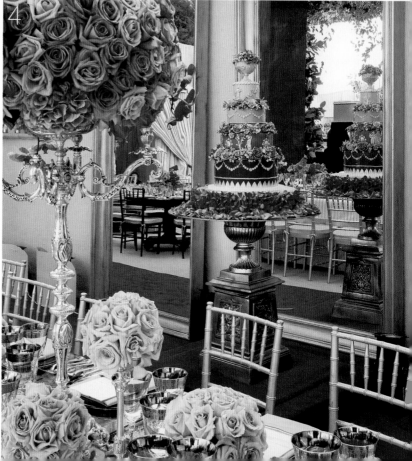

1 ALL TOGETHER NOW: This single long banquet table, placed in front of the stairwell, serves as the main table.

2 MIRRORED TABLETOP: Placing a mirror, in this case an antique one, on top of the table adds a tremendous amount of glamour.

3 PERSONALIZED RAILING: For the entry to the dinner reception, a Plexiglas version of the event's logo is integrated into the wrought-iron safety railing.

4 CAKE ON DISPLAY: The cake takes center stage in the reception décor, looking extremely glamorous placed in front of a mirror, and creating wonderful reflections for the cake-cutting photographs.

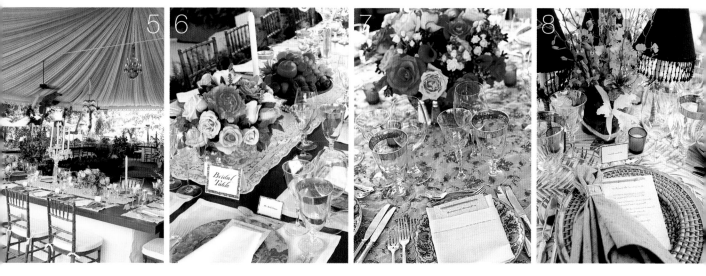

5 DANCE-FLOOR
BORDERS: For this
wedding, three main
tables—one for the
bride and groom and
their wedding party,
one for the bride's
family, one for the
groom's family—are
placed along three
sides of the sunken
dance floor, all of it set
under a swagged tent
that's adorned with
crystal chandeliers and
ceiling fans.

6 RESIDENTIAL TABLE:
To keep the tables
interesting, this party
uses three completely
different scenarios.
This main table is
meant to look as
homey as possible; it is
fashioned from wood
and set with starched
linen place mats, a lace
runner down the cen-
ter, and arrangements
of California garden
roses and bowls of
fruit.

7 MIX AND MATCH: Here
the Indian overlay
cloth is beautifully
beaded and festooned
with assorted roses
arranged in Chinese
porcelain. To give a
collected look instead
of a rented one, we
mix different styles of
glassware and flatware
at each setting.

8 MIX AND MATCH, PART
TWO: On the outdoor
wraparound patio, the
tabletop is treated
to a more al fresco
approach using a
leaf-motif cloth paired
with rattan place mats
trimmed in brass and a
matching brass napkin
ring. Note the small
lampshades that cover
the candlesticks, pro-
tecting the flickering
flames from the wind.

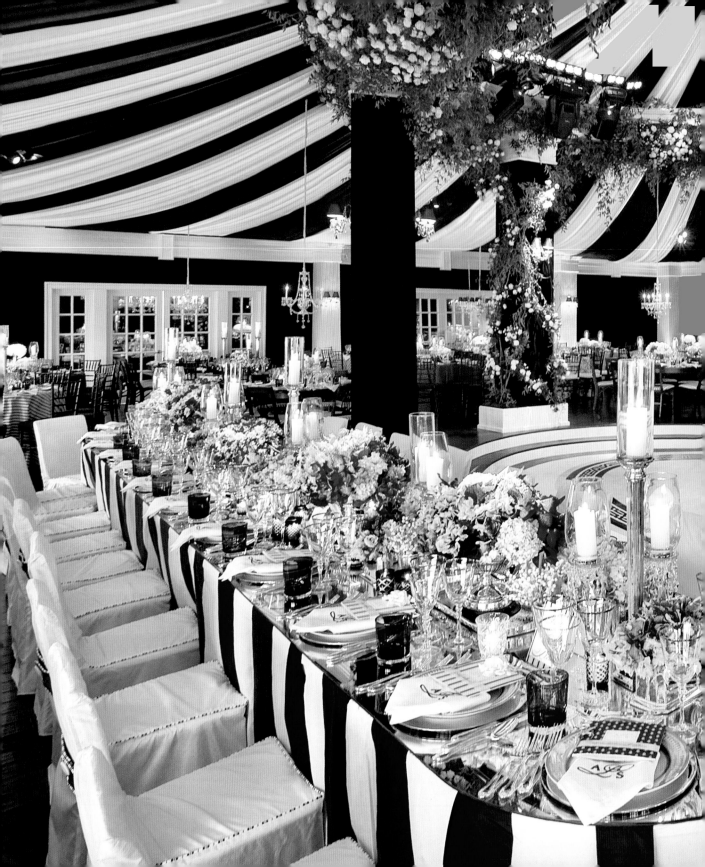

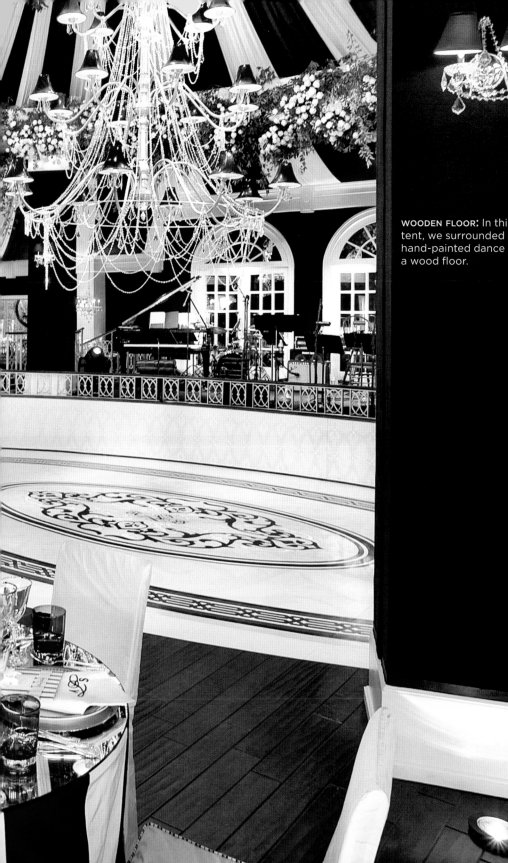

WOODEN FLOOR: In this dinner tent, we surrounded a sunken hand-painted dance floor with a wood floor.

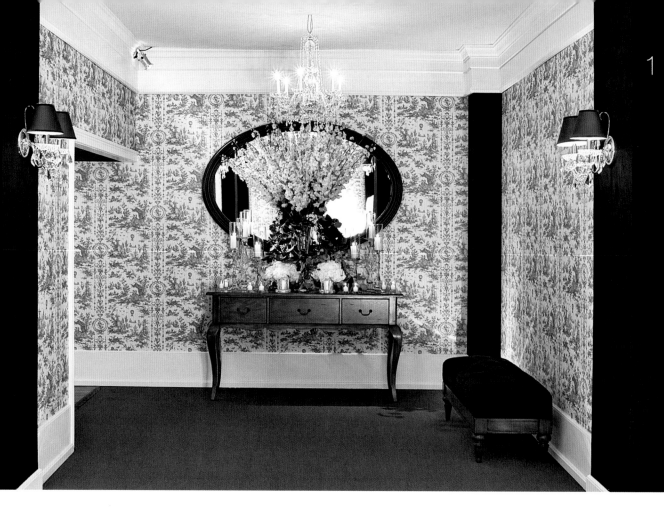

1 INVITING ENTRYWAY: At the tent entrance, we carpeted the floors, papered the walls, built columns, and installed crown molding, creating a truly warm welcome.

2 VARIATIONS ON A THEME: There are five different types of table décor at this dinner, and here's the first: an oval wooden table, uncovered, with a striped cushion for the seats that matches the menu covers.

3 VARIATION #2: This scenario is a round table, covered in a beautiful nautical striped cloth, with a matching menu sitting atop the monogrammed napkin.

4 VARIATION #3: This table is swathed in a blue-and-white French toile, with napkins in a corresponding blue.

5 VARIATION #4: This setting is a Provençal-style cloth with a white linen napkin trimmed in a fabric that matches the table's. Note that all the tables are tied together visually with matching cobalt-blue water glasses.

6 CROWN MOLDING: To give this tent architectural integrity, we added crown molding between the walls and the ceiling.

7 DETAILED DÉCOR: I wallpapered this tent in Ralph Lauren stripes, and installed a pair of sconces topped with navy-blue silk shades.

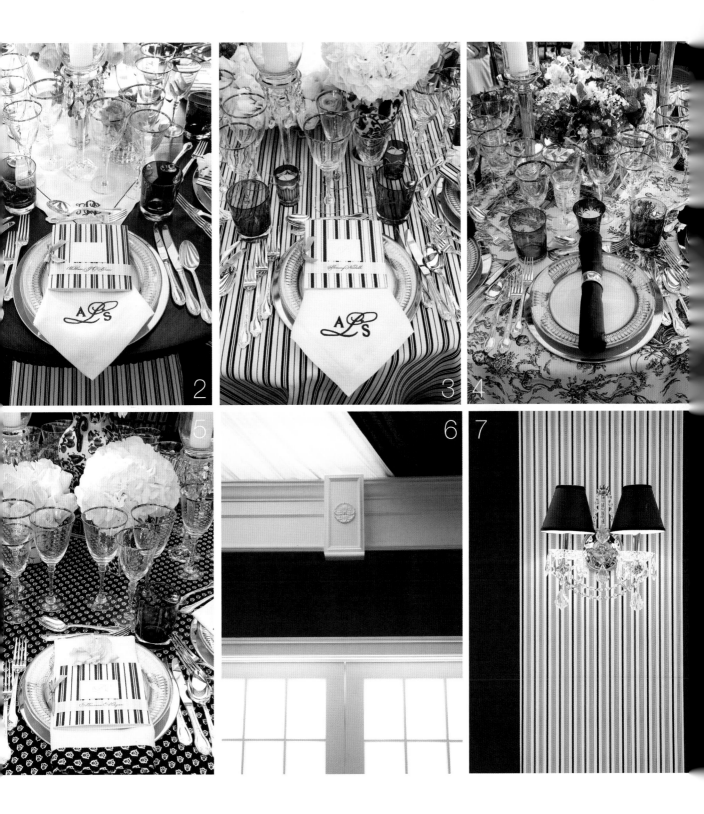

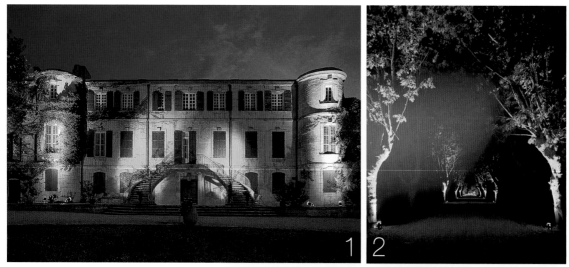

1 **LIGHT UP THE HOUSE:** Remember, what you don't light at night will fall to black, and who would want to miss the exterior of this beautiful *maison*, which really comes to life with a bit of theatrical lighting?

2 **UPLIT TREES:** The long road to the main house is lined with beautiful oak trees, which are all uplit to illuminate the path with drama and elegance.

3 **LAVENDER LIGHT:** The palette for this wedding is eggplant and lilac (note the bottom fourteen inches of the tablecloth, trimmed in deep purple). The soft lavender light we cast upon the very sculptural olive trees accentuates the color scheme and creates a sublimely romantic environment.

4 **UNIFORM PALETTE:** At each place setting, on top of the lavender-and-eggplant-trimmed napkin, is a personalized menu booklet with the guest's name on top. An array of chartreuse, lilac, amethyst, and lavender flowers and vases adds to the overall effect: a striking color statement.

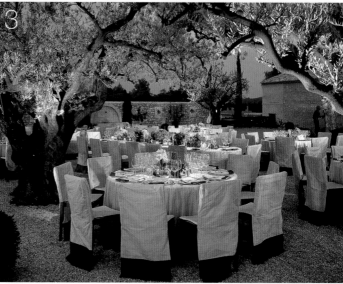

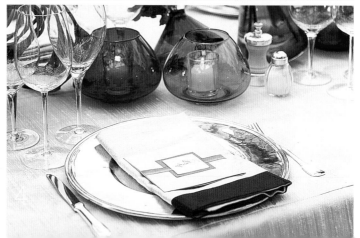

5 TICKLE THE THIGHS: This tabletop overlay is sized so that the edges, which are trimmed in gorgeous beading, just brush the top of guests' legs.

6 UPLIT TABLE: The chairs are wearing a three-quarter slipcover—sexy, with the legs peeking out—and the tables, lit from underneath, turn into glowing light boxes.

7 WARM GLOW: For this Caribbean wedding, we decided to have our dinner indoors, to guarantee that the weather would never gain the upper hand. But we made sure to keep all the inside lighting in amber or soft white.

8 FOR THE LADIES: Fresh gardenia blossoms and personalized menus await at each lady's place setting.

9 ROOM WITH A VIEW: Guests are seated looking either into the party or out to the spectacular sea.

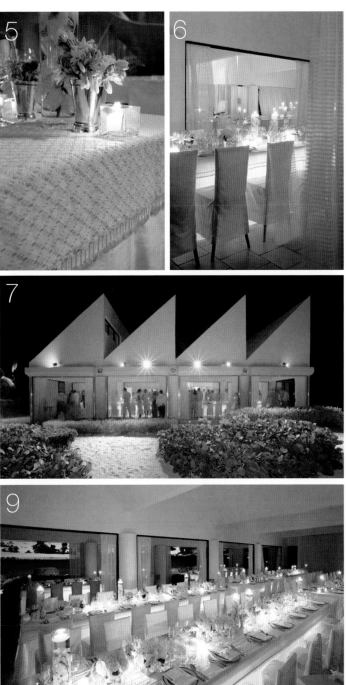

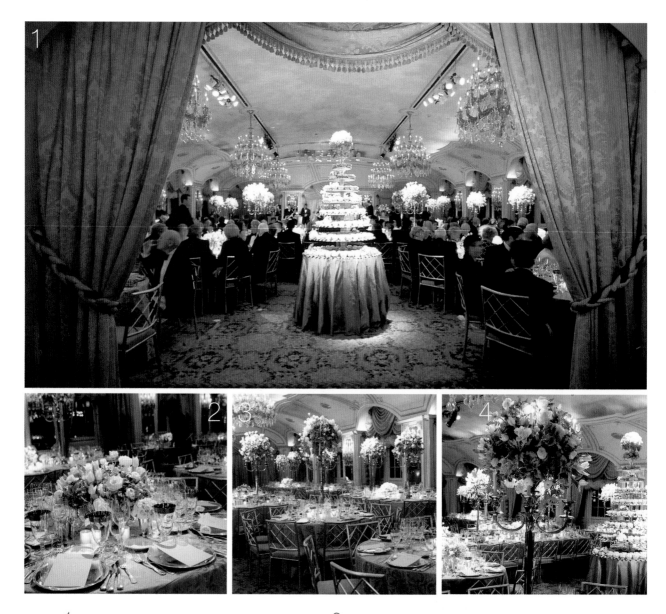

1 **CUPCAKE PYRAMID:** The focal point at this wedding's entrance is a terraced pyramid of enticing cupcakes.

2 **GOLDEN GLOW:** The color palette for this wedding is robin's-egg blue with taupe and gold accents; the gold votive candles cast a matching glow on the guests.

3 **PATTERN ON PATTERN:** At this formal reception, the French damask tablecloth complements the patterned carpet of the ballroom.

4 **ALTERNATING HEIGHTS:** For variation, half the centerpieces are low pudding shapes in silver urns, while the other half are arranged atop tall silver candelabras surrounded by gilded julep cups packed with white tulips, roses, and Dusty Miller leaf.

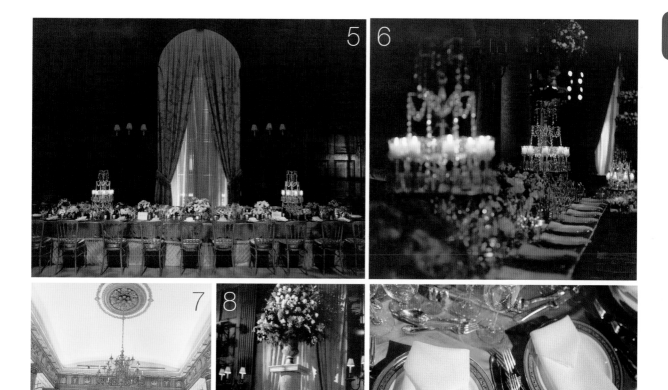

5 DARING DAMASK: For an added dose of glamour, these rich gold damask draperies and matching sconce lampshades bring the room alive.

6 OVER THE HEDGE: Long banquet tables are illuminated with votives placed between a hedge of green and white flowers.

7 GRAND ENTRANCE: An imposing entrance makes a great first impression at any nuptial celebration.

8 GOLD STANDARD: To break up the large space, tall columns are covered in gold velvet and topped with massive arrangements of flowers.

9 FINE LINENS: Each place setting is personalized with a finely embroidered linen napkin.

10 TABLE TEMPO: An aerial view of the dinner ballroom shows the glamour, elegance, and energy of well-arranged tables that mix up banquet and round shapes.

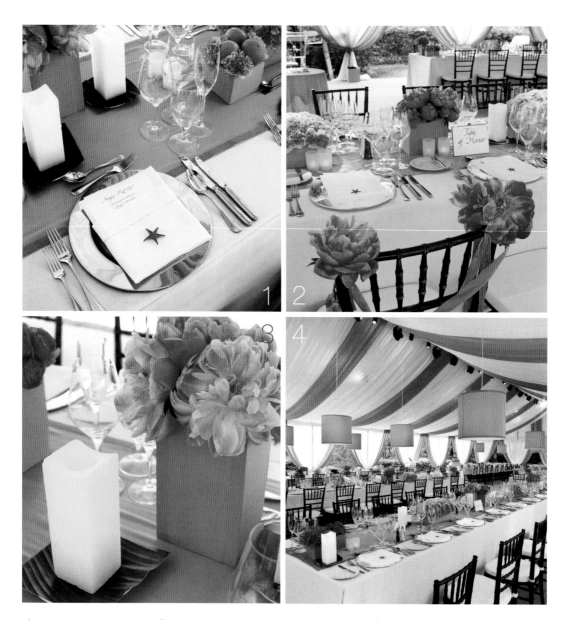

1 SILVER CHARGERS: At this beach wedding, a touch of elegance is added by using silver chargers, on which sit coral-calligraphed menus tucked inside hemstitched ecru napkins that are garnished with coral starfish.

2 PEONIES: Guests at a coral-themed wedding are treated to chairs finished with coral silk ribbon and full-blooming peonies.

3 PROTEAS AND PEONIES: Fabric-covered boxes are filled with pincushion proteas and full-bloomed coral peonies set on a coral runner and interspersed with bowls of oranges and arrangements of carnations.

4 DRAPED CEILING: Embracing a coral and white theme, this ceiling is draped in ivory fabric and coral streamers, dividing the room while allowing guests to see the natural beauty of the outside garden.

5 RATTAN CUBES: In keeping with the minimalist décor, the flowers are arranged in simple glass cubes cleanly lined with rattan.

6 OPEN PAVILION: To create a sense of intimacy in this glorious outdoor space, we use PVC piping as the framework for a geometric grid that supports a long swath of fabric, so guests dine under billowing gauze.

7 WHITE ON WHITE ON THE OCEAN: For this wedding in Los Cabos, Mexico, guests are seated at one long table, whose minimal color scheme does nothing to interfere with the natural beauty of the perfect setting.

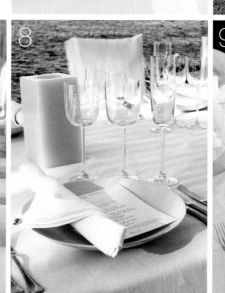

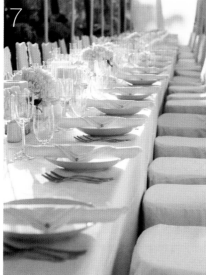

8 DEEP WICKS: To ensure that the candles don't blow out in the stiff ocean breeze, we drill wide-diameter holes deep into the wax, then insert votives down at the bottom.

9 CLEAN LINES: All the china and crystal are from a collection I designed, paired with personalized menu cards embossed with a simple seashell.

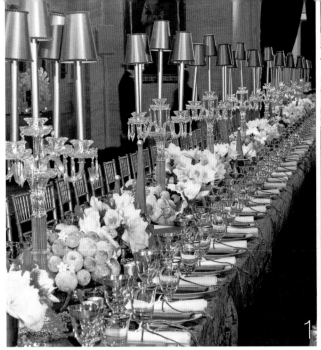

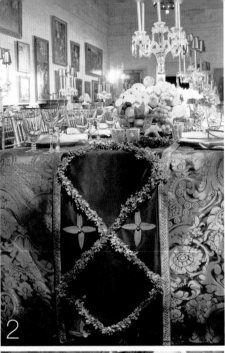

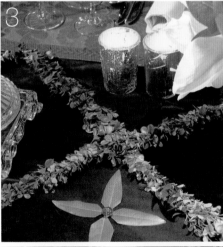

1

2

3

4

1 PERIOD SETTING: As befits this elegant room, reminiscent of an eighteenth-century ballroom, the table is set with a deep emerald damask cloth, topped with a gilded plate, a napkin ornamented with a white stephanotis blossom, and a personalized menu card. For a true period feel, the place settings are punctuated by architectural obelisks covered with fresh bay leaves and topped with ornaments.

2 REGAL RUNNER: The runner is made of silk velvet trimmed with gold brocade, then embellished with a pattern fashioned from boxwood, bay leaves, and crystal beads.

3 OPULENT CONTRAST: The contrast between the silk damask cloth and the velvet runner makes for a truly regal table.

4 FAUX FLICKERS: Because these long tables are set in an art gallery, open flames are verboten. So instead we use battery-operated faux candles that really do flicker, set under green silk lampshades. The large candelabras balance the extraordinary height of the space.

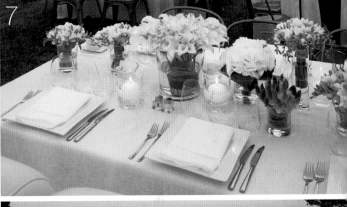

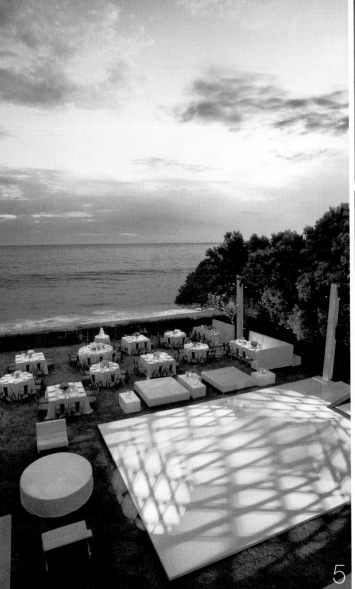

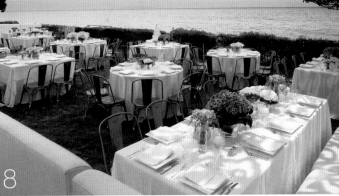

5 WHITE NIGHTS: For an all-white wedding, we even used a white dance floor (a regular dance floor that's covered with white gam) and surrounded it with a suite of white modern furniture.

6 SPLENDOR IN THE GRASS: As the sun sets, the front lawn comes alive with patterned lighting that creates a damask tablecloth over the summer lawn.

7 PRISTINE PLACE SETTINGS: In keeping with a modern theme, white porcelain dinner plates are paired with well-starched white linen hemstitched napkins. And there's no such thing as too many candles.

8 BANQUETTE BORDERS: To create a sense of intimacy in a garden, the borders of the seating area are fashioned from banquettes.

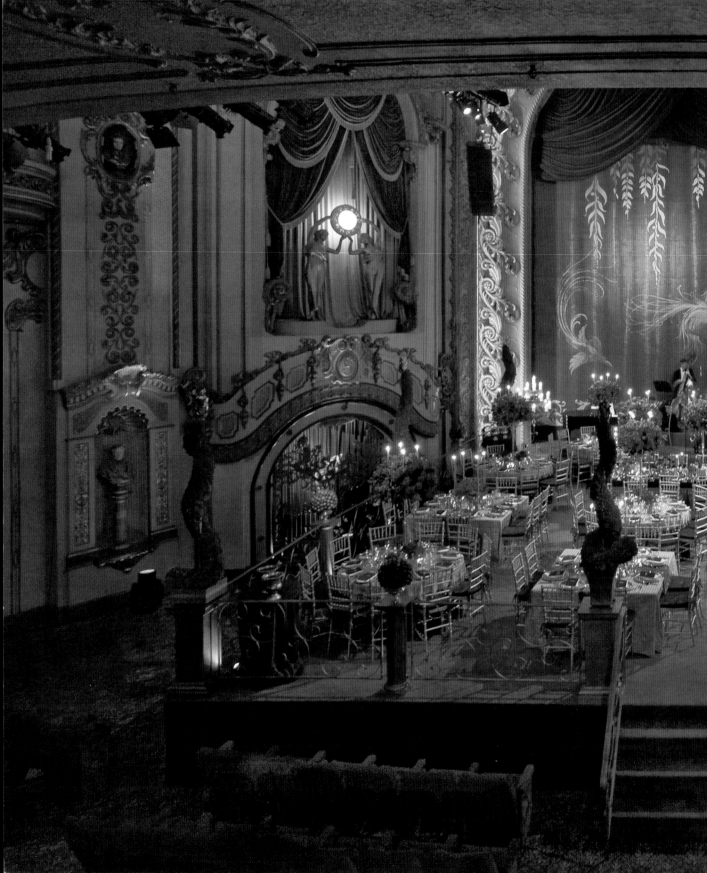

STAGE EXTENSIONS: For this dinner in the Sydney State Theater, the stage is extended well into the seating area, providing ample room not only for the dinner tables, but also for the after-party dance floor that's hiding behind the curtain.

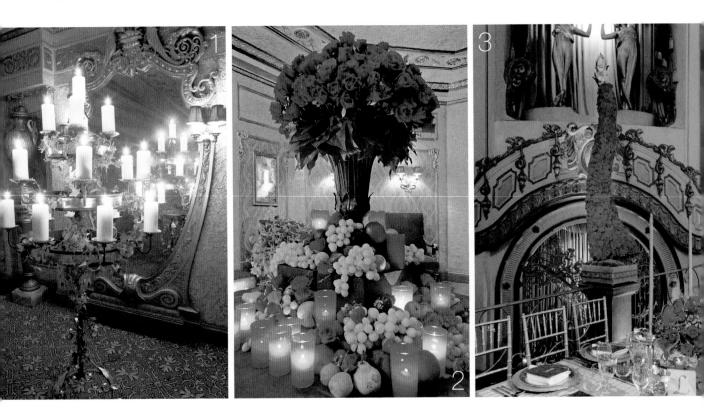

1 ITALIAN LIGHTING: These can-
delabras are inspired by those
in the Orsanmichele church in
Florence, lovingly re-created
with ornate metalwork and
wrapped lightly with smilax and
ivy, to create a wonderful sense
of arrival.

2 FLOWERS, FRUITS, AND FIRE:
For a Renaissance-
style wedding, the for-
mal arrangements of Black
Magic roses and feathers are
anchored by a cornucopia of
fruits and candles, creating a
period-perfect tableau.

3 WHIMSICAL TOPIARY: This eye-
catching topiary is fashioned
out of red roses and topped
with a gilded finial made from
spray-painted gold artichokes.

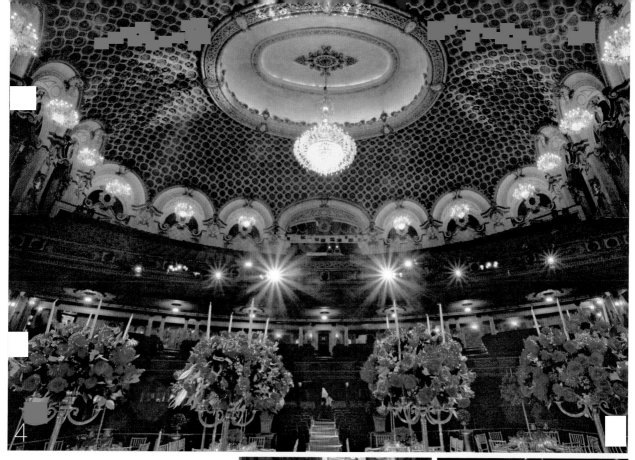

4

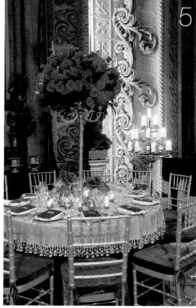

5

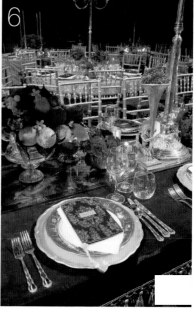

6

4 EXTRA-HIGH: When working in a high-ceilinged space—such as this theater, the most extraordinary rococo architecture in all of Australia—I like to create additional height in the centerpieces by inserting tall tapers into the flowers.

5 HIGH DRAMA: To add an element of drama and height, we place tall topiary rose centerpieces on some of the dining tables.

6 GEOMETRY LESSON: Instead of tables all in one shape, I prefer to place round, square, and rectangular tables side by side.

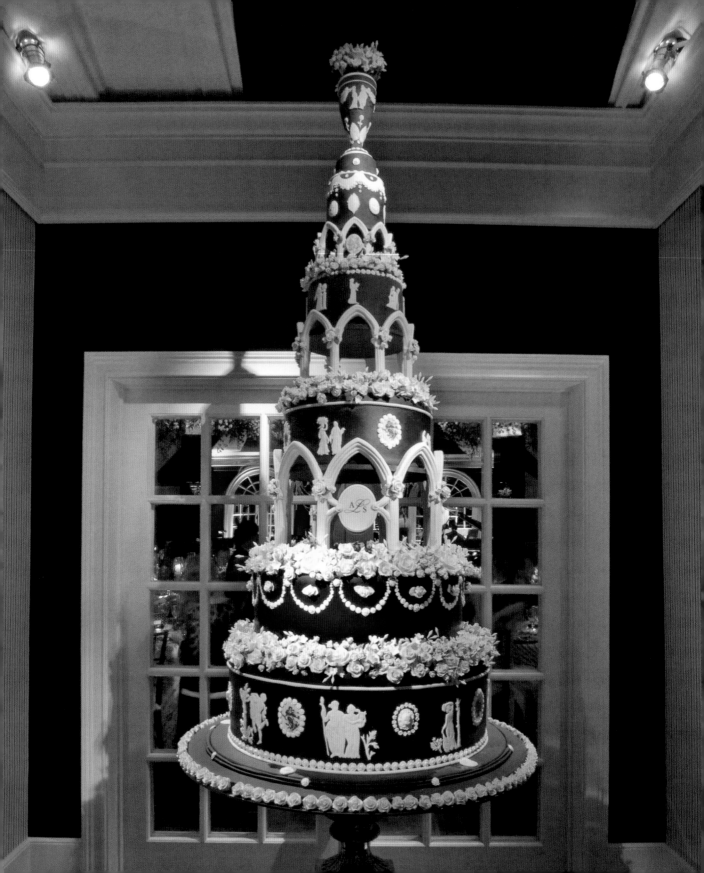

5
cakes

Your cake is the crowning glory that ties together all the design elements of your wedding. It's the delectable finale to a life-changing event. Think of all the magazine photos depicting overjoyed couples licking frosting off each other's fingertips, and you start to see that the cake is the ultimate icon of your celebration. If every picture tells a story, the shot of you and your groom cutting that first little slice of heaven says it all. I always make a point of thinking about the cake only after all the other design decisions have been made: the color, style, and pattern of your table linens; the satiny gown and lacy veil; the delicate flowers of your bouquet—they can all be blended into one luscious end note. In the hundreds of weddings it's been my pleasure to help bring to life, I've never once chosen a cake out of a look book and neither should you. Your cake represents an extraordinary chance to stretch the limits of your own—and your pastry chef's—imagination. So put together a swatch board that includes the textures, materials, style, and palette of your wedding, then sit down with a brilliant baker and collaborate on designing an absolutely showstopping delicious cake.

Cakes used to be very formal, and were almost always white with white decoration. And I must admit, I've never been a big fan of the miniature bride and

THE CHURCH: Inspired by the main arch of the church in Marblehead, Massachusetts, this cake was a passion project for pastry chef Sam Godfrey and one of my all-time favorites. Cakes like this need to have an entire internal steel structure, coated in icing, so they don't blow or fall over. Not for the faint of heart.

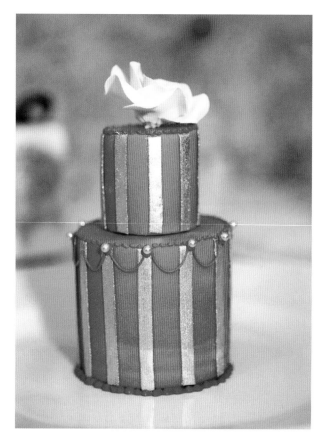

groom topper. Today's best pastry chefs are artist, architect, and gourmet all at the same time. They have mastered the latest techniques and materials for their sugared fantasies. They use fabulous old standbys like buttercream and fondant, but they also drape with white chocolate. They make breathtakingly real-looking flowers from sugar paste, but they also work with the world's most exotic fresh blooms. They hand paint, they sculpt, they mold, they pearlize, they finish their cakes with a flawless silky smoothness. If you can dream it, they can build it!

I've had the honor of working with the most talented, celebrated bakers and designers in this highly specialized field, and their wildly varied creations are the delicious content of this chapter. I've always loved finding the right baker and the ideal cake for a given event; here's a little advice in the hopes that you will also find that gorgeous confection:

- Delivery: Arrange for the cake to be delivered and installed at a specific time in a specific place. Confirm this *twice*: the date, exact time, and location in writing. Then have someone make sure that the cake is indeed delivered exactly *where* you want it.

- Moving: I can't stress this enough: Try never to move a wedding cake yourself, and also avoid the almost-as-terrifying occasion of moving the table on which the cake is installed. You don't want to find yourself running around town buying Sara Lee boxes and cans of frosting, then frantically trying to repair or build your own cake. I have personally been there and done that when the baker delivered

CHARMING MINIATURE: Working off a vibrant pink base, equidistant gold vertical stripes are joined with a swag of pink icing and punctuated with gilded dragées.

the cake to the house and the wedding was in the garden twenty steps down—as I tried to move the cake, it came tumbling down in pieces!

- Height: Even at a small wedding, the cake needs presence. If necessary, use a cake stand, or the bottom tier can be faux for added height and drama. A single sheet cake just won't do. For large wedding parties with multitiered, towering cakes, make sure that you're working with a baker who's experienced with complex designs and has the proper equipment. I suggest a dowel system for structural integrity. There's a first time for everything—but don't make your reception the baker's first time stacking ten tiers on top of one another.

- Refrigeration: Allow the cake to remain chilled as long as possible, and never let it sit in the sun. It's best to keep it in a controlled environment cooler than seventy degrees. If your wedding is outdoors, make sure the cake can sit under an umbrella or is shaded by a tree. If not, gravity will take over quicker than you think.

- Flowers: Flowers made from icing can be very costly; a good alternative is to incorporate real flowers into your cake, between tiers, or as a garland. Just be absolutely certain that no toxic flowers ever come anywhere near it. (There's the story—maybe an urban myth—of the bride who got thirsty in the middle of the night. On her bedside was a glass of water with an oleander blossom in it. She tossed the flower aside, gulped down the water, went back to sleep . . . and never woke up. Needless to say, this makes for a really bad honeymoon.)

- Personalization: I've never—not even once—placed a figurine of the bride and groom on top of the cake. What could be more generic? Instead, the cake topper should draw from other design elements of the ceremony and reception. Consider inscribing the cake with your initials, the date, a favorite line of poetry, a beautiful silver bell, a single gorgeous flower, or anything else to make it memorable—and unique.

- Tasting: This may sound obvious, but while you're busy worrying about how the cake looks, remember that how it tastes counts every bit as much. Unless you're serving the finest caviar (which is not a bad plan if your budget allows), your cake is probably the single most expensive food item at your celebration, so make sure that it's unbelievably delicious by having the baker provide you with a few choices to sample and decide from. Use your imagination. You can

do something for everyone by creating a different flavor for each tier of cake. You can choose a cake based on the season—angel food or lemon in spring and summer, brandied fruit and nut or chocolate in fall and winter. Or you can simply go with your groom's all-time favorite. It's wonderful to feel secure in the knowledge that whatever a truly reputable baker does will be absolutely sublime, but taste a sample anyway just to be sure.

- Serving: When the cake is cut, you can serve it not just as a single solitary slice, but as a composed dessert plate. Garnish with a delicious fruit coulis, a scoop of sorbet, a chocolate sauce, powdered sugar, or even a few berries and a scoop of ice cream. The key is to make it look as inviting and original as possible. Also keep in mind that the cake cutting is a golden opportunity for you as a couple to say a few words of thanks to your family and friends.

- Keepsake: According to Anglo-Saxon custom, the bride would take home some of the cake, wrapped in paper, to put under her pillow for sweet dreams. This was challenge enough when women were dealing with a fruitcake covered in marzipan and royal icing. But that style of cake has never been particularly popular with American palates. In the United States, we favor sponge cakes or denser cakes filled with mousses and fresh fruits, iced with gooey buttercream or fondant. None of these choices count as hair conditioners, and they should not go under, above, or next to anyone's pillow. A more practical custom is to take home the top tier, freeze it, and serve it on your first anniversary. Just make sure you very clearly communicate to both the baker and the caterer that you intend to save this part of the cake, and designate someone specific to take custody of it. Worse comes to worst, or best to best, keep a picture of your cake so your baker can create a replica of the top tier when you celebrate your first anniversary; it's definitely tastier than a year-old piece that's been defrosted.

1 PLAY ON PINK: A light pink is layered on top of a darker pink tier finished in polished fondant icing with a white swag and a bright pink rose. 2 BAR CODES: This series of square tiers is bordered with a vibrant bar code and topped with white daisies and bright spider mums.

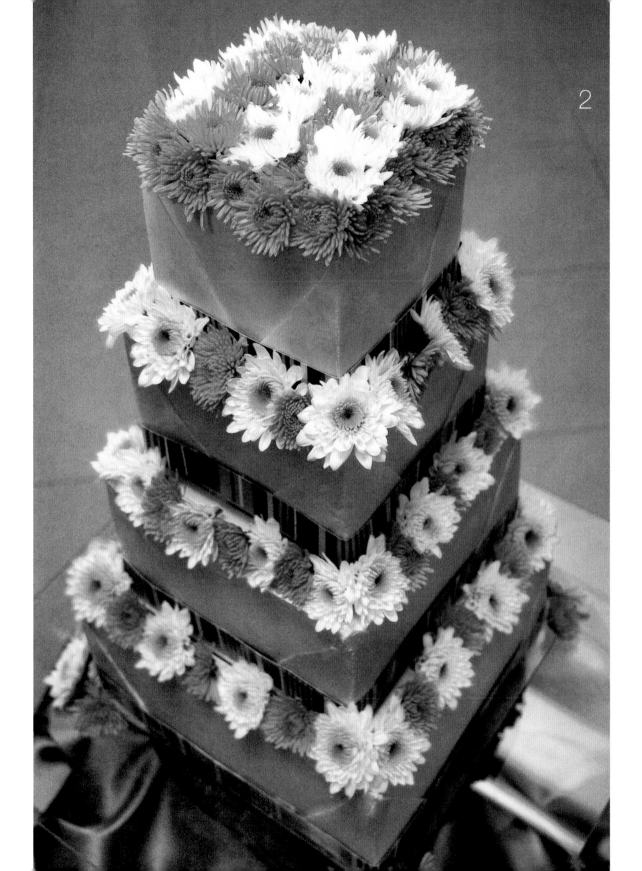

towering
confections

1 **3-D EXTRAVAGANZA:** Iced appliqué figures and garlands are first carved out of wax, then formed into rubber molds filled with silver icing, then finally added as three-dimensional elements to the sides of this extraordinary cake.

2 **CLASSICAL MOTIFS:** The bas-relief, complete with figurines and garlands of roses, is created by first carving the shapes, then casting them in chocolate, and finally appending them to the outside of the tiers. A divine cake!

3 **INITIALS:** To personalize this fantastic cake, the bride's and groom's initials and the wedding's logo are incorporated. Wow!

4 **CAKE IN A METAL CAGE:** This simple cake sits in an ornate open-framed cage, adding an opulent touch of magic to the lavender-decorated ballroom of the Beverly Hills Hotel.

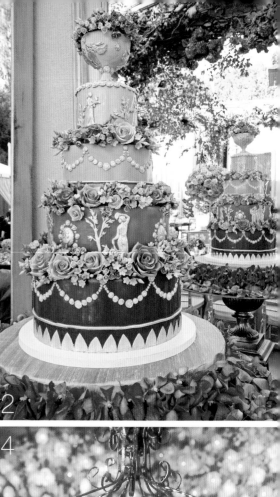

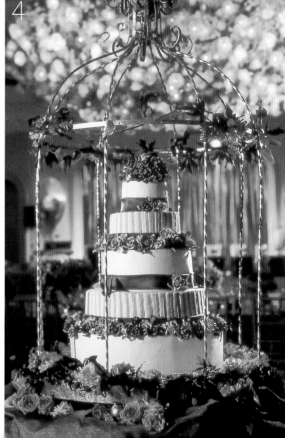

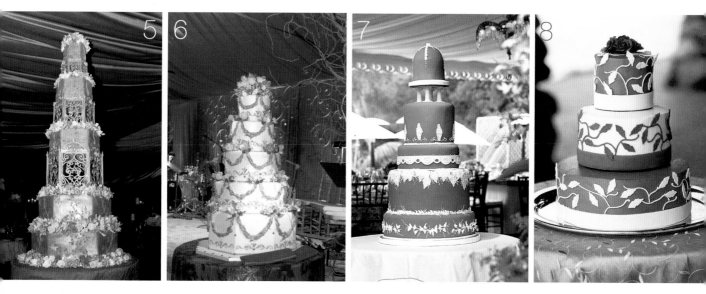

5 METAL CAGE IN THE CAKE: Quite honestly, this is one of the most extraordinary cakes I've ever seen—and I've seen a lot of cakes. The filigree cage is copied from the embroidery of the tablecloth, which in turn is echoed in the railing placed around the sunken dance floor. The entire confection is constructed around an intricate dowel system to ensure structural integrity.

6 SWAGS AND FILIGREE: For this fall-themed cake, the filigree is reminiscent of the design that serves as a backdrop to the stage, and the opulent gold swags visually link the cake and the room.

7 USE THE CHINA: The architectural cake for this Anglo-Indian-inspired wedding is a labor of love—all the relief icing is carved first, then molds are created and cast in white chocolate. The designs are attached to the cake for a three-dimensional effect that's an eerily perfect evocation of Wedgwood china; note the capricious scale variations among the different tiers.

8 RE-CREATE THE TABLECLOTH'S PATTERN: This reversible blue-white pattern was inspired by the simple, understated design of the tablecloth.

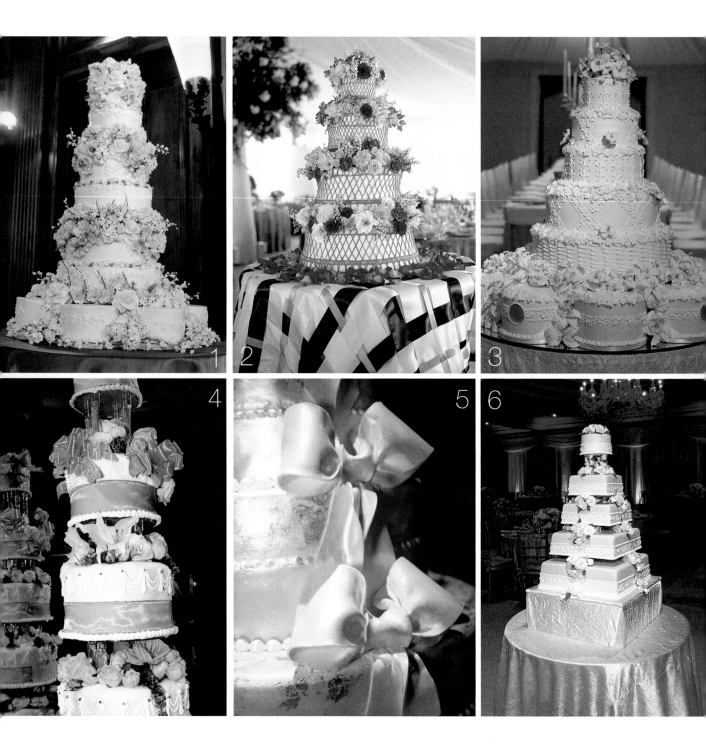

1 **FLORAL EXPLOSIONS:** The abundant use of exquisite handmade flowers, stemming from the rounded hexagon base and continuing to the very top, creates a dramatic vertical statement.

2 **HANGING GARDENS:** This cake is designed to echo the beautiful fall colors that adorn the latticework in the garden. It's decorated with Leonidas roses and cream roses as well as stems of lily of the valley.

3 **MONOGRAMS:** The bride's and groom's initials are embossed on the menu, embroidered on the napkins, and stamped in iced silver in the base of this cake.

4 **FLORAL TABLEAUX:** For this very tall and supremely elegant cake, intricately arranged and painstakingly crafted iced flowers, sugared fruits, bunches of sugared Champagne grapes, and pulled-sugar ribbons create a series of still-life tableaux between layers.

5 **FOCUS ON HER RIBBONS:** The cake is dressed in ribbons like those that tie up the back of the bride's exquisite dress.

6 **WRAP THE BASE:** To achieve additional height seamlessly, wrap your base in the same fabric as the cake's table, with all of the cloth mimicking the cake design itself. A cake like this one, which turned out to be shorter than everyone expected, now appears to be much higher than it actually is.

7 **FLOATING TIERS:** Small two-inch placers allow this white-chocolate-draped cake to breathe—almost to float. The extremely simple cake design embraces the color scheme of this very feminine wedding, a soft pastel pink and mint green. Pin-dot icing and an iced mint-green ribbon add texture and dimension to a quiet palette, and a romantic silklike celadon bow on top adds a charming finish.

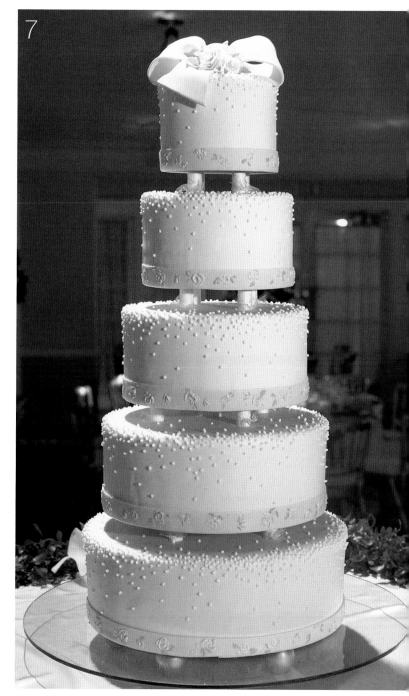

7

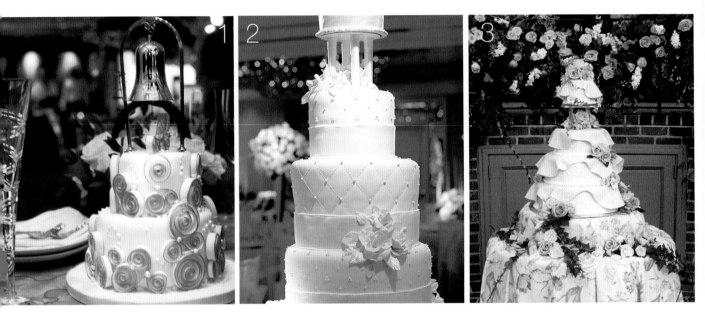

1 BELL: The icon for the top of this mini cake is a real sterling silver bell.

2 MATCH THE QUILTED TABLECLOTHS: The white-on-white satin-finish pattern is punctuated with small clusters of roses for this extraordinarily chic all-white wedding.

3 FLORAL EXPLOSION: Here a simple summer cake is brought alive with vibrant cattleyas, cymbidiums, shocking pink roses, and dahlias.

4 MATCH HER RIBBON SASH: A cascade of satin ribbons—matching the bride's and bridesmaids' dresses—and fresh flowers fall from the top tier to the base of this beautiful fall cake.

5 ECHO THE RIBBONED EMBELLISHMENT: This white chocolate cake is punctuated with miniature violets and lavender iced ribbons, which echo the braid of varied satin ribbons in the tablecloth.

6 CORAL: This coral-themed wedding features a simple stacked cake that comes alive with three-dimensional iced coral and iced dots that drip down from the top of each layer like water bubbles.

7 IDEALIZED BLOOMS: For this very tailored cake, fuchsia and saffron ribbons with silver dragées are topped with fresh roses for an idealized vision of cut flowers.

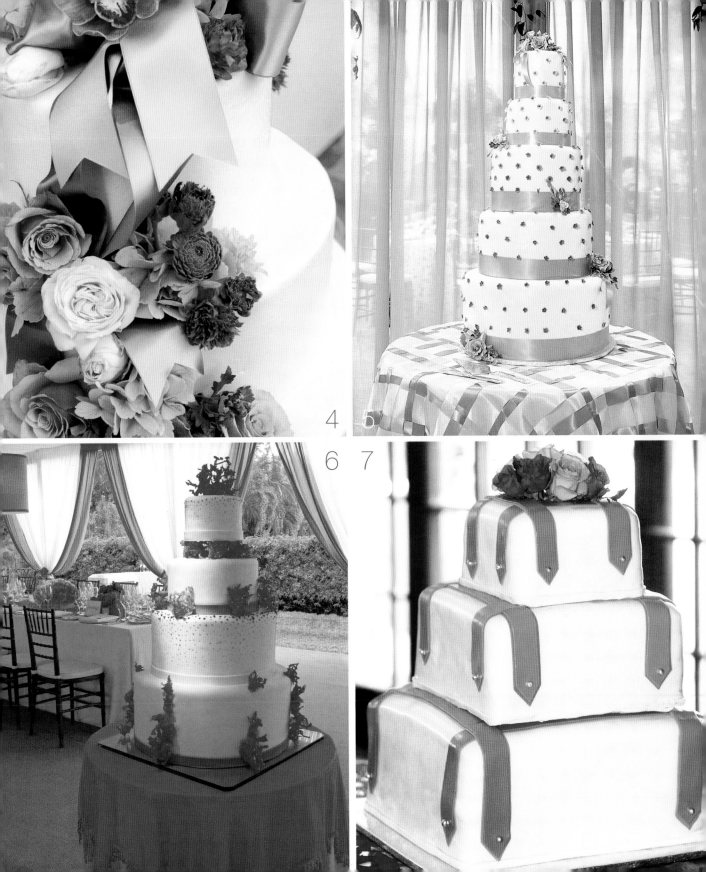

4 5
6 7

whimsical

1 **ALLUDE TO THE TABLE RUNNER:** A stacked-tier cake is a study in vertical stripes, hand painted to mimic the barcode table runner on the dining tables, given dimension by attaching strands of pearlized beads.

2 **FLOWERS:** Showy peonies, made from fondant icing, top this polka-dot-themed ultra-elegant wedding cake.

3 **CROWN:** For this princess bride, the cake is topped with a crown, the inside of which is inscribed with the date of the event and the names of the bride and groom.

4 **DRAW FROM THE TABLECLOTH'S PALETTE:** This lighthearted, witty cake is an ode to brown, with each tier a different shade punctuated with contrasting three-dimensional bubbles, a burst of sophisticated fun that's ideal for a daytime wedding.

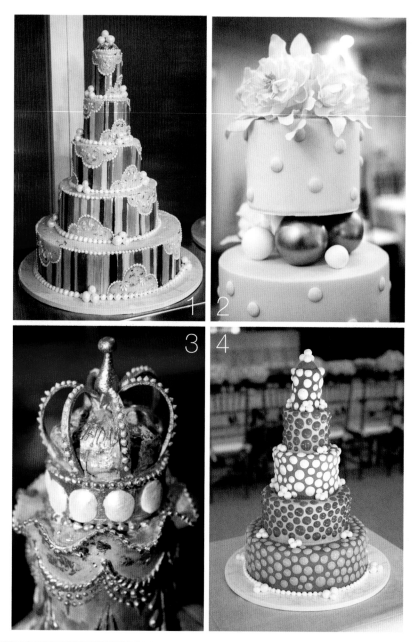

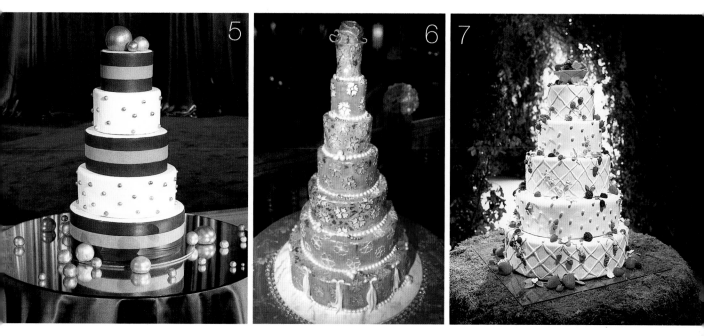

5 USE MIRROR MAGIC: Place the cake on a mirror, which will create both drama and extra perceived height. For this Halloween wedding, the color scheme was pure autumn—cognac, burnt sienna, tangerine, copper, and gold—and the round cake design mimicked the in-the-round ceremony. Set atop this mirrored base, all these circles and spheres seem to extend down to the earth and up to the heavens.

6 PURE PRESENCE: The delightfully hand-painted top embraces the color scheme of watermelon and mango and mimics the hand embroidery of the Indian tablecloths. It's pure fun.

7 COMPLETE WITH LADYBUGS: This Secret Garden–style quilted stacked cake is decorated with handcrafted blueberries, wild berries, boysenberries, and even hand-painted ladybugs. A tablecloth made of moss takes the garden theme above and beyond.

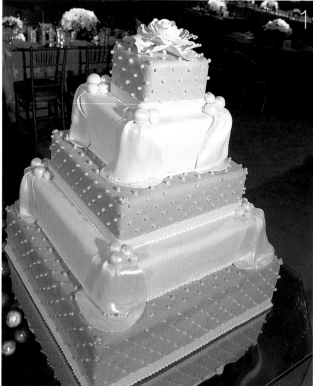

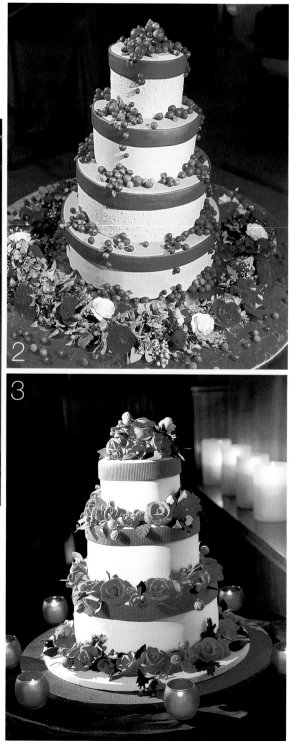

1 MATCH HER PEARLS: In this gorgeous 1940s-style quilted cake, the small balls of icing are pearlized with sugar to be dead ringers for real pearls. White ribbons, which are fashioned from white chocolate, look luminous with a pearly finish; and the overscaled rose on top makes for a simple but sublime statement.

2 FIND INSPIRATION FROM HER DRESS: For this winter wedding, the bride wore a cranberry-red satin dress, so we adorned the cake with cranberry-red ribbon and cascades of cranberries and wild berries that were handmade from icing.

3 CHRISTMAS: Holly and roses detail this red-and-green-iced cake for a Christmas-night wedding.

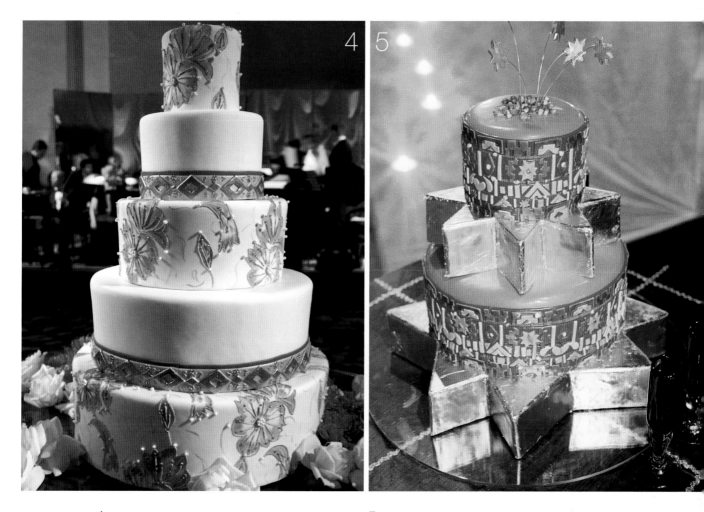

4 **TAKE ADVANTAGE OF A LARGE PEDESTAL BASE:** Even if your wedding is for a small group of people—and your cake is not tremendous—you can still create an impressive illusion thanks to this clever trick. Here the bottom tier is polystyrene, not cake, to provide a larger base.

5 **FIREWORKS:** For this Mexican wedding, the fireworks-topped cake is cut moments before the real fireworks start. On the circular tiers, the cake's exterior decoration, which exactly replicates the fabric used at the reception, is handcrafted from three-dimensional elements that are painstakingly applied. These vivid layers are interspersed with starburst-shaped tiers of cake covered in gold leaf (which is not something you want to try in a humid environment—the gold leaf might melt onto everything else).

daytime beach

1 MATCH THE TABLECLOTH'S COLORS: This understated pistachio-and-ecru cake is an ethereal evocation of the tablecloth, with a playful variety of square and round shapes, as well as unexpectedly different tier heights.

2 SEASHELLS: For this wedding at the Atlantis resort in the Bahamas, the cake picks up the nautical theme with three-dimensional seashells and ocean bubbles used as spacers between the layers.

3 WAVES: The open petals of stacked white chocolate tiers resemble the waves in the background of this beachside wedding.

4 BONNET: This simple cake is designed like a bonnet topped with miniature handmade iced floral blossoms, with white chocolate ribbons cascading from the top tier. Note the contrast between the white-on-blue versus the blue-on-white, for added texture and interest.

5 OCEAN ELEMENTS: The sea is wonderfully evoked with three-dimensional coral, shells, seaweed, and water bubbles, not to mention the pearls in shells—the jewels of the cake that rest alongside.

6 CHAMPAGNE BUBBLES: Curlicue-shaped wires are strung with tiny pearls to look like bubbles coming out of Champagne.

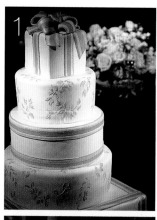

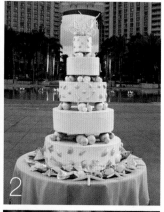

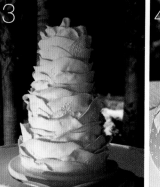

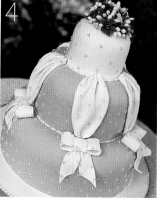

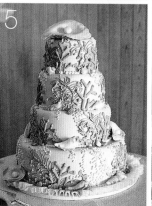

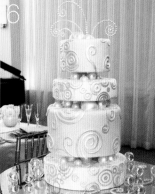

BEACHY CLEAN: For a very contemporary beachside wedding, the beautifully simple white cake is finished off with a cascade of smiling white phalaenopsis blossoms.

garden

1

2

3

4

1 CHERUBS: Gilded cherubs ring the top layer of the cake, holding a beaded chain that joins them. The top cherub holds a simple bouquet of lily of the valley.

2 NATURAL BLOOMS: For this garden wedding, the iced flowers on the hexagonal cake match the fresh flowers growing in the garden.

3 SYMBOLIC: Even though individual cakes are served to every guest, there's still a cake-cutting ceremony with this symbolic cake, which is decorated with a profusion of white flowers and green foliage.

4 JEWELS: These ultrafeminine cakes are draped in fondant icing with pearlized beading and hand-painted flowers.

5 PLAY WITH SCALE: The small size of the violet-filled terra-cotta pots—one pot for each bridesmaid—makes this whimsical ten-tiered cake appear enormous. Note that the ladybugs on the cake, as well as the green-and-white scales that exactly match the tablecloth, required a truly Herculean effort—each individual scale is actually composed of three different pieces that are hand pressed together to make a thumbnail-size leaf, whereupon all the leaves are joined by hand. Extravagant, to say the least!

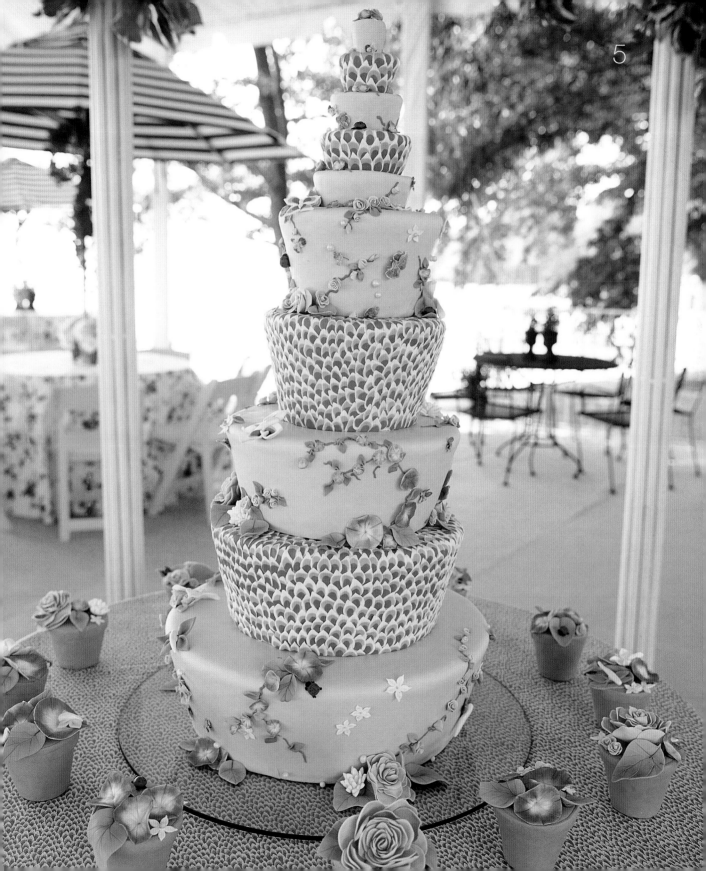

miniatures

 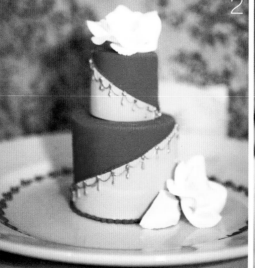

1 A FLIGHT OF FEMININE FANTASIES: Men receive a simple red-bowed box. But each woman gets one of eight fantastically eye-catching designs.

2 SWAGS: This two-toned cake is garlanded with small swags of gold icing and finished off with royal icing white roses.

3 MEN'S CAKES: The male guests receive small white boxes with a gilded seal and ribbon made from royal icing.

4 HATBOXES: For this morning wedding, lovely little cakes come in the shape of hatboxes.

5 STACKED: These miniature stacked cakes are decorated with a tone-on-tone flourish of hand-painted gilded rings and a sprinkling of colorful iced flowers.

6 SWEET SELECTION: A selection of cakes complements the reception décor, in shades of green from celadon to chartreuse that are all garnished with miniature iced flowers.

7 CUPCAKE TOWER: Individual cakes are currently all the rage, and of course cupcakes are the progenitor of the one-guest cake. These little gems are placed in concentric circles on wooden tiers, giving the illusion of a single large cake. This is a tremendously charming idea for a wedding someplace grand, like this one, at the St. Regis Hotel in New York City.

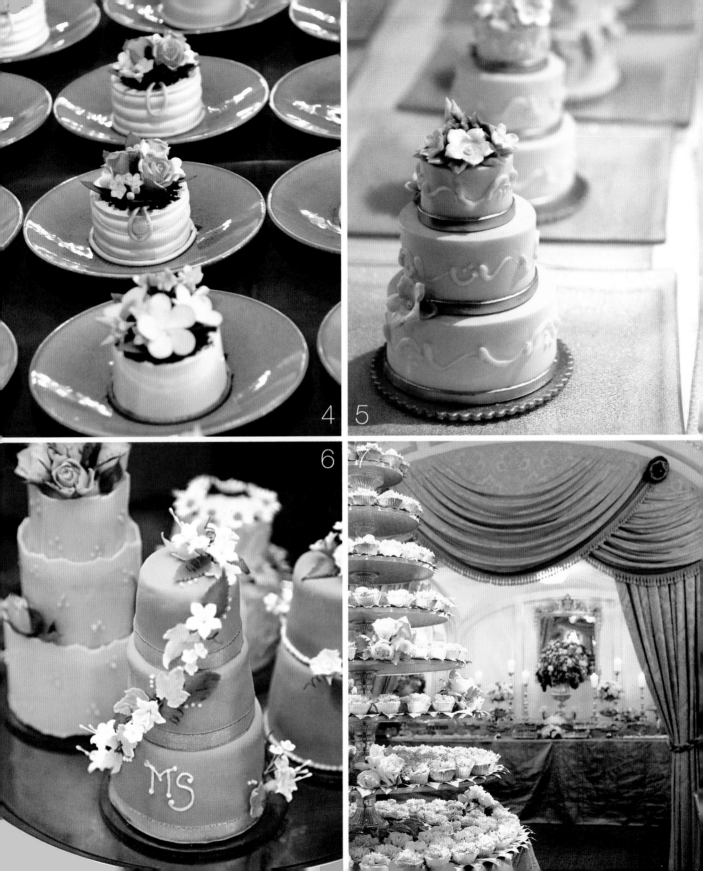

1 VARIETY: Each guest at every table received a different design, each one of them gorgeous and unique.

2 WICKER BASKETS: Perfect for a morning wedding, these miniature cakes are fashioned in the form of wicker baskets that are overflowing with small white and lavender blossoms and a handle that's made from edible iced ivy vine.

3 WEDDING FAVORS: Thousands of hand-painted cakes—made with gold-leaf appliqué, pearl trimming, and silver dragées—are hermetically sealed in gift boxes and given as favors. Wow!

4 PEARLS: The surreally undulating tops of these cakes is more formally offset with the pearlized detail around the bottom, the large pearlized balls on the top, and the mottled silver leaf scattered over the surface.

5 COMPLEMENTARY COLORS: It's just lavender and lime for the many individual designs—some stacked, some tiered, some in the bombé shape of this Hawaiian wedding.

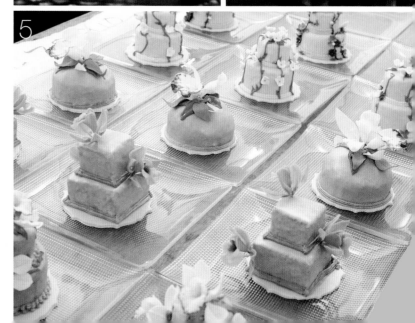

individual cakes

A trend that I love (and that I take credit for starting) is the miniature wedding cake. When all the different styles are served, even the most reserved guest can't help but be utterly charmed. I've seen it happen again and again—suddenly the fun factor skyrockets and everyone begins to mingle and share tastes of their individual confections. And when you're freed from making that one big choice, you can make whimsical little choices instead: like cake for the ladies but chocolates for the men, or monogrammed cakes, or cakes that match the plates, or whatever else you want. If individual cakes are beyond your budget, think outside the cake box and create the same delight with gorgeous designer wedding cupcakes. The point is to create a sweet ending to your perfect day!

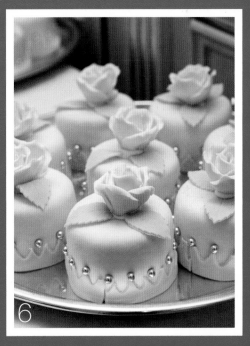

6 **JEWELS, OF COURSE:** For this ladies-only reception in the Mideast, the order of the day was restrained elegance and softness—and just a dash of cha-cha-cha.

Lisa Wilfong

IN HONOR OF

Lisa & Stephen

Appetizer

THAI LOBSTER MARTINI
Mango, Corn, Tomato and Lobster Salad with a
Thai Herb Vinaigrette and Lemongrass Skewer

Lunch

FRENCH-CUT ORGANIC CHICKEN BREAST
with preserved lemon and porcini jean sauce,
cherry tomato risotto and haricot vert bundles

Dessert

DECADENT CHOCOLATE MOUSSE PYRAMID
with chocolate sauce and fresh berries

Wedding Cake

6
invitations and other paper, gifts, and favors

After the flurry of breathless phone calls—telling friends and family, "We're engaged!"—the first bit of real information that most of your guests will receive about your wedding is the invitation, or possibly a save-the-date card. This little piece of paper has a big job to do: It needs to set the tone, the look, and the feeling of your event. It's the first glimpse of the celebration to come. Do you want your guests to open an oversize envelope made from the most luscious card stock, hand lettered in meticulous calligraphy with the details of a formal wedding and black-tie reception? Or do you want to pack a handmade envelope with a piece of dried lavender to accompany green card stock with aubergine ink, announcing a morning ceremony followed by a garden reception? Do you want to convey, "Join us for a weekend of fun and celebration in Tuscany," lovingly embossed on a terra-cotta card wrapped in a piece of cream linen? Or do you want to provide the facts in an understated fashion—the when, the where, the dress code, and the RSVP date—for next summer's ceremony?

Fortunately, you aren't limited to sending a note engraved with gold ink on ecru card stock, or with black ink written in a formal calligraphy font. Whether using a boutique stationer, a national chain, or even doing it yourself on your home computer, at specialty paper stores, craft stores, and online you'll find gorgeous papers and embellishments that visually represent your personal style and the

MENU WITH SHAGREEN: This square card is covered in lime-green shagreen, and the top personalized menu is adhered with two ribbon details.

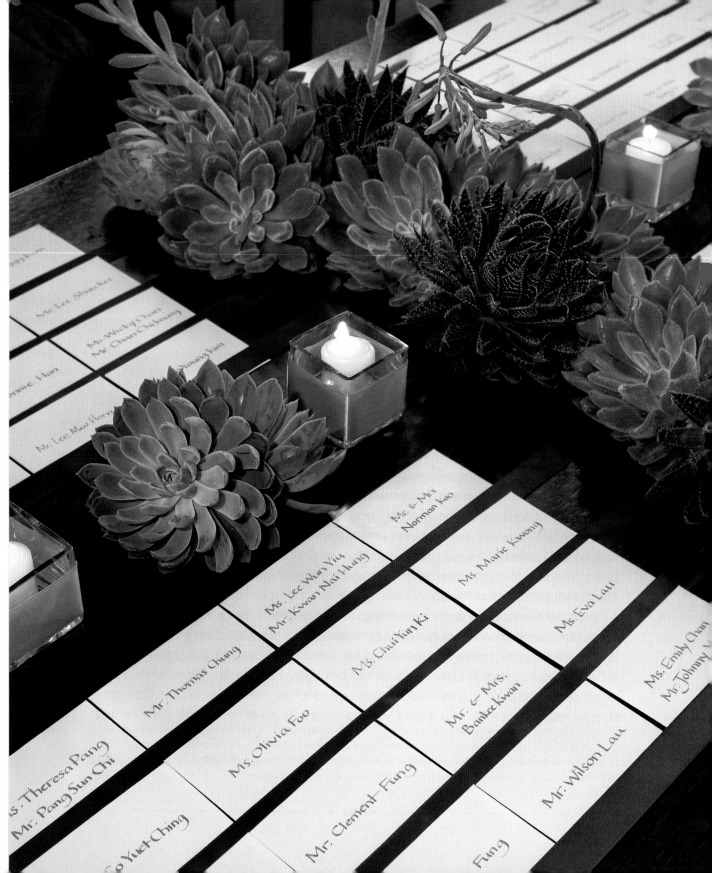

you not go overboard. There's really no need to use an embellishment on every single surface. Think about where your flourishes will have the most impact and then use them judiciously.

I have a mantra that's well worth repeating: A well-informed guest is a happy guest! This holds true through all stages leading up to—and during—the event. If it's an out-of-town wedding or a weekend event with a series of parties beginning with a welcome cocktail reception or rehearsal dinner and ending with a post-nuptial brunch, I find it helpful to send out a confirmation package (to the positive RSVP list only), detailing all the nuts and bolts, including travel arrangements (lodging options, and if it's a small airport, I even include airline preference and possible flight choices), the local weather, passport requirements, clothing and attire, and anything else guests might want or need to know. For out-of-town guests or even local friends checking in for the weekend, have a welcome package waiting in their hotel rooms; it could be as simple as a handwritten note reiterating what's to come at what time and how to get there, or as elaborate as a printed card that accompanies a gift. Never hesitate to repeat information; few people remember to bring along their invitation with all the details. And be sure to include a schedule of events; weddings rarely consist solely of a ceremony and reception, but usually include rehearsal dinner or other night-before festivities, brunches, lunches, and entertainment activities. Also include a name and contact number they can call with any questions (*not* yours—the maid of honor or a willing family member will do); and a note thanking your guests for coming.

I'm not a huge fan of what people call "favors," which far too often turn out to be tchotchkes that guests feel obliged to lug home and then move from drawer to drawer until they're eventually tossed. I'm not saying you shouldn't give departing guests a heartfelt thanks and a token from the wedding. But unless the favor has special meaning, I suggest that you instead spend the money on the very best gift of all: an *experience* that your guests will remember and cherish forever. If you're planning a late, late, late Saturday night, a bag of bagels and cream cheese plus a Sunday-morning paper will certainly be appreciated. If you love chocolate truffles, why not prearrange a surprise: Who wouldn't want to get into his or her car and find that the valet has left chocolates for their enjoyment on the

SPARE AND CHIC: For a chic country wedding, the host cards are placed on a wooden table divided into sections using live succulents.

ride home? If budget is a consideration, have the valet leave a note of thanks on the dashboard. You can even set a table in the hotel lobby with mints and bottled water so guests can help themselves as they leave.

I believe in making your guests feel comfortable and appreciated. A little pampering goes a very long way toward making the people you love feel truly welcome. One special touch is to have hotel staff place preprinted good-night wishes that you provide on your guests' pillows at turndown service. Or consider arranging for a little local flavor in the form of a bottle of wine or a food specialty grown in the area, or even have something as simple as a compilation CD of your favorite songs from the party waiting in the room. If you're having a breakfast or brunch the morning after your wedding, one of the best favors I've ever been given was a wonderful CD filled with pictures from the wedding weekend—everyone likes receiving photos and memories of themselves having a good time. No matter what notes, gifts, or amenities you give, take special care to make sure they are presented and wrapped beautifully, in a scheme that ties in to the look of the wedding itself—perhaps use the same color ink for a note as you used for the invitations, or tie a knot around a local map with the same ribbon used in your bouquets. Anything worth presenting is worth taking the extra few seconds to be sure it's presented with style. As with so many wedding details, it's not about what you give, but about the meaning and care that went into it.

Your reception dinner provides another opportunity to use paper creatively. Printed menus used to be optional, but my feeling is that it's important to have at least a single menu on the table, if not one per guest. Menus allow people to see what they'll be served before a plate is placed in front of them, providing opportunity for them express to the waiter any concerns, dietary restrictions, or food allergies. If you're hosting a sit-down lunch or dinner with printed menus for each

1 VARIATIONS ON A THEME: This dining room features three different tablecloths in complementary patterns, and a different fabric menu pairs with each cloth, all in variations of nautical blue and ecru.

guest, it's a nice touch for them to be personalized with each guest's name, serving double duty as a place card. And as for place cards, it's a lot of extra effort but with more than six guests per table, it's worthwhile to help balance the table's energy, placing the chatty Cathys on opposite ends, passionate travelers with frequent fliers, fashionistas with the flawlessly put together, separating the terminally shy, and keeping the loquacious guests from having to shout over one another to be heard. At the very least, have place cards at the bridal table and, if you're feeling inclined, also at the main tables where your parents are seated. As I've said, part of your role as host is to try to ensure that each and every guest has a genuinely magical time. Organizing the seating is not always easy, but your guests' appreciation tends to make it well worth it.

In the vein of gifts and amenities, there are a couple of other thoughtful approaches to making your wedding an affair to remember: the first is to arrange separate activities for any children who may be attending. Whether that means finding an off-duty schoolteacher to read stories or a camp counselor to supervise games, or erecting a series of tents and sleeping bags for an outdoor slumber party, parents—and all your other guests—will have a much better time if the children are safe and entertained. Don't hesitate to speak with your caterer or hotel banquet manager to find a staff member who loves children and can fill the role.

Second, anticipate life's little inconvenient truths such as headaches and torn stockings: Place amenity baskets in the restrooms that contain aspirin, tampons, sanitary pads, mouthwash, dental floss, mints, clippers to repair broken nails, and clear polish to repair snagged panty hose. If anything goes wrong, these baskets will help your guests fix it, collect themselves, and get back to enjoying your party, making it the best experience for them, and for you. By treating every guest like royalty, and anticipating his or her smallest needs, you'll make everyone feel that much more special and that much happier to be part of your beautifully thought out, marvelously executed, absolutely fabulous wedding.

2 MENU CARD WITH ORCHIDS: Menu cards sit in folded napkins and are garnished with lavender orchid blossoms.

intriguing invitations

1 DESTINATION CAPRI: For a wedding on this magical Mediterranean island, a faux-antique map is printed on the bifold, which opens to reveal a series of pockets and cards.

2 DIE-CUT INSERTS: The tops of the card-stock pockets and inserts are all cut to resemble the hilly skyline of Capri, utilizing the colors of coral found in Capri.

3 SARI SILK: For an Asia-inspired wedding, sari silk covers the bifold, and the interior panel includes the invitation copy with the bride's and groom's names in gold and their initials in the center of a gold lotus blossom.

4 GIFT WRAPPING: We bought every available square inch of this Anglo-Indian paper, and used it for the invitation's border, to line the envelope, on the menu card for the reception, and anywhere else paper was called for. In fact, this paper pretty much dictated the color scheme of the whole wedding.

5 CELADON CHERUBS: This trifold invitation has directions on the left, the RSVP card on the right, and the invitation itself in the center, all held together by the soft color scheme reflected in the ink and ribbons.

6 SEA GRASS: For a destination beach wedding in the Bahamas, all the travel information is in the left-hand pouch, and the RSVP material is in the right pouch. Tea-colored ink against a cream background complemented with sea-grass paper creates a thoroughly beachy feel.

7 CUSTOM-DYED RIBBON: For a simple beach wedding, the light card stock is printed with sand-colored ink, and this custom-dyed ribbon reflects the secondary colors of the wedding— mango and watermelon.

8 EXTRATHICK STOCK: For an art deco theme in the style of the 1930s, this extremely thick card is debossed and printed in blue with a thick silver beveled edge.

9 BEACH-CASUAL BOOKLET: For this relaxed beach wedding with a coral theme, the simple ceremony booklets are made with hand-torn recycled paper to impart a vintage quality, then calligraphed in bright coral ink.

1 ORNATE PAPER: A bifold invitation is ornamented with the embossed initials of the bride and groom, copious stretches of gilded borders, and a totally luxurious Florentine paper.

2 CUSTOM-LETTERED NOTE: A fun way to send invitations is in the form of personalized note cards, which are printed by letterpress. A calligrapher then handwrites the name of each invitee in the same style and ink as the printing, giving the illusion that each invitation was written entirely by hand.

3 ORGANZA RIBBON: Here the invitation is just a single card, but oh, what a card! The bride's and groom's initials are embroidered in silk and then wrapped around the card stock, and the card itself is wrapped with a large piece of organza ribbon.

4 BROWN TISSUE: For a fall wedding, the invitation and an accompanying beautiful piece of poetry are wrapped in brown tissue paper and placed in a matching envelope also lined in brown tissue.

destination-wedding invitations

I firmly believe that most rules are meant to be broken. But some rules are all about your guests' convenience, and those are rules that I think are worth following. Here are a few of my suggestions for destination weddings:

- TIMETABLE: The standard used to be to mail the invitations six weeks before the wedding. But that's not nearly enough advance notice if you're asking your guests to travel significantly, especially abroad or at peak travel times. So send a save-the-date card up to six months in advance, and the invitation itself eight to twelve weeks ahead of the event.

- CONFIRMATION PACKAGE: When you receive a positive RSVP for a destination wedding, send a confirmation package with all the pertinent travel information: logistics, accommodation, attire, activities.

- WELCOME PACKAGE: Available in every hotel room should be a packet of information very similar to the confirmation package—about the locale, the events and other activities, and anything else your guests might find useful. Don't expect everyone to have traveled with the confirmation package you mailed earlier.

- GOOD-NIGHT WISHES: For turndown service, it's a nice touch to have the staff place preprinted or prewritten cards on your guests' pillows with a bit of poetry, an apt saying, or simply a heartfelt thank-you for their attendance. This is especially appropriate when your guests have traveled long distances, sometimes at great expense, to share your nuptials.

- GIVING THANKS: When you're designing and ordering the invitation, the confirmation package, and the welcome package—a lot of individual pieces of paper—you might as well throw in a set of matching thank-you notes in the same theme as your other paper goods.

ceremony booklets

1 FINE BOOKMAKING: These booklets are placed inside padded covers that are the same fabric used for the invitation, embossed and gilded with the bride's and groom's initials.

2 FORMAL AFFAIR: A buttoned-up look is created by embossing and gilding a crest—designed for the family—on the cover, which is then finished with matching gold fringe and tassel.

3 SUMMER CHIC: For a bright summery wedding, this tall thin booklet is printed with vibrant pink ink and secured with a vivid coral ribbon.

4 EXTRA! EXTRA!: Waiting for the ceremony to begin, guests have the opportunity to read about the bride and groom—and the events of the weekend—in this special-edition two-page newspaper.

5 OLD-WORLD TOUCHES: This more formal ceremony booklet is made from heavy, decorative paper done with a botanical pattern, and secured with refined silk ribbon and a traditional wax seal.

table names and numbers

1 DECO GLAM: Often the main table is referred to as the table of honor. For this wedding, the table name is written in French and mounted on a pink-trimmed card, which itself is affixed to a black-and-white-striped tented card.

2 TABLE OF HONOR: Instead of referring to the main table as table one, this bride and groom's table is named the table of honor, proclaimed by hand in calligraphed red ink on heavy gold cardstock with a beveled edge.

3 STREETS: Handwritten in calligraphy, the table name insets in a beautifully patterned tinted card.

4 WRITERS: This bride chooses to name her tables after favorite authors.

5 EXTRAORDINARY LETTERING: Here is an example of very elegant use of calligraphy on a blue-striped tented card that tells the story of this over-the-top affair.

6 NAME OF THE ROSE: The table name, handwritten in elegant calligraphy, nestles between mountains of roses.

1 NEIGHBORHOODS: White faux alligator skin is topped with brown suede paper and printed with names of different neighborhoods in New York City.

2 CITIES: For this Australian wedding, every table is named after a city down under.

3 MORE NEIGHBORHOODS: These table names, also representing different areas of New York, are die cut and then suspended from gold pedestals with pink ribbon.

4 COUNTRIES: Tables here display the names of places the bride and groom have lived.

5 QUALITIES: Here the bride and groom name their tables after the things they look for in friends.

6 MORE CITIES: Honoring one of the places the bride has lived, this card tucks under a potted arrangement of spring bulbs.

7 NUMBERS: When all else fails, a simple number does the trick with more than enough clarity—and style.

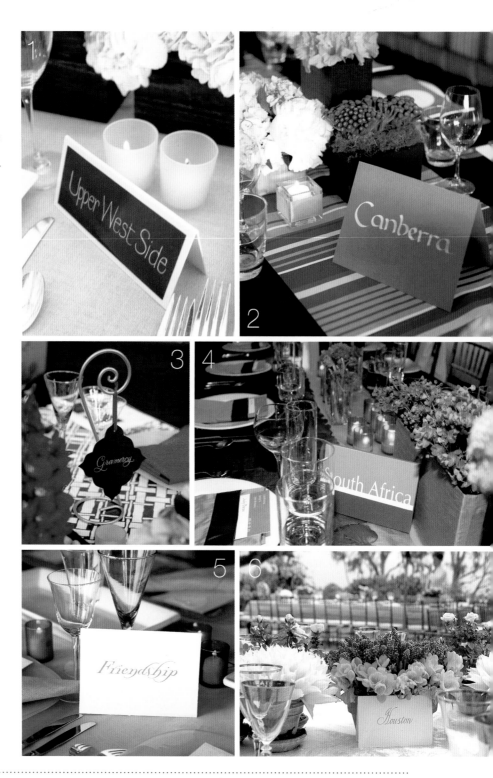

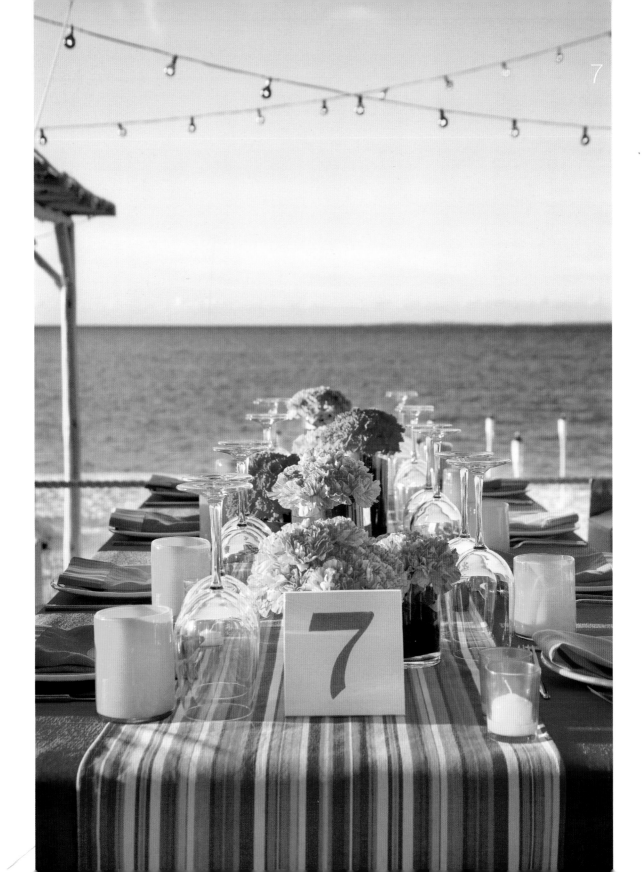

host cards

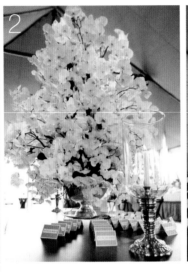

1 WHITE IN THE ROUND: This large brass frame is garlanded with roses that range from off-white to shades of pink, all arranged with gilded leaves to offer a rich nineteenth-century look.

2 WHITE GOES VERTICAL: This table is anchored with a tower of white phalaenopsis that was created by placing multiple blossoms on scores of long Lucite and bamboo rods, giving the effect of a tall tree from the short-branched blossoms.

3 NOIR CENTRALE: The center of this host-card table is a tall footed black vase topped with a globe of coral roses and finished with a colorful plume of porcupine quills.

4 GILDING THE ROSES: At a very formal wedding, the host cards sit on a mirrored tabletop anchored with a large gilded urn of Schiaparelli pink and red roses, red anemones, and springeri fern. Gilded pedestals packed with red and pink roses flank the urn for a truly eye-popping experience.

5 COUNTRY CASUAL: For this rustic wedding, host cards are placed directly on an old wooden table as well as inside its moss-lined drawers.

6 A TOUCH OF TEAL: White calligraphy stands out on a simple but effective tented teal card.

7 A TOUCH OF SECURITY, THIN SILK VERSION: To ensure that the wind never blows away these host cards, strands of orange silk ribbon secure them.

8 A TOUCH OF SEXY: A brushstroke of Schiaparelli-pink ink brings the simple white card to sexy life, and the mirrored tabletop adds tremendous glamour.

9 A TOUCH OF EXOTIC: For an Asia-inspired wedding, these bright orange host cards are finished with an embossed gold seal of a lotus blossom.

10 A TOUCH OF CRAFTSMANSHIP: For an old-world wedding, the edges of these tea-colored cards are all hand torn.

11 A TOUCH OF MODERNISM: Here the guest's name is in blue ink on a vellum overlay, while the table name shows through in white ink from the card underneath.

1 A TOUCH OF NATURE: Here host cards are arranged on a table carpeted in various garden mosses.

2 A TOUCH OF SECURITY, METAL VERSION: Wide pins can also be used to keep the host cards in place.

3 A TOUCH OF CONVENIENCE, CONTEMPORARY STYLE: These trays of cards are divided by stretches of the alphabet.

4 A TOUCH OF SECURITY, WIDE SILK VERSION: These host cards are secured with a piece of ribbon anchored with an orchid, creating a look of order and precision while also keeping the cards safe from the wind.

5 A TOUCH OF WHIMSY: The names are set into a series of cherry branches that are arranged to resemble a tree in full bloom.

6 ANOTHER TOUCH OF WHIMSY: These host cards are fashioned into the shape of leaves and hung in trees, among which guests gather for the cocktail reception; to facilitate, the names are grouped alphabetically, with the men's cards in one color and the women's in another.

7 HARVEST OF GUESTS: These curly-willow-covered metal trees drip with the names of all the guests (and their tables), written on leaf-shaped paper and tied to the tree with ribbon.

8 MINI BUBBLY: For a walking cocktail reception, each guest finds the miniature bottle of Champagne with his or her name—and table assignment—written on it, then strolls to the reception site while sipping through the straw.

ceremony accents

1 RATTAN FANS: For this completely casual barefoot wedding on the beach, baskets are filled with rattan fans for the taking.

2 PADDLE FANS: The height of summer demands countermeasures, such as these elegant paddle fans, beautifully monogrammed with the date and location.

3 SAND SOLUTION: At this beach wedding, guests leave their shoes on a patio while strolling barefoot to the ceremony site in the sand. When they return to their shoes on solid ground, they find a damp hand towel tucked inside, to help them clean every last grain from their toes before making their way to the dinner reception.

4 CHINESE FANS: At an outdoor wedding in the tropics, chairs are thoughtfully laid with inexpensive Chinese fans to help the ladies keep cool during the ceremony.

5 SHOE BAG: If you're going to ask your guests to don snowshoes for a trip to the mountain summit, it's a nice touch to provide monogrammed velvet bags to store their evening shoes.

6 ASSIGNED SEATING: At most weddings, I create a seating plan for the family and label the seats accordingly, which helps avoid uncomfortable conflict or confusion, especially in situations of mixed marriages, divorced parents, or other complicating factors.

kids

7 ARTS AND CRAFTS: For this beach wedding, guests receive a boat-in-a-box kit, with a little how-to booklet, bound up in a red ribbon.

8 BEACH TOYS: It's always fun to include the children, especially for a beach wedding, and here's a fantastic assortment of toys, games, towels, and sunscreen.

9 KID KITS: To keep the little ones entertained, these backpacks are filled with books, toys, snacks, and even a little sleeping bag for a camping sleepover while the grown-ups dance the night away.

place cards

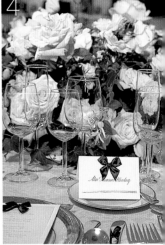

1 NATURAL ACCENTS: Keeping things modern, the name is hand lettered in lime-green ink on a round disk and punctuated with a vibrant green chrysanthemum.

2 MENU-COVERING CARDS: This place card is adhered to a band and secured with a ribbon, adorning the front cover of the menu booklet.

3 KNOCKOUT WHITE: For a waterside reception, robin's-egg-blue cards are handwritten in classic calligraphy with white ink, then framed with a white mitered border.

4 GILDED VELLUM: Old-world gilding meets new-world vellum in this updated but still traditional place card with hand-torn gilded-edge vellum covering the calligraphed card, secured with a small silk ribbon.

5 MODERN MIX: For a colorful beach wedding, the guests' names are printed in white ink on simple pink cardboard disks.

6 PLEXIGLAS PLACARDS: At this elegant reception, the guests' names are etched into mirrored Plexiglas tiles and placed on top of the napkins, making a strikingly twenty-first-century statement in a traditional setting.

7 PERSONALIZED MENU CARDS: Each of the menu cards is personalized with tea-colored ink calligraphy and adorned with a pristine miniature calla lily.

8 CRYSTAL-CREATION PLACE CARDS: For a crystal-themed wedding, not only are the flower containers and napkins trimmed in crystals, but a single crystal also sparkles in the twelve-o'clock position in these square place cards.

9 NATURAL CONNECTIONS: For a fall wedding, guests' names are written with Magic Marker on dried leaves—a simple, inexpensive approach with a big impact.

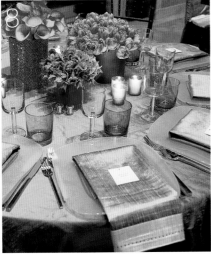

menus

1 FORMALITY RULES: These menus are masked with gold paper, and a gilded seal is embossed on the front, with the guests' names handwritten on top.

2 ORNATE FABRIC: The personalized menu booklets, with each guest's name hand painted on a brass plaque, are bound in the same fabric as the tablecloth.

3 SIMPLE ELEGANCE: For a quiet but thoroughly elegant look, the bride's and groom's initials are embossed and gilded on thick card stock, crowned by the guest's name.

4 VARIATIONS ON A THEME: This dining room features three different tablecloths in complementary patterns, and a different fabric menu pairs with each cloth.

5 WITH ORCHIDS: Menu cards garnished with lavender orchid blossoms sit in folded napkins.

6 TWO TONES: These napkins have silk on one side, linen on the other; the simple rectangular cards tuck into the linen sides.

7 WITH A STARFISH: At this beach wedding, the coral-colored menu is popped inside a white napkin, which is finished with the bright burst of an orange starfish shell.

8 SILK SHEATH: The personalized menu card is tightly sheathed in a crushed persimmon silk napkin.

9 WITH A SEASHELL: Personalized cards slip into crisply starched white hemstitched napkins, dotted with small seashells.

10 BIBS: For this clambake, the bride's and groom's initials are printed on the paper bibs that also serve as menus.

11 WITH JEWELS: Here a menu card sits snugly in a silk napkin wrapped with a silk ribbon and secured by a jeweled clip.

12 WITH CRYSTALS: These menu cards are adorned with Swarovski crystals, then wrapped in stark white linen and garnished with fresh sage leaves—an enchanting mixture of high-end elegance and simple, natural beauty.

13 WITH A ROSE BLOSSOM: For modern contrast, ecru ink is used on dark card stock; for romance, each place setting is punctuated with a big rose blossom.

5

6

7

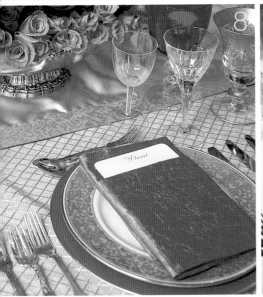

8

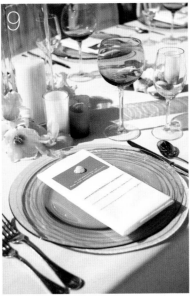

9

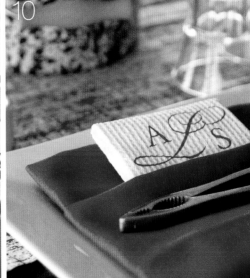

10

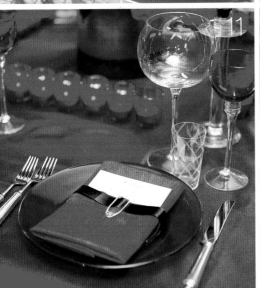

11

12

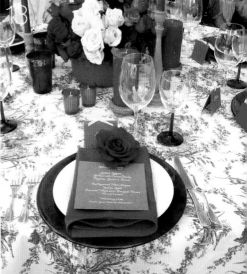

13

1 WITH A LEAF: For a mountain-aerie wedding, a dried leaf is secured with suede ribbon to the top of the menu.

2 WITH A CRYSTAL BUTTON: This heavy-stock card is a gold rush, from the printing to the border to the calligraphy, with a crystal button adhered to the top for a final touch of elegance.

3 WITH STEPHANOTIS BLOSSOMS: For a completely casual, tropically themed wedding, the card stock matches the napkin and the charger, and the ink matches the terra-cotta of the plate. Amid all this matching, a couple of stephanotis blossoms add a touch of whimsy.

4 WITH A PERSONALIZED STAMP: The bride's and groom's initials, in the center of a lotus-blossom pattern, are stamped onto the menu in gold foil.

5 WITH A SEASHELL: This ecru card is embossed with a seashell, then personalized in tea-colored ink. A real seashell on the white hemstitched napkin completes the story of this beach wedding.

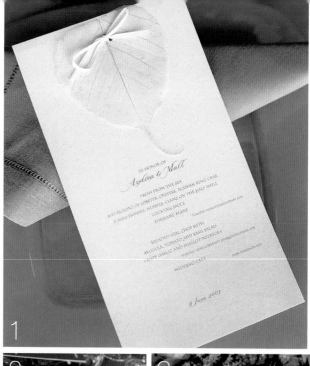

6 WITH COLOR: This otherwise simple menu card is enhanced with the bride's and groom's initials and large panels of color.

7 WITH TENTING: The simple robin's-egg-blue card is tented, so it stands upright on its own.

8 WITH FLORENTINE PAPER: The base card stock is topped with a layer of fine Florentine paper, which in turn is topped with the gold-engraved menu, and finally the guest's name is personalized in lime-green ink.

9 WITH A CRYSTAL CROWN: A series of Swarovski crystals creates an arching crown over the top of the bride's and groom's initials.

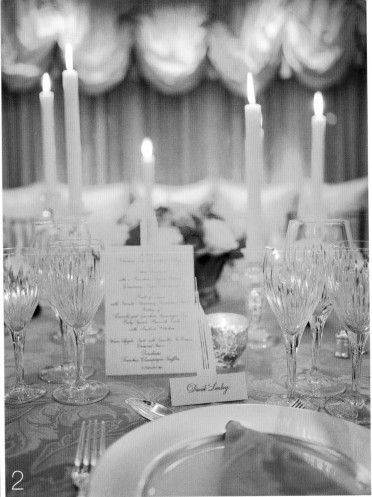

1 **WITH CROCODILE PAPER:** This vertical card stock is wrapped in glossy white crocodile-pattern paper, with a matte printed card atop as well as a band wrapped around the middle for the guest's name.

2 **SENSE OF PLACE:** For this sophisticated New York reception, all the place cards and menus are fashioned after the silhouettes of landmark buildings, including the Empire State and Chrysler buildings.

3 **WITH VELLUM:** For a very fresh approach, the menu is printed on clear vellum and placed beneath a transparent glass charger.

4 WITH RIBBON: Here the guest's name is written in calligraphy on brown ribbon that's slipped over the menu card.

5 WITH SILHOUETTE: To anchor the event in its locale, high above Capri, the silhouette of the mountains is cut from the edge of both the dark coral bottom card and the cream top card.

6 FRAMED MENU: Instead of creating menu cards for each setting, you can place a pair of freestanding menus, in matching vintage silver frames, on either side of the table.

7 WITH RATTAN: For a beach wedding, this base is topped with a rattan wallpaper and then with another card stock that features an embossed shell and the guest's hand-lettered name, which is written in the same cognac ink used on the printed menu.

welcome gifts

1 2 3 4

1 FRAMED-PHOTO WELCOME: The welcome package for this country wedding includes a bamboo-framed photo of the couple along with bottles of flat and sparkling water with custom-made labels.

2 SITE-SPECIFIC WELCOME: It's always a good idea to welcome guests from afar by presenting them with local flavor. This fantastic gift collection includes candies in the silhouette of the Sydney Opera House and a kangaroo-shaped shortbread cookie as well as a street map, along with local tea and an artisan-made candle, all bound up in a fabulous Schiaparelli-pink ribbon.

3 BRANDED-BOX WELCOME: This rustic but still refined wooden box, with the wedding details branded into the sliding top, contains moisturizer, a candle, sunscreen, hand and foot warmers, a welcome note, and a brochure explaining the incredible array of activities in this Colorado mountain paradise.

4 WINE-COUNTRY WELCOME: For a Santa Barbara wedding, near the of-the-moment · wineries in the Santa Ynez valley, a bottle of local wine, along with a locally crafted candle and magazine and a light snack, sits in a rattan box.

5 HOME-SPA WELCOME: Here the welcome package invites guests to indulge in pampering during the weekend, with Aveda products, mineral water, and fragrant candles, all arranged in a pressed cardboard box packed with raffia and tissue paper.

6 CANDLE WELCOME: Inexpensive yet effective, this welcome note is accompanied by a simple candle floating serenely in a bowl of water.

7 WINE WELCOME: Each guest receives a bottle of local wine, along with a heartfelt note of thanks from the bride and groom.

8 BEACH BAG WELCOME: Guests are thrilled to receive this utterly practical welcome of a monogrammed beach bag filled with a pareo (a saronglike wrap), sunscreen, a towel, a baseball cap, and even a light lunch—everything they need for a day at the beach, except the bathing suit.

5

6

7

8

1

2

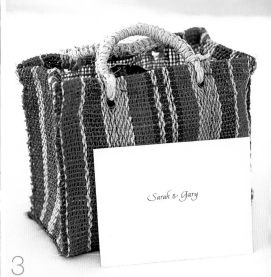

Sarah & Gary

3

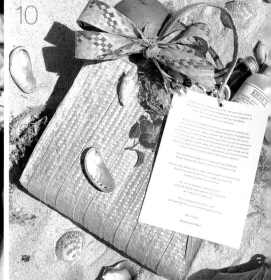

4

5

CAPRI
ANTONIO
&ERICA
10·6·00

6

7

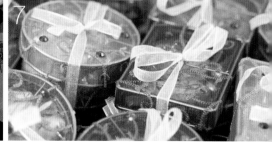

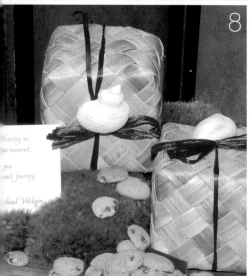

8

9

10

1 CANDLES WITH RIBBON: A candle is elegantly wrapped, matching the wedding colors. The bride's and groom's initials are embossed onto the foil stamp.

2 BEACH BASKET: In the Bahamas, the basket includes candles, sunscreen, CDs, mineral water, and a tube of quarters for the casino.

3 HANDCRAFTED BAG: This *bolsa* comes from the local craft market and is packed with a scented candle, a monogrammed baseball cap, even insect repellent.

4 SILVER SHELLS: For this Hawaiian wedding, each guest receives a sterling silver shell beautifully presented in a box that's wrapped in the colors of the reception.

5 CANVAS TOTE: At this Capri wedding, the welcome package is a monogrammed canvas tote with a bottle of the local specialty drink, limoncello; a lovely lemon candle; and a colorful pareo.

6 TROPICAL BLOSSOMS: At this Mexican wedding, the welcome package is wrapped in tropical leaves and finished off with dramatic birds of paradise.

7 DELICIOUS DRAGÉES: A traditional party favor for many weddings, candied almonds in silver and gold rest in elegant silk jewel boxes.

8 CANDLES IN RATTAN: Secured with purple twine and a pearlized shell, the rattan boxes strike the perfect beach chord to present each guest with a candle.

9 WINTER WARMTH: The guests at this cold-weather wedding are thawed out with candles and a warm note from the bride and groom.

10 BEACH SUPPLIES: For this wedding at the beach, guests receive a bag with necessities including the schedule.

11 KEEPSAKE PHOTOGRAPH IN A BOX: A photograph of the guest in an engraved frame is presented in an elegant box, along with a good-night wish from the bride and groom.

12 HOLLYWOOD WELCOME: Videos for relaxation, refreshments to go with the movies, and a monogrammed baseball cap to pretend that you're hiding from the paparazzi.

1 POWDER-ROOM BASKETS: Customized for men and women, these restroom amenity baskets include nearly everything a guest might need in an emergency, from nail polish to stop a stocking run to hair clips to stop a runaway coif.

2 A TASTE OF HOME: For a West Coast wedding with an East Coast family, guests get a copy of the Sunday *New York Times* as well as a bag of bagels and some cream cheese.

3 WEDDING-LOGO AMENITIES: For this endlessly fun beach wedding in Anguilla, the bride and groom created a logo of two trees and their initials, which was then placed on everything from baseball caps and T-shirts to the matchbooks that lie in cocktail-table ashtrays.

4 GOOD NIGHT, AND GOOD LUCK: This late-night thank-you from the bride and groom is accompanied by a little something to help combat the inevitable Sunday-morning hangover.

5 KEEPSAKE PHOTOGRAPH IN A RIBBON: This favor is a lovely thought that's not about the wedding couple. All the guests receive pictures of themselves, taken at some stage of the weekend, in an engraved frame.

and pastels are frequently offered in addition to the traditional white and ivory. It's not uncommon for brides to select a dress from a favorite fashion designer or boutique rather than a bridal shop.

When it comes to gown design, less is definitely more. It is very easy to look overdone and overproduced if you're not conscious of how all the elements work together. Rather than a gown made of multiple fabrics that's elaborately embellished with puffs and poufs every which way, I suggest that you find a dress made from one or at most two fabrics with one or two embellishments such as lace and some beading, or ribbons on their own to create a simple, understated look that allows you to shine. Remember, you need to wear the dress, and not vice versa. The most elegant wedding fabrics for your dress (and for that matter, your

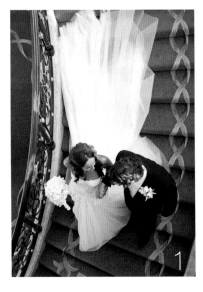

bridesmaids') are usually duchesse satin, silk organza, four-ply silk, charmeuse, pleated tulle, or silk tulle.

Of course, you need to consider whether the fabric will be appropriate and comfortable for the season. Tulle is the one wedding fabric that seems to work well year-round. Wools can be gorgeous, but on a humid summer day, they are also sweltering. For spring and summer, I think of soft fabrics like chiffons, cottons, voiles, light silks, and linens. Soft pinks, cool lavenders, vibrant greens, and even off-whites are beautiful in both solids and floral prints for brides' and bridesmaids' dresses. Slips in chiffon, cut on the bias, make for an elegant summery look with movement. When bare shoulders and strappy dresses are the order of the day, a gorgeous sheer wrap in a coordinating style will ensure that the bride and her attendants are comfortable in an air-conditioned environment. (Shawls and wraps can also create a change in appearance between the ceremony and the reception.)

And for the groom, khaki pants, linen suits, white shirts, and open collars are still elegant choices. Ties in a floral print, stripe, or solid that complements the bride's and bridesmaids' dresses will add just the right touch of formality.

1 BALL GOWN: This traditional gown has a full skirt and a cathedral-length train, but the low bustline and the spaghetti straps keep it sexy and a bit summery.

In the fall, the nuptial color spectrum can capture all the wonderful autumnal shades—cognac and brown, olive and rust, mustard and butterscotch. Fabrics for the fall bride are generally a bit heavier (like wool or cashmere) than in the spring or summer, and hemlines and sleeves may be longer. Bridesmaids might opt for pashminas or shrugs for added warmth and comfort. For the gentlemen, try a tone-on-tone monochrome—the same color in different textures—such as a chocolate-brown suit, shirt, and tie—or go with a navy tux. For the less ad-

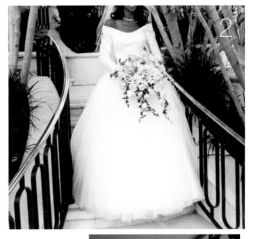

venturous, a lightweight wool suit in navy, dark brown, or black can be dressed up with the right shirt-and-tie combination, or dressed down with complementary patterns and color.

Winter colors tend to be darker—you can even include black for bridesmaids and groomsmen—with rich jewel-toned accents for punctuation. The fabrics are also slightly heavier. The most popular cold-weather wedding fabrics are velvet, four-ply silk, gabardine, wool crepe, and rich bro-cades, which work wonderfully for bodices or even handsome vests or ties. This is also the season when a gown embellished with heavy beadwork or decorated with Austrian crystals looks most appropriate. There are no rules regarding sleeve length or cut for winter, but if the dress is bare or strappy, it is a good idea to add a little bolero jacket or luxurious velvet-lined wrap for comfort. For the groom, the open-collar shirt without a tie still isn't a fashion faux pas, but the closed collar and tie can add a little warmth. Most important, the groom's attire needs to match the level of formality of the bride's. If you're wearing a cathedral-length train, he should be in a tuxedo. If you're in an Audrey Hepburn–style dress, have him wear a suit and tie.

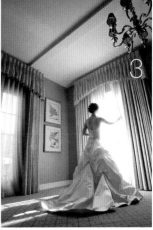

2 OFF THE SHOULDER: Here's a classic winter dress—off-the-shoulder long sleeves in white satin paired with a full ballroom skirt. 3 DUCHESS: This glamorous satin ball gown includes a strapless top and a full bustled skirt. After the ceremony, the train will bustle up under the skirt, allowing the bride to move and dance freely.

Regardless of the season, many brides still choose to wear the traditional veil, but there are alternatives, and selecting the right headpiece will enhance the entire outfit and help draw together the dress, accessories, and shoes. You may buy the dress first, then shop separately for the shoes, then the veil, and last but not least, the accessories. However you do it, at each step of the way be sure to put on the whole ensemble, stand in front of a full-length mirror, and ask yourself: "Is this how I want to look?" Each component on its own might be fabulous, yet the combined effect might not be flattering and may leave you looking overproduced and unlike yourself.

In recent years, I've seen many brides embrace the idea of changing to a post-ceremony dress immediately after having photographs taken. This option has its pluses and minuses. A great party has a sense of timing and rhythm, and it's important to keep the energy building from ceremony to cocktails and reception. If you're considering changing out of your gown, remember, a cocktail hour should take no longer than forty-five minutes to an hour; you'll need fifteen minutes to move guests from one area of your party to another. A quick photo session with a group shot of the bridal party, and another of your family and his, can be done in less than twenty minutes, if you're organized, leaving another twenty-five to make a quick change; so if you can squeeze it in and be ready to see your guests without dragging the cocktail hour out an unbearable amount of time, feel free to put your dinner dress on before hitting the party. If you have a long list of shots that can't possibly be accomplished in less than forty-five minutes (figure about three minutes per picture to determine realistically how much time you have to spare), you won't have a chance to change. In addition, if your dress has multiple pieces and removing it takes the time and effort of a dedicated dresser, consider waiting until after the dinner is served and there's a natural break in the energy when you'll be able to slip away to change without notice.

1 SILK CUMMERBUNDS: These exuberant silk sashes provide a striking contrast to the flower girls' white dresses.

You can duck out before the cake cutting, before dancing, or before the party is over if you have a get-away outfit. Just be sure you don't leave the room while you and your groom are being toasted!

Now, where to begin finding what you and your bridal party will wear? To start the process, collect your thoughts by creating a file of pictures from fashion magazines, bridal magazines, and catalogs. Save the photos that speak to you, and take them with you when you shop. With pictures in hand, and maybe even a few fabric samples, you'll be able to give the sales staff a better sense of your personal style. Think about all the elements, not just the dress itself: Your shoes and gloves, your jewelry and bouquet will also define your look. And before you head out the door to go shopping for your dress, make sure that you're absolutely certain of the locale and the time of day your ceremony will take place—and, of course, the date, or at the very least, the season. (If you haven't decided on the date and location of your party, you shouldn't be giving anyone a deposit on any dresses.) A small wedding at home may be an occasion for an understated dress for the bride and a two-piece suit for the groom, befitting the intimate setting; an outdoor wedding under a tent in July might call for a strappy A-line or a simple fitted dress of crisp linen. If your reception will be in an ornately decorated hotel ballroom, you might consider a more formal dress, perhaps with a train and veil. For a grand church wedding, you can wear an elaborate gown with a cathedral-length train, veil, and gloves. Whatever the case, don't just rush out to buy a dress because you're both excited and a little panicky at the same time. Don't get stuck with a dress meant for a church wedding in winter only to find yourself exchanging vows on a bluff overlooking the beaches of Mexico.

I can't stress enough how important it is that you go to at least three different stores and try on as many different dresses as possible before buying one. That may sound like a big time commitment, but it's important to sample a range of styles so that you can determine what really looks best on you, and what's most comfortable. A dress that seems terrible hanging on a rack may end up absolutely transforming you when it's on your body. Examine the line of the dress and

2 PRECIOUS PUMPS: These gorgeous shoes are like jewelry for the feet.

how it works with your body shape. If you've got great legs, show them off. If you are long waisted, avoid a dropped waistline or a dress that cuts you across the middle and emphasizes your torso. If you are full-figured, stay away from flouncy, frilly confections or horizontal features that add bulk to your silhouette. Be careful that the dress doesn't end up wearing you! Can you bend easily? What happens when you lift your arms in the air? Will you be able to dance? Sit down? Eat comfortably? Ask the salesperson to explain the fashion terms that apply to your dress style and accessories so that you'll be able to use them when describing the overall tone and style of your wedding to florists and other vendors. And never buy a wedding dress that is a bit small, thinking you'll diet into it.

I say all this because on this day you should look and feel your absolute best. You should not be surprised by anything, so I suggest you do a test run with your hair, jewelry, and makeup a few weeks before the ceremony. Stand in front of a mirror and ask yourself, "Is this *exactly* how I want to look?" If you're not happy, edit—alter, add, remove—until you feel 100 percent beautiful. (That said, try to avoid looking overproduced. Coco Chanel said it best when she offered advice on being well dressed: "Always take off the last thing you put on.")

The same logic applies to your groom. The happiest day of his life shouldn't find him standing stiffly at the altar in a boxy rented tuxedo, first cousin to a penguin—especially if he's really a surfer who wanted to be married on the beach. A casual couple might find it more comfortable and a whole lot more fun if the groomsmen wear khaki pants and white linen shirts, and the bride wears a white Calvin Klein–style dress with no veil, her face lightly made up to accentuate the sun's kiss. I can't say it enough: The right attire might not be what your best friend or your mother or your grandmother had in mind. But it's not their wedding.

Last but not least, as unromantic as it may sound, don't forget to consider your budget. Your dress is just one piece of the big picture. When you add up all the expenses, it's easy to find yourself spending double what you really want if you're not careful. My advice: Rather than splurging on your dress and skipping the Champagne toast, buy a dress that you can afford, look gorgeous in, and are comfortable wearing, and spend the rest of your money entertaining your friends and family with a great party. The memories will last forever.

..

SATIN-TRIMMED VEIL: The traditional sweetheart neckline looks very flattering with a capped sleeve, a fitted bodice, and a veil with turned-satin detail on the edge.

daytime or outdoor dresses

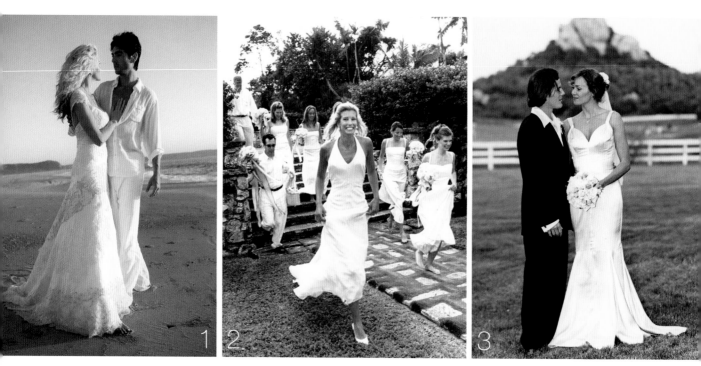

1 **DAYTIME COUTURE:**
This great dress for daytime or beach includes a lace neck, which makes it extremely feminine, as well as crystals that sparkle amazingly in the sun.

2 **HALTER NECK:** For a beach wedding, this very simple Vera Wang silk-and-chiffon dress does the trick.

3 **MERMAID:** This simple form-fitting mermaid silhouette is gorgeous for a sunset garden ceremony, and it offers a flair of vintage glamour in the spirit of retro Hollywood.

4 **ORGANZA:** The breeze brings to life the layers of organza and chiffon, making for a very dramatic entrance as the bride

walks down the aisle. A piece of vintage family jewelry is used to secure the back.

5 **PRISTINE SHEATH:** This dress by Mary McFadden is made from pleated silk with a stunning thick brocade on the neckline, creating a look that's at once pristine and elegant, and oh-so-very Grace Kelly.

6 **NUDE:** This bride chose a nude color instead of white, with multiple layers of chiffon and organza and a matching nude veil.

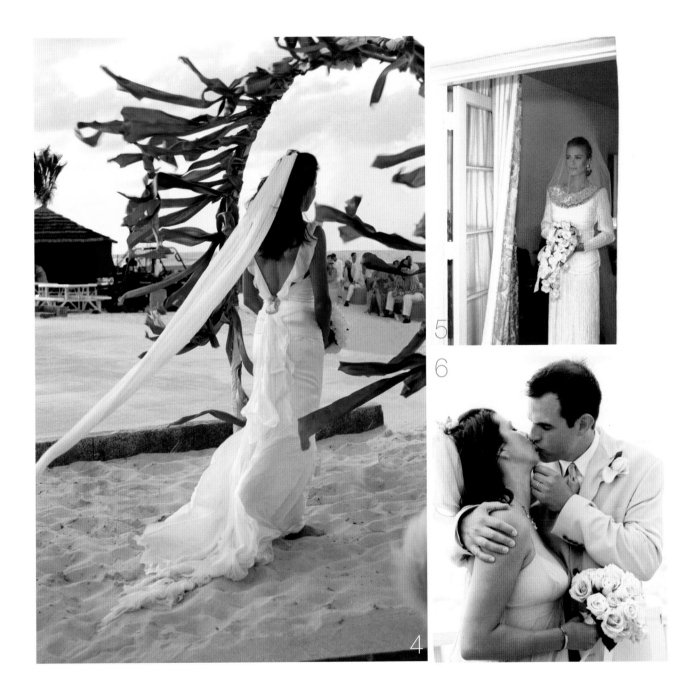

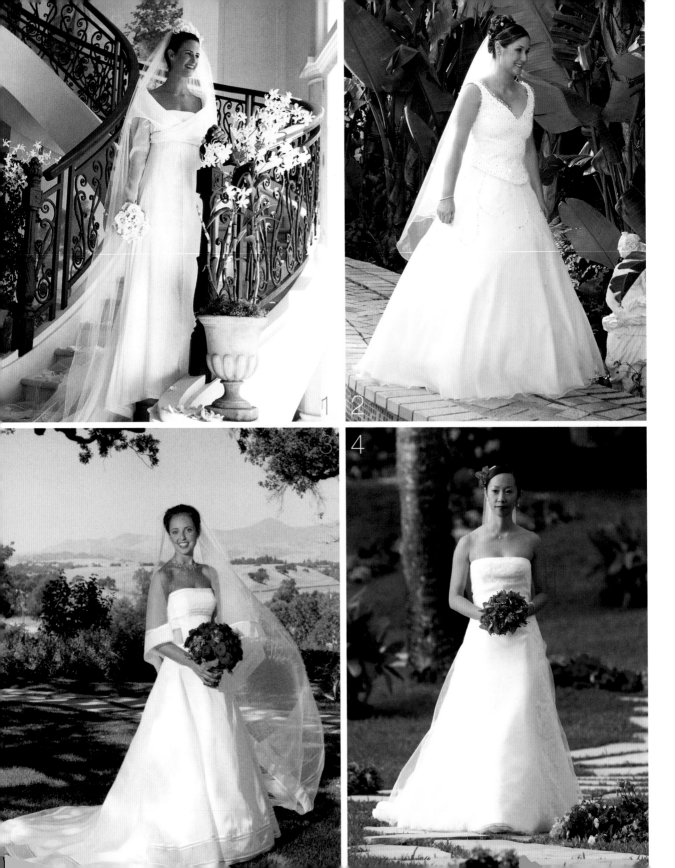

1 KIMONO: Borrowing from a Japanese idea, the bottom layer of this dress is a silk sheath that's topped with a kimono-style coat of organza. Note that this design isn't for everyone—you need to be particularly tall to pull it off.

2 BODICE: Taking into consideration the hot South African climate where this wedding took place, the dress consists of a bodice with 2,200 crystals that tops a full-length A-line skirt for the ceremony. It was swapped for a shorter, more comfortable and cooler skirt for the reception.

3 A-LINE: In an extremely simple gown like this tight-fitting A-line, the small details make a huge difference, like the matching detail at the bustline and the hem.

4 OVERLAID A-LINE: This strapless silk A-line is topped with a tulle overlay to create a dress that's romantic, young, and fresh.

5 SLIP: Ideal for a morning wedding or any daytime affair, this very simple, chic Audrey Hepburn–inspired slip is made of silk faille and is paired with a cropped veil.

5

hair and makeup

1 STRIKING SILHOUETTE: This is a very sixties-esque shape, with the bun sitting on the back of the head, but looking totally natural—as if pulling out a single pin will bring the whole thing tumbling down.

2 FINISHING TOUCHES: At the end of the day, whether it's the hairpiece or the shoes, the necklace or the earrings, or the false eyelashes, you want to make sure that the look is going to enhance you and make you happy, and not date you or be too trendy.

3 TIMELESS ELEGANCE: When it comes to makeup, I think the most important thing is to remember that the goal is to make the best of your features, not to be the trendiest.

4 CHANNELING AUDREY: This vision is very Audrey Hepburn, with the hair up in the back and a necklace fashioned like a tiara.

5 SCULPTED HAIR: Here is the most spectacular head of hair I've ever seen for a wedding, with an extraordinary silhouette of curls that have been literally carved into the hair by master Jean-Luc Minetti, then secured with pearl and diamond pins from Alexandre de Paris.

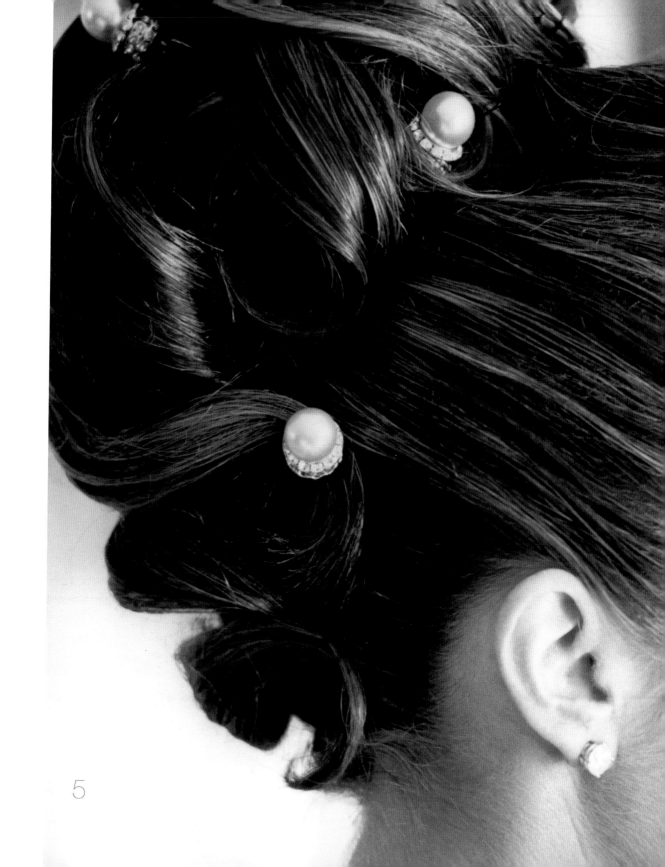

5

Marybeth

and

Sudhir

1 CHOKER: A very simple, inexpensive mother-of-pearl choker is the perfect piece of jewelry for a bride with a long neck wearing a low-neckline dress, especially when paired with beautiful pearl earrings.

2 EMERALDS: For a bride with vibrant red hair, no complement is as wonderful as a bit of green—especially in the form of fresh flowers and emerald earrings, here augmented with a drop-dead diamond necklace borrowed from her mother.

3 FOB WATCH: The bride isn't the only one at the altar who should think about jewelry; a vintage watch fob makes for an excellent gift for the groom, one he can start wearing even before the exchange of vows.

4 MATCHED SET: For him, a simple gold band; for her, white gold surrounded with channel-set diamonds.

5 MANLY BAND: This spectacular mascu-line wedding ring is centered with a large diamond.

6 CLASSIC COUPLING: The most traditional way to go is two extraordinarily simple bands. Remember, you're going to wear this for the rest of your life—choose a piece of jewelry that you'll be comfortable wearing on a daily basis.

7 CONTEMPORARY CLASSICS: The groom's ring is modern brushed platinum while the bride's is a pavéed diamond affair.

8 PINS: If you're wearing your hair up, jeweled hairpins are a good approach to accessoriz-ing and accenting your hair.

9 COLLAR: For a striking complement to a strapless dress, try a beautiful diamond-and-pearl collar. Whenever you're wearing a simple dress with a simple neckline, embrace a more ornate piece of jewelry.

bridesmaids

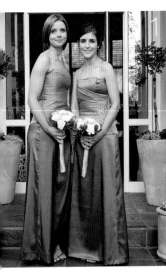

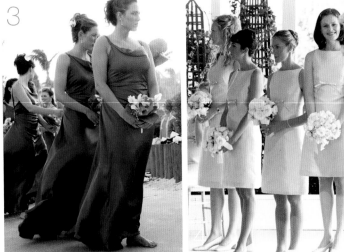

1 SETTING THE TONE: These two-toned strapless dresses in olive and moss are extremely slimming and flattering, creating great effect with color instead of detail.

2 GOLD: For an autumn wedding, the bridesmaids look perfectly autumnal in strapless sheaths in warm satins of amber and gold.

3 TEAL: For a beach wedding, the bridesmaids are all dressed in matching silk teal dresses.

4 MINT: For a morning ceremony, these bridesmaids all wear a sheath that's reminiscent of Audrey Hepburn in the 1950s, here done in a mint-green zibeline (a type of silk) with matching shoes.

5 CROCHET: To keep things casual chic at this beach wedding, the bridesmaids all wear crocheted skirts and knit tops.

6 WATERMELON AND MANGO: This palette is perfect for a summer wedding—separate tops and skirts in watermelon and mango dupioni silk, with shawls to match.

7 ECRU: Another approach to a beach wedding is the very simple, very understated echo of the sand in this ecru lace.

8 EGGPLANT: The deep-eggplant spaghetti-strapped silk sheath comes alive when placed next to the chartreuse bouquet of flowers.

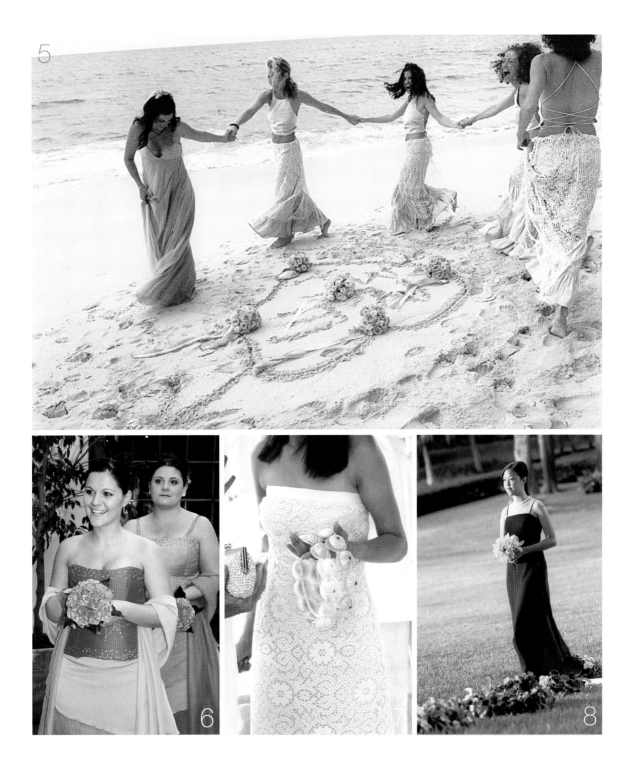

formal grooms

1 COAT AND TAILS: For the utmost formality in a daytime affair, it's coat and tails—pinstriped trousers, cutaway jacket with tails, white shirt and vest, and white necktie.

2 PERIOD LOOK: For a very romantic look, especially in the wintertime, nothing beats the wing collar worn up—that is, not folded over—with a four-in-hand necktie, a waistcoat, and a three-button jacket.

3 CRAVAT: This modern take on the nineteenth century is created with a wing collar paired with a cravat and a patterned silk vest.

4 BLACK VELVET: There's nothing quite as elegant as a rich creamy silk shirt with a creamy satin tie under a velvet coat.

5 TONE ON TONE: A trendier take on the classic black tie—and how I do formalwear, by the way— is to wear a tuxedo or black suit with a black shirt and black tie: handsome and elegant.

non-formal grooms

1 ALL WHITE: For this beach wedding, the groom and all his groomsmen wear white linen for both shirt and trousers.

2 MORNING COATS: For a daytime wedding, groomsmen always look great in formal morning attire, with pinstriped trousers and cutaway jackets.

3 COORDINATING GROOMSMEN: All the gentlemen look elegant in their matching Ermenegildo Zegna suits with a contrasting set of ties and waistcoats, creating a richly varied look for a daytime wedding.

4 NAVY SUIT, SILVER TIE: A similarly tailored look is achieved with a classic navy suit with a crisp white shirt and a satin silver tie.

5 GRAY ON GRAY: For a morning or daytime affair, this fitted gray suit looks spectacular over a light gray shirt, patterned gray tie, and finished with a gray silk pocket square.

6 BEACH CASUAL: Many weddings today are barefoot-on-the-beach casual, and here's a great choice for such a groom: a casual linen suit with a white cotton shirt.

7 NAVY SUIT, NAVY TIE: A handsome look for daytime or evening is a navy suit and matching silk tie with a pointed-collar white shirt.

8 LINEN SUIT: Ideal for a beach wedding is this off-white linen suit worn with a cool cotton blue shirt. Remember that for a beach wedding, a necktie is inappropriate.

4

6

5

7

8

children

1 **EVERY LAST DETAIL:** This young man wears the classic tux with all the accoutrements—vest, tie, even a boutonniere.

2 **THE KNICKERBOCKERS:** These two young boys make a handsome entrance wearing knee-length knickerbockers with matching vests.

3 **FORMAL FOR THE SMALL:** How formal are these two? She wears a fitted bodice with a full tulle skirt, and he wears a classic tuxedo.

4 **PERIOD LOOK:** For a romantic vision from another era, this young lady wears a dress with a cap sleeve, a dropped waist, a full skirt with a crinoline petticoat, and a series of bows down the front of the bodice.

5 **SIMPLICITY RULES:** Sometimes less is more. This girl wears an utterly simple yet beautiful cotton and organza dress with a little embroidery around the neck for a look that's fresh, clean, and elegant.

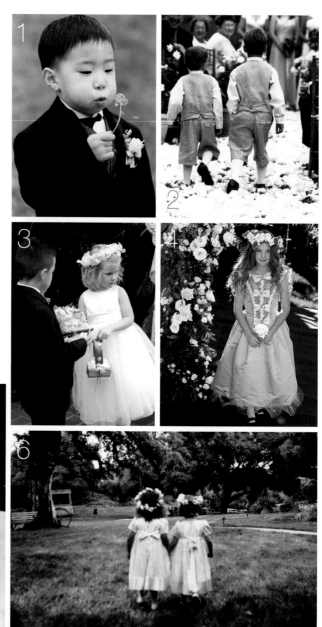

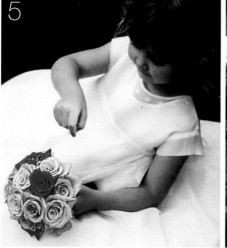

6 FLOWER GIRLS IN CHIFFON: Two little flower girls make their entrance hand in hand with satin-trimmed chiffon gowns and matching crowns of fresh flowers.

7 SEAWORTHY: For a beach wedding, this smocked dress is finished off with a crown of seashells.

8 MATCHED SET: All the junior flower girls and ringbearers look priceless in their coordinating outfits.

9 FLOWER GIRLS IN SILK: These girls look adorable in their matching full-length ecru dresses trimmed in buttery silk, carrying baskets overflowing with green orchids that match their headbands.

10 SORBET SUITE: For a wedding that showcases spring sorbet colors, all the children are decked out in three different complementary tones.

11 CONTRASTING SASH: This little girl is gorgeous in a baby-blue skirt with a huge contrasting purple sash around the waist.

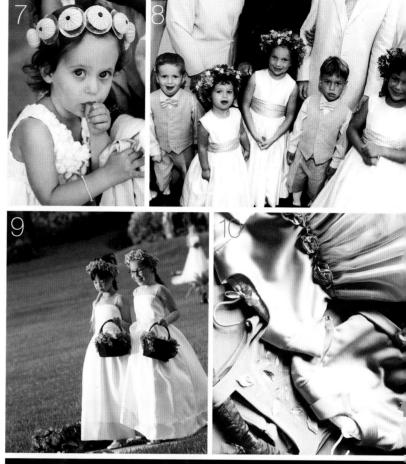

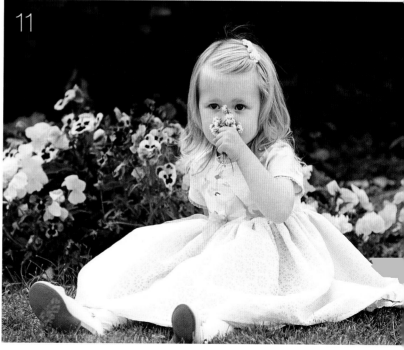

8
ritual and
ceremony

love ritual and have a deep respect for what it can do for us. Rituals add extra layers of meaning to milestones in our lives and give the people we love insight into who we are and what's important to us. They might include a family tradition passed down from generation to generation, a religious custom, or an experience from your travels that you want to share with your friends and family; no matter what its inspiration, adding ritual to the ceremony turns a collection of many individuals into a single united congregation.

Today we live in a world where the boundaries between cultures are blurred, and it's not unusual to find people of one group borrowing and blending the rituals and traditions of another—not only in wedding ceremonies, but also in life. The very idea of borrowing resonates as an openness to exploring spiritual meaning. You don't have to be Jewish to break the glass, you don't have to be Indian to walk seven times around the fire; similarly, you don't have to throw the bouquet just because your sister did (in fact, the single women over thirty among your guests might just thank you for forgoing this time-honored practice).

If you've always dreamed of being married in the glow of candlelight, then have a candle placed on everyone's seat before the ceremony; dim the lights; and just before exchanging vows, light your unity candle with your spouse, then use its

......

BRIDE AND GROOM HAND WASHING: Prior to the exchange of rings, the bride and groom wash each other's hands. The mothers come forward to dry their children's hands—for the last time before their children become true adults.

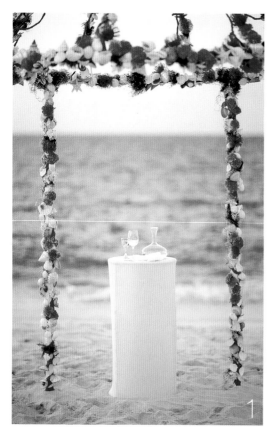

flame to illuminate the rest of the candles in the room, symbolically uniting the energy of all the guests. Imagine exchanging vows with this show of love and the glow of a hundred candles surrounding you. Ask your mother to read a passage from a favorite book, play that song you've always wanted to dance to with your father, toast your guests with a Bellini cocktail you discovered on a trip to Venice. Find a way to open a window into your souls and share with your friends and family.

More and more couples are willing—even eager—to weave different traditions into the tapestry of their celebration. The bride's father walks her down the aisle as a symbol of passing ownership to her new husband; the wedding ring indicates a couple's never-ending commitment; the shower of rose petals or rice symbolizes posterity. If it's a croquembouche you want instead of a traditional wedding cake because you love the French tradition and the irresistible stacked pastry dessert over the marzipan wedding cakes seen time and again, that's what you should have. If you've always wanted to open a magnum of Champagne with a saber just before everyone hits the dance floor, then do it with gusto. If there's a prayer or a proverb that's touched your heart, share it with your guests.

I've learned of many rituals from my dear and most respected friend, Dr. Linda Garbett, who's presided over many of the weddings that I've been a part of. She officiates with a generous, open spirit that embraces all the cultures and traditions of the world. Linda has traveled to more than a hundred countries, always seeking out the shamans, the Yogis, the holy men of every land, to explore their rites of passages, beliefs, and rituals. She's become more than just a friend; I consider her my family. She's a mentor to me, and everyone I introduce to her feels the same way.

. .

1 KIDDUSH: The Jewish ceremony's focal point is the kiddush cup from which the bride and groom drink during the service.

You can ask your longtime family priest or rabbi who's known you since you were a child, or a local justice of the peace, or perhaps the captain of a ship at your destination wedding about customs that only they might be familiar with. You might find out about the naval tradition where the bride and groom leave the wedding reception under an arch of swords raised in the air, or an old Latin prayer calling for peace on earth with a few seconds of silence and personal reflection. You may want to do something that's quite meaningful to your grandmother and raise a glass of wine in a toast to her, thanking her for being a strong support in your life.

The following are some of my friend Linda's favorite rituals. Many of the brides I've worked with have incorporated these ideas into their celebrations, personalizing them along the way. Some were borrowed from other cultures, while others we created ourselves to add importance and meaning that will be remembered forever:

- African earth ceremony: The day before the ceremony, the bride and groom each collect a cup of the local soil. At the altar, these samples of earth are kept in separate wood bowls until the bride and groom (or the officiant) merge the bowls' contents into a third bowl. This ceremony is literally grounded in the acknowledgment that we are all taking something from nature, and using it to sustain ourselves. It is simple, visual, and profound all at once; it requires that the bride and groom think about what's supporting them; and it involves them, in an elemental fashion, with their ceremony. For a variation, soil can be replaced with sand for a beach wedding, or you can substitute flower petals from roses or tulips. Flower petals are definitely a favorite of many of the brides and grooms I've worked with, and it's a lovely image when they merge the petals with their own hands while looking into each other's eyes.

- Circle of love, or eternity circle: A circle is established around the ceremony site with a garland of greens, a string, a piece of rope, or even some gorgeous ribbon. When guests arrive at the ceremony site they're invited by an usher,

2 TIBETAN BELLS: The officiant, Dr. Linda Garbett, rings Tibetan bells to call the congregation to order.

family friend, or officiant to collect some small piece of the natural world—flower petals or seashells, shining crystals or smooth stones—from bowls placed at the entrance to the aisle. Before being seated, guests carry these items to the site, and place them upon the circle, creating the sacred space for the ceremony. Since all the guests participate, they feel a part of the marriage, engendering an almost tribal sense of community; this happens before the wedding starts, thus providing a participatory and visual element while guests wait for the main event; it can be employed with virtually any size congregation. My favorite is when a heart shape is created out of greens fashioned into a garland. At the top of the aisle, each guest is given a flower, such as a gardenia blossom. They walk down the aisle and place the flower in the garland while making a wish for the bride and groom. The couple gets to exchange their vows in the collective love and energy of their family and friends.

- Handheld hearts: When guests arrive, they are invited to draw, from a designated bowl, heart-shaped crystals or stones, along with a set of printed instructions that instruct guests to hold the heart during the ceremony, to put their love and support and best wishes into this heart, and, after the ceremony, to deposit the hearts in a box, for the bride and groom to keep. In this way, guests become even more emotionally vested in the ceremony—they are putting their own hearts, their love and wishes and energy, into these symbolic hearts.

- Love banners, or goodwill banners: With the invitations or confirmation package, guests receive a piece of ribbon or fabric, two or three feet long. They're requested to inscribe it with personal words, a wish, a blessing, a poem, a quote, a memory, or anything about the couple they'd like to share. The guests are instructed to bring these ribbons or streamers to the ceremony, where they are hung from an arch erected at the head of the aisle, at the altar, or even strung down aisle stanchions by the bridesmaids. The intention is for the couple to be

1 FLORAL GARLAND: For this beach ceremony, guests pick gardenia blossoms from baskets, carry the flowers down the aisle, and use the gardenias to decorate the garland of simple greens that surrounds the ceremony site.

married surrounded by the love and good wishes of their guests and the positive energy of the congregation. Have extra ribbon and a suitable writing pen available at the guest arrival area, just in case the forgetful guest accidentally left her wishes at home.

- **Infinity beads:** This string of beads—or crystals, or beach glass, or shells—is traditionally about six feet long, and can be custom made in colors or a style to match the décor of the ceremony, as well as inscribed with the name of the bride and groom and any other details. The beads might be used in any number of fashions, but a typical scenario is that during the ceremony, right before the exchange of vows, the best man, parents, maid of honor, or someone from the wedding party drapes the beads around the bride's and groom's shoulders in the infinity shape (a figure eight), signifying that their union is now and forever. These beads could also be placed on the bridal table during the reception as part of the table décor. After the celebration, the beads become a keepsake to be placed in a box and taken out again at anniversaries, or whenever the married couple wants to draw upon the support of their friends, their family, and the blessing of their union. I've often seen the beads left on a coffee table as an objet d'art, or placed lovingly in a glass box on a bedside table.

- **Unity candle:** During this simple, ever-popular Catholic ritual, the bride and groom usually hold individual candles, with which they simultaneously light the bigger unity candle. Involving elemental fire, this custom emphasizes simultaneous effort, commitment, and of course the symbolic importance of unity in the marriage.

- **Guests' hand washing:** Hand washing is a very important part of many African cultures' rituals, and it's a symbolic gesture in which all guests can

2 PERSONALIZED INFINITY BEADS: These custom-made beads showcase the colors of the wedding and are further personalized with the names of the bride and groom engraved on the heart.

participate. Brides and grooms may place a beautiful silver bowl and crisp linen towels at the entrance to the ceremony area, accompanied by a sign that invites, "Please be a part of our ceremony with this symbolic hand washing." Through it, the guests announce that they are here to participate with love, that all things are new and fresh, that they recognize the wedding as a beginning.

- Parents' hand washing: If this ritual doesn't bring a tear to your eye, nothing will. The father of the bride pours blessed, lavender-scented water from a silver pitcher into an organic wooden bowl or other decorative container; first the bride washes her hands, which her mother then dries with a soft linen cloth. The groom and his parents repeat the same steps. These are the parents' final moments of being mother and father, offering a final cleansing to their children, before they move through the rite of passage into true, permanent, irrevocable adulthood.

- The story of life and love: To hear the love story of how the bride and groom met, and the feelings and wishes of the couple's friends, is one of my favorite rituals. Along with the invitation, guests receive a note card requesting that each of them write something about the couple they'd like to share. It can be an experience, an anecdote, a toast, anything. The cards are then returned along with the RSVP and placed in a box for the bride and groom to open on their wedding day or saved to be read in privacy. It's fun to see a groomsman reach into the box, pull out a card, and read it aloud as a toast during the reception.

- Toasts: This ritual is often what people remember most, because when toasts are done well, they can illuminate the love the bride and groom share and introduce them to friends and family who might not know each other as well. Of course, sometimes toasts are memorable for other reasons (usually involving groomsmen with too much alcohol and too little sense of decorum), so it often helps to have your master of ceremony or groom or father-in-law ask those who will raise a glass to remember that toasts are meant to focus on the great attributes of the bride and groom—not their great ability to do something funny in college that's best left unremembered. And it's certainly not a time to make jokes and poke fun at the bride and groom or their past loves—it's a toast to the happy couple, *not* a roast. Toasts should avoid inside jokes—nothing makes guests feel less welcome than to be left out. And nothing makes guests feel

more tired than someone who details every event in the couples' courtship. A warm, amusing three-minute story that sums up their couplehood and wishes them well is all anybody wants to hear—and that's more than enough time to say what needs to be said.

If chosen with care, adapted to be personal to the couple, and elegantly performed, rituals add a new dimension to the meaning of the day, and one that people will remember for years.

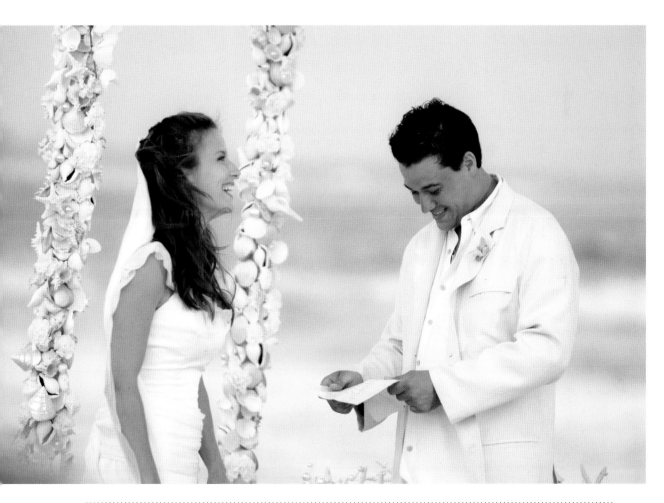

EXCHANGE OF VOWS: Rather than using textbook vows, I suggest that the bride and groom write their own, to declare their love for each other directly from their hearts.

1 CALL-TO-ORDER BELLS: The crisp sound of these traditional Tibetan bells calls the ceremony to order.

2 SITE PURIFICATION: Moments before the first guests' arrival, the officiant—in this case, my friend Dr. Linda Garbett—uses sage to purify the ceremony site, an age-old ritual.

3 GUESTS' HAND WASHING: When guests arrive at the site, they are asked to wash their hands in a gleaming silver bowl, a purification rite in preparation for the ceremony.

4 SWEEP OUT THE OLD: An important ritual in the African American tradition, particularly during slavery, was called "jumping the broom," a practice carried over from West Africa. The broom would be held over the bride and groom during the ceremony, and at the end the couple would literally jump over it. A related and less strenuous ritual that we use today is to employ the broom to sweep away the old, sweep in the new.

5 INFINITY BEADS: These beads are hung around the bride and groom in the shape of an infinity symbol, uniting the bride and groom forever during their exchange of vows.

6 CELEBRATORY BELL RINGING: These bells are for all the children in this wedding party to form a sonorous conga line, leading the congregation to the ceremony site as a group.

7 CEREMONIAL BOWL: At this beachside ceremony, a shell bowl is used for the hand washing.

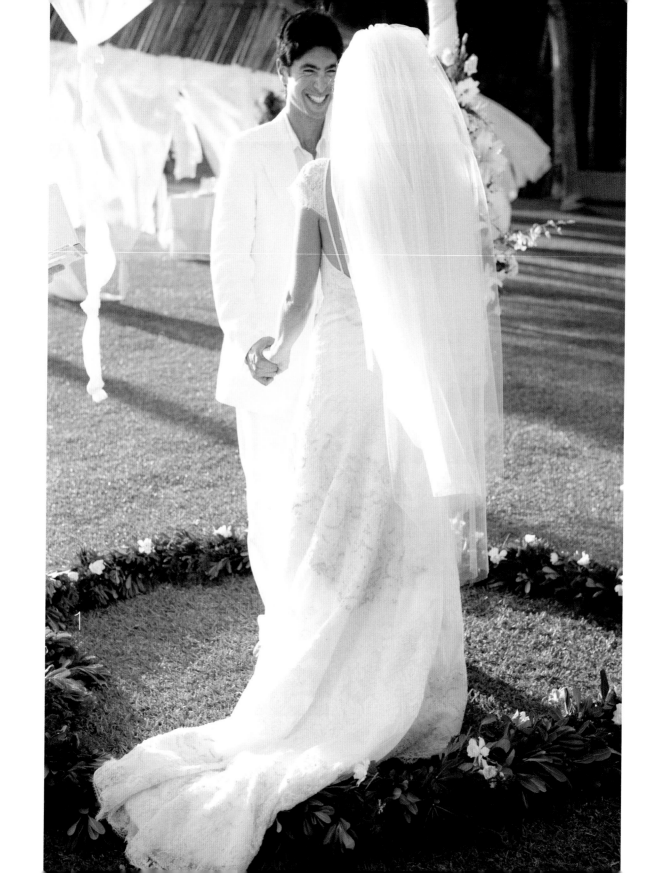

2

3

4

1 HEARTFELT HEART: The bride and groom exchange their vows while standing in the middle of a garland fashioned in the shape of a heart. Each gardenia blossom was placed by a guest, who at the same time made a wish for the couple; therefore, the bride and groom are connected by the collective love and good wishes of all their assembled family and friends.

2 NEW FAMILY: For this second-time-around marriage, with two children from the bride and one from the groom, the five of them tie together a garland, then walk down to the sea to release the flowers as a family unit.

3 CANDLELIGHTING: At the improvised altar for this wedding, the candles are readied for a lighting ceremony beside a pair of silver kiddush cups for drinking the wine.

4 LIGHTING THE UNITY CANDLE: Bride and groom simultaneously light the unity candle, combining their efforts, love, and energy as one.

9
food and drink

Think of your dinner as a night of theater. The lights dim, your guests are seated; the curtain rises, your first course appears. The story unfolds; the wineglasses are refilled as laughter carries around the table. The audience is completely enchanted, and your guests can't wait to see what happens next.

As you plan each course, whether it's smoked salmon with capers to start, followed by a selection of grilled chicken or barbecued local fish with crispy roasted potatoes, always bear in mind that the color, flavor, temperature, texture, and taste of each course should be well balanced and part of a big picture. You can make even the simplest grilled meat and basic potato exciting with colorful vegetables and the right garnish on the right plate, paired with an appropriate wine. Remember, you first taste with your eyes, so every course should be as visually appealing as possible. A bowl of grayish-brown mushroom soup isn't particularly attractive; but add a teaspoon of yogurt or crème fraîche and garnish with a generous sprinkling of chopped chives, and you've taken the dish from drab to fab in an instant. A green salad with toasted pecans, a slice of Bosc pear, and a crumble of rich Stilton cheese accompanied by a crispy slice of grilled flatbread is simple yet infinitely more inviting than a bowl of plain greens with julienned vegetables. Even side dishes should play a part in lending a bit of drama, adding color and texture to the meal, and making the plate visually appealing.

..

FRESH OJ: For a morning wedding, greet your guests by serving tall glasses of chilled fresh-squeezed orange juice garnished with fragrant spearmint leaves.

sauces and their attendant risks of splattering, dripping, and double-dipping. Skip the forks, knives, and plates during this time, unless a buffet is set. (By the way, I'm a big proponent of small stations of food paired with appropriate beverages: caviar with chilled vodka, smoked salmon with frozen aquavit, artisanal cheeses with vintage port, home-cured charcuterie with fine wines, crudités of fresh garden vegetables with a blue cheese sauce and a crisp chardonnay.) If you do feature stations, I suggest placing several small tables and chairs and stand-up cocktail tables around the room so guests can eat comfortably and elegantly.

Another good strategy is to remember that your food will be prepared by a team of professionals trying to do their best, so consider the strains that the real kitchen might face, and plan accordingly. Try to choose a first course that can be served ten minutes late or a few minutes early, without any difference in quality. Consider interspersing hot courses with cold ones to give the kitchen some leeway and preparation time working in makeshift kitchens or banquet spaces. Despite all the planning, a wedding schedule doesn't always hold to the exact minute—unforeseen circumstances can move it up or push it back. Don't serve soufflés or pan-seared foie gras for the appetizer unless you have a large number of staff hired (one waiter per every ten guests is the norm; foods that require a last-minute preparation and serving require more, about one person ready to tend per every six to eight guests!). To make it as easy as possible, look for something with strong visual appeal but an easy preparation. There's very little chance of anything going wrong with a chilled soup or a crunchy salad. And for your main course, I've found that instead of offering a choice of beef, chicken, or fish to everyone, you can choose one dish and have your caterer prepare an alternative for the 10 to 15 percent of your guests who, having seen the informative printed menu, will request an alternative. No one should go hungry because of dietary restrictions, but offer-

1 OYSTERS IN SALT: The bed of salt prevents the shells from tipping or slipping when carried by a waiter for tray-passing; it's vital to completely separate the oysters from their shells, so they can slide directly into the mouth without a fork.

ing an option to everyone will increase your costs and will tax the kitchen, resulting in slow service and lag time between when various guests are served, even at the same table. And don't forget the vegetarians—there are always a few in every group (which is why you might want to make your alternate dish one that's meatless).

Regardless of your preferred type of cuisine, remember that the white-gloved, seated, four-course dinner, complete with silver candelabras and French service, isn't your only option. Today we've embraced a much more casual style, and it permeates every aspect of life, including wedding dinners. If you dread setting foot in formal restaurants, and prefer spending Saturday nights eating family-style dinners at home, then serve family-style at your wedding as well. You sacrifice absolutely no chicness points by offering golden roast chickens paired with crispy rosemary roast potatoes and grilled summer vegetables on platters placed down the center of long banquet tables surrounded by spirited friends bathed in candlelight. Who can resist large, rustic bowls of handmade pastas or bountiful platters of chilled seafood with spicy cocktail sauce followed

by chilled lavender-scented hand towels for quick clean-up afterward? And nothing says you can't mix and match your service styles. Feel free to have waiters plate your first course in the kitchen and then serve your second course family-style at the table followed by a dessert buffet. How about setting a beautiful buffet with guests casually seated at smaller tables or even on lounge-style furniture instead of the more typical rounds?

With your full menu in hand, be sure to arrange for a complete prewedding tasting to ensure that everything is exactly as you intended, and that what you planned can indeed be executed as you wish; this tasting is well worth the cost. Bring along your fiancé, your mother, and his. Too stressful? You and your fiancé, the best man, and a friend whose culinary taste you respect will do. Don't forget a

2 GRILLED LEG OF LAMB: This boned, butterflied, and marinated leg of lamb is grilled to a perfect medium-rare and served with lemon wedges, arugula salad, and crispy roast potatoes.

pen and paper and camera, so you can document and take detailed notes of what you like and what you don't. If the vegetables should be elegantly sliced and instead are cut into large chunks, if they're too salty and their consistency is on the mushy side, take note. If the potatoes aren't crispy or they're mashed with twelve pounds of butter, make note. If the salad looks better on a dinner plate than a salad plate, make note. If the meat is well done when it should be served medium rare, don't just shrug your shoulders and hope for the best. Ask the chef to do it again, and again and again, until you're 100 percent happy, and you and the chef are in agreement. He is as eager to make you happy (or should be!) as you are to make sure your guests have the best dinner possible. If the food seems complicated, and the tasting for four isn't working well, I guarantee that it won't get better when you have more than a hundred friends waiting for their dinners. This is an indication to edit and continue to do so until you come to a place that gives you confidence.

When requesting adjustments, remember that how you criticize is just as important as what you say. Convey your concern with kind words and the right attitude, and the problem will be fixed. Don't pander; everyone likes to please, and of course everyone loves praise, but only when it is sincere. And whatever you do, don't throw a tantrum—turning your chef into an adversary is not a smart idea. Ideally, start with the things you most appreciate: the flavor of the sauce, the size of the serving, the temperature of the meat. Then begin discussing what you'd like improved. Demanding corrections won't get you anywhere. Instead, broach the mistakes or your expectations in a way that motivates your team—in this case, the kitchen staff—to improve because they're proud of their work, they respect your attention to detail, and they'll actually want to make the best meal they can for you. If it's simply a salad dressing that's too tart, you can ask the chef to rejigger the proportions right there. But if the changes are significant, I recommend setting up another tasting to ensure that everyone ends up on the same page. I understand that might be difficult to arrange, but the alternative is that your chef might not understand what you want. If all else fails, and after the second or third tasting the results are still not what you want, change the menu. Or your caterer.

SUMMER: Nothing is as refreshing as the ideal summer salad of peppery arugula tossed with juicy watermelon and fresh feta cheese, with a sunflower-seed garnish providing a hint of crunch.

What's being served and how it's served are of equal importance. If at all possible, have a sample table set with linens, glasses and plates, and flowers. At the very least be sure to have the dishes being used at your reception or a few choices of china patterns at the tasting, so you can see how your finished dishes pair with the plates. You may need to move the food from plate to plate, right there on the spot, to find the best visual combination. The tasting also provides the right moment to confirm the service plan for the event with your party planner or banqueting manager. Find out exactly how many runners, busboys, captains,

1 SQUASH AND LOBSTER: Perhaps the perfect cold-weather soup, hearty winter squash with luscious lobster medallions makes for a very impressive first course.

bartenders, and sommeliers will be doing what, when, and where. Even if the world's finest chef prepares a spectacular feast according to your exact specifications, and the china and crystal and linens are exquisite, if the service isn't up to snuff, your guests won't be happy and all the chef's hard work will go unnoticed. You may not know how to judge whether the service plan is sufficient; but the mere exercise of asking to have the plan put on paper will mean that the professionals have given it some real thought. Again, estimated needs are one waiter for every ten guests at a seated dinner, and busboys and barmen are additional.

If possible, choose your beverages—the cocktails for the cocktail party and dance receptions, and the wines for dinner—in advance of this tasting, so you can include them as well. Cocktails have made a huge and extremely welcome comeback, and mixologists are receiving well-deserved celebrity status. There's a whole world of options out there beyond the vodka and tonic served in a highball glass, and a skilled bartender can craft a cocktail to serve before dinner, during the meal, or at your dance party. Consider a glamorous Martini, a menu of four or five exquisitely crafted specialty cocktails, coffee- or espresso-based drinks to fuel the dance party and lend an air of sophistication, and sexy shooters for tray-passing to guests who are partying the night away. Perhaps each cocktail is named after a bridesmaid or groomsman. Again, even if your venue offers only limited options for an open bar, you're not condemned to a night of basics. Speak to the venue staff about offering perhaps one special cocktail, for which you have the recipe in your tear sheets. Even tried-and-true Manhattans and screwdrivers are a welcome offering when passed on trays so guests can help themselves. Investigate whether they'd let you bring in your own glassware (as I mention in Chapter 4, there are many inexpensive options available) or a special garnish. Presentation can make all the difference and turn something simple and basic into something extraordinary.

As for the wine, discuss your style preferences with your caterer, then be sure to taste the array of options, bearing in mind that incredible wines abound at very reasonable prices from around the world, especially from what the wine industry calls the New World: the Americas, South Africa, Chile, Australia, and New Zealand (that is, everywhere that's not Europe). An inexpensive Lebanese Shiraz

..

2 TUNA TARTARE: This sumptuous raw tuna is served over a molded brunois of vegetables, resting on a bed of paper-thin cucumber slices.

can prove just as tasty and well paired with a spicy rack of lamb as a much pricier first-growth Bordeaux. For every course, try to taste two or three wines from different regions and price points to ensure that you're making the best pairing you can, without spending unnecessary money.

Spending *necessary* money, on the other hand, is another matter. For the cocktail reception, Champagne is synonymous with weddings. I like to serve from the largest-format bottle I can find, to add some drama. Bottle sizes range from the relatively common magnum (1.5 liters, the equivalent of two regular wine bottles) to the jeroboam (3 liters) all the way up through such outrageous sizes as the balthazar (12 liters) or the hypertrophied nebuchadnezzar, which, at 15 liters, is the equivalent of twenty bottles—very possibly requiring all your groomsmen lending a hand to pour! For even more drama, nothing beats the sword: After the bride and groom are pronounced husband and wife, have the bartender use a ceremonial saber to pop the cork off that first celebratory bottle, kick-starting the party with a bona fide bang.

If Champagne isn't in your budget, serve a sparkling wine. Add a splash of cranberry juice or pomegranate juice for a dose of elegance. A dash of crème de cassis in your sparkling wine makes a Kir Royale. A sugar cube at the bottom of the glass with a dash of Cognac creates a lovely Champagne cocktail. Consider rimming the glass with caramel or sugar for an extra touch that's sure to be noticed. There are many ways to dress up a sparkling wine and make it über-chic. And of course, failing that, serve your favorite cocktail.

Cheers, and let the reception begin!

..

SET THE STAGE: There's nothing quite as impressive as a sterling silver bucket filled with a dozen bottles of Cristal, set on a tablecloth fashioned from moss woven with cymbidiums and chrysanthemums.

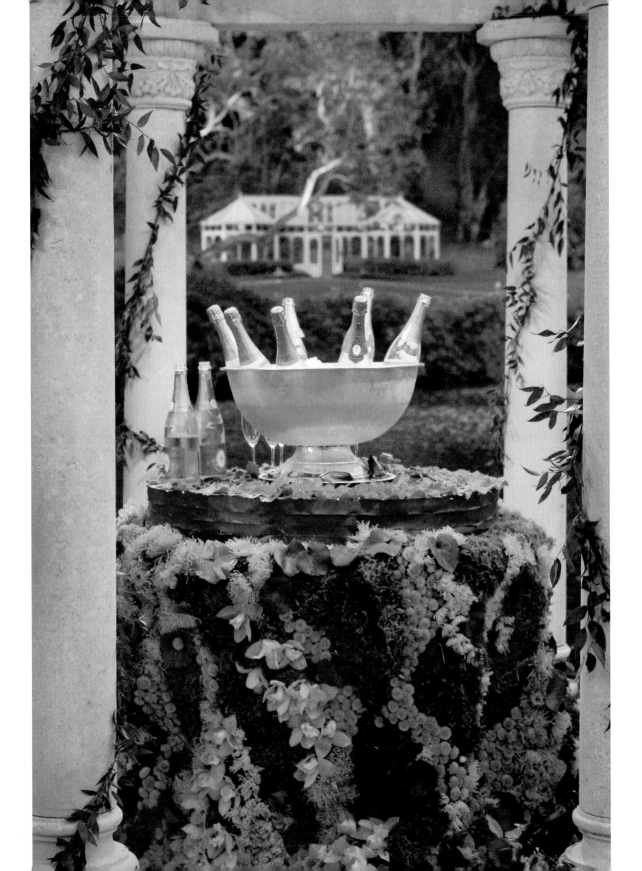

coolers and quenchers

1 FRESH OJ: For a morning wedding, greet your guests by serving a tall glass of chilled fresh-squeezed orange juice.

2 NONALCOHOLIC COCKTAILS: Serving alcohol before the ceremony is risky—that type of pregaming rarely ends well—but that doesn't mean you can't serve delicious cocktails. These iced tumblers are filled with passion-fruit juice topped up with club soda and garnished with fresh mint.

3 ADES AND CRUSHES: In a hot climate, serve guests something cooling as soon as they arrive. A refreshing nonalcoholic lemonade or orange crush is especially welcome when served with metallic-blue specialty straws.

4 BRUNCH OPTIONS: The classic prenoon pick-me-ups—Bloody Mary, Gin Fizz, and Mimosa—are all great options for daytime weddings and, of course, are naturals for the morning-after brunch.

5 BEAUTIFUL BELLINIS: For a truly sophisticated cocktail that's light, refreshing, and ideal for morning consumption, nothing holds a candle to a Peach Bellini (Prosecco with peach puree) garnished with a fresh slice of white peach.

6 FRUIT SALAD: This brightly garnished mixed-juice combination—cranberry, orange, and carrot—offers an original way to start a morning party.

7 BIG BATCH: For a down-home country wedding, large pitchers filled with lemonade and iced tea ensure that all the guests stay hydrated.

champagne

1 KIR ROYALES: A fabulous twist on straight Champagne is this variation on the Kir Royale, made with a dash of Chambord (instead of the traditional crème de cassis), sparkling wine, and a strawberry slice for garnish.

2 THE DOM ON ICE: Whenever I use an ice sculpture, I like to make it as practical and functional as possible, such as this bowl that's custom designed to chill a case of Dom Pérignon.

3 THE WIDOW ON ICE: This 1940s-inspired sculpture holds three magnums of the Champagne called La Grande Dame, made by Veuve Clicquot ("the Widow Clicquot").

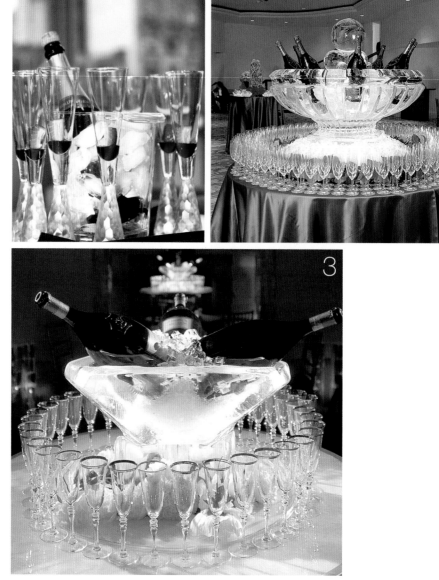

4 FRENCH PYRAMID: Moments before the cocktail reception begins, a giant double magnum of Champagne sits beside a classic French pyramid constructed with the old-style Champagne glass called the Marie Antoinette, whose cup was designed in the shape of the infamous queen's breast.

5 OVERSIZE BOTTLES: While the standard Champagne bottle, like the standard wine bottle, is 750 milliliters, sometimes it's worth seeking out larger sizes such as the magnum, which holds the equivalent of two regular bottles.

6 PEDESTAL BOWL: What better way to kick off a glamorous party than by displaying a silver punch bowl filled with bottles of Champagne?

7 THE SABER: Care to dazzle your guests? Open the first bottle of Champagne with a saber! Just run the blade down the seam of the bottle at a forty-five-degree angle to the neck, popping the cork off with a flourish. This is not child's play. The person who's going to attempt this should practice on a bottle or two of Château de Plonk before bringing out the good stuff.

8 CHAMPAGNE IN WAITING: To lead the guests from the ceremony site to the cocktail reception, a series of equally spaced waiters stand with silver trays showcasing fruits and bottles of Dom Perignon.

cocktails

1 CLASSIC COSMOPOLITANS: A tray of sexy blush-colored Cosmos is a gorgeous way to jump-start your reception.

2 GREEN GLASSES: If you can dream it, today's rental market can make it happen, so don't limit yourself to clear glass if your tastes run to something more colorful. These chic glasses are terrific for a Sour-Apple Martini.

3 GREEN GODDESS: This cucumber martini called the Green Goddess, delicately flavored with elderflower essence, is a sublimely refreshing cocktail for a summer wedding.

4 CAIPIROSHKA: For a heartier cocktail, try this variation made with vodka, lime juice, lychees, and ginger. Note the round ice balls and ice fingers.

5 LAYERED DRINKS: This expertly poured layered cocktail takes a long time to prepare, but its showstopping look makes it worth the wait.

6 FUN FUEL: To keep the party jumping, alcohol and caffeine make a high-power combination, and these espresso-based cocktails will keep the revelers on their toes.

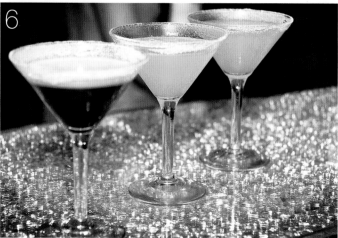

shooters

7 **LUCITE TRAYS:** Clear-plastic trays provide another stylish way to hold test-tube shooters. These would be straight out of tenth-grade biology if it weren't for their very adult contents: the pick-me-up called Strepe Chepe, made from vodka, lime, and mint.

8 **TEST TUBE, BABY:** Each of these ultramodern test tubes holds a chocolate-tequila shooter inside, and the outside is tied with a silk ribbon printed with a fond wish.

9 **HIGH-SPEED PIT STOP:** To keep up the energy of a party, I like to have trays of shooters brought out to the dance floor. The dancers get a nice kick without needing to wait at the bar, or hold a glass, or keep track of their drink—instead, just a quick shot without missing a beat.

caviar

1 BACCHANALIAN BUFFET: If you really want to make a fabulous impression, and money is no object—none whatsoever—the way to go is caviar served by the pound alongside the traditional accoutrements: chopped egg whites, chopped egg yolks, crème fraîche, chives, lemon wedges, and blinis.

2 HELP YOURSELF: If your pockets happen to be particularly deep, the best way to serve caviar is in a gigantic glass bowl nestled in a bed of ice, with all the proper accoutrements—paper-thin melba toast, gauze-covered lemon wedges, and exquisite serving pieces everywhere.

3 AMUSE MA BOUCHE: One of my favorite amuse-bouches is this smashed potato topped with a little crème fraîche and Osetra caviar—the ideal first bite of a meal, if you ask me.

4 HOT POTATO: These baby potatoes are deep-fried until crispy on the outside and melting within, split in half, then topped with a dollop each of Osetra caviar and crème fraîche and finished with a snipped-chive garnish.

5 À LA RUSSE: In the tradition of imperial Russia, every mother-of-pearl spoon of beluga is paired with a shot of chilled premium vodka; and in the tradition of Colin Cowie, the spoons rest in a tray of clear-glass marbles.

6 TRÈS CHIC TRAY: On crisp white linen, baby potatoes with caviar and crème fraîche alternate with stuffed zucchini trumpets to create a colorful, elegant, and totally sumptuous presentation.

7 UNTOLD RICHES: Cubes of well-chilled foie gras topped with dollops of beluga—it doesn't get more decadent than that!

8 FORGET PEANUT BUTTER AND JELLY: One-bite sandwiches made of white bread and caviar, with a colorful micro green garnish. How very sophisticated.

9 BEGGARS' PURSES: Little crepes are filled with caviar and crème fraîche, and a blanched chive ties the whole bundle together. For added glamour, top the purses with a bit of edible gold leaf.

10 PURITY: Here's proof of the time-tested approach to cookery. Get the best ingredients you can find, and do as little to them as possible—like taking caviar and doing nothing to it except putting it in spoons.

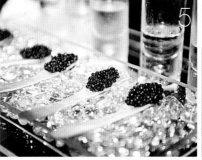

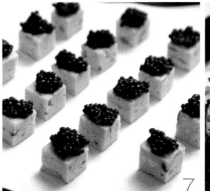

meat starters

1 **NATURAL LAMB STICKS:** Nature always provides, and a Frenched lamb chop—with all the meat cut away from the end of the bone—acts as a marvelous handle for the meltingly tender meat. Obviously this is intended for a more casual or rustic affair.

2 **MINI KEBABS:** I happen to believe that anything grilled is delicious, and that's particularly true for lamb, here in the form of bite-size kebabs and a mint-yogurt dipping sauce.

3 **SKEWERS AND STICKS:** Grape skewers complement prosciutto wrapped around one-inch lengths of crunchy breadsticks.

4 OYSTERS IN A CLAM: At the top of everyone's list of aphrodisiacs is the raw oyster, here served on a large metal clamshell and passed with cocktail forks for spill-free consumption.

5 SHOT GLASS: A novel way to present shrimp—and to avoid communal double-dipping—is to serve the shrimp hanging inside a shot glass that's filled with a teaspoon of cocktail sauce. This allows guests to double-dip—or triple-dip, for that matter—without offending anyone.

6 SPICY SKEWERS: These prawns are marinated with the spicy Mozambique-made chili sauce called "peri-peri," and speared on bamboo skewers for a very elegant presentation of a rustic dish.

7 SILKY SALMON: This is the center cut of a home-cured side of wild salmon, served on bamboo skewers and passed on a black tray for powerful contrast.

spoons and lollipops

1 SEARED TUNA IN A SPOON: A novel way to present food such as this seared tuna with wasabi cream and seaweed salad is in a Chinese spoon.

2 TARTARE IN A SPOON: This unconventionally spicy tuna tartare accompanied by a very fine tequila is served in spoons that rest in a bed of clear glass marbles.

3 LOBSTER LOLLIPOPS: These luxurious lollipops are constructed from poached lobster lightly brushed with vinaigrette and threaded onto cocktail forks.

4 TUILLE CONE: A lovely way to serve a tuna tartare is this clever takeoff on the ice-cream cone. Small sesame-tuille cones are stuffed with the tartare and a spray of mustard greens. A custom-made wooden block holds the cones upright.

5 PASTRY SHELLS: What's most important at a cocktail party is that the passed hors d'oeuvres be bite-size—like these small savory pastries—allowing guests to get all the flavors without any risk of breaking or spilling.

6 PRIMI POPS: Here we reinvent the traditional Italian *primi* (first-course) preparation of creamy mascarpone cheese with fruit, by stuffing dates, prunes, and apricots with the cheese and presenting them as luscious lollipops.

soup

1 TALL SOUP: You don't come across towering soup all that often, which makes this preparation particularly memorable—a spicy broth garnished with a pyramid made from a pair of langoustines.

2 SQUASH AND LOBSTER: Perhaps the perfect cold-weather soup, hearty winter squash with luscious lobster medallions makes for a very impressive first course.

3 GAZPACHO: To serve the classic Spanish tomato-based cold vegetable soup—an ideal first course in hot weather—it's fun to pour tableside from a glass carafe.

4 DEMITASSE: A novel way to offer soup at a cocktail reception—or even as a seated first course—is in an espresso demitasse, to be sipped if there are no solids (such as for a bisque) or accompanied by a demitasse spoon if there are.

starters

5 **SPRING:** Watercress nestles inside a handful of endive spears, secured with a blanched leek.

6 **ICE-MOLD BOWLS:** Ideal for a summer wedding, and sure to make a fantastic first impression, these ice-molded bowls are a great way to serve a decadent crab salad.

7 **WINTER:** The wonderfully strong flavors of bitter radicchio paired with pungent herbs, sliced Stilton, and a crispy potato chip will warm you right up.

8 **RED, WHITE, AND GREEN:** Homemade mozzarella is topped with a couple of microgreens and sits on a thick slice of beefsteak tomato—simple, tasty, and elegant.

9 **STEAMERS:** Bamboo steamer boxes are presented for the first course of grouper for an Asia-themed wedding.

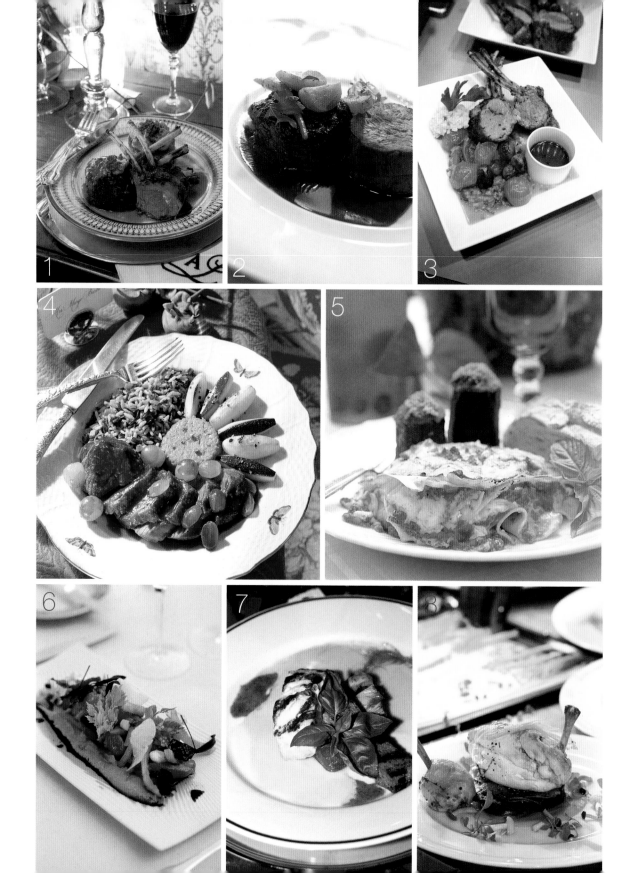

main courses

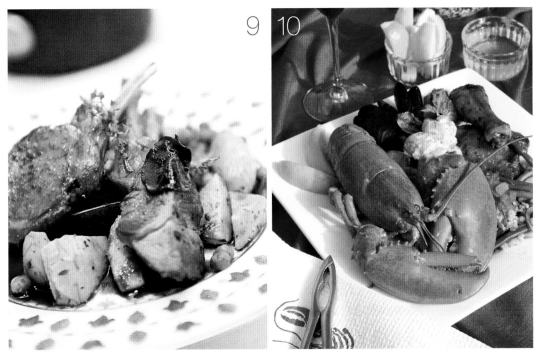

1 **DOUBLE-CUT LAMB CHOPS:** Probably the most popular of the red meats for a wedding, particularly in the summer, these double-cut lamb chops are cooked to pink perfection.

2 **CHATEAUBRIAND:** One slice rests sunny side up, the other down, in a pool of light bordelaise sauce, showered with roasted baby vegetables.

3 **CHOPS WITH SAUCE ON THE SIDE:** Two sets of double-cut lamb chops are sauced with a ramekin of tomato-thyme bordelaise and paired with caramelized onions and cherry tomatoes.

4 **LOIN OF VEAL:** A grape sauce, wild rice, and a carrot timbale enhance this incredibly tender cut, as do roast zucchini and potatoes.

5 **LASAGNA:** For a Tuscan-style lunch, this feather-light tomato lasagna is coupled with veal-stuffed zucchini.

6 **BRANZINO:** The whole Mediterranean fish is filleted, and served with a puree of carrot and a mélange of herbed spring and summer vegetables.

7 **JOHN DORY:** This summery presentation is John Dory in a light Champagne sauce with a drizzle of pesto, fresh basil sprigs, and fresh tomatoes.

8 **PHEASANT BREAST:** The elegant game bird is served on an equally elegant mille-feuille of sautéed spinach, fried potato, and an earthy assortment of wild mushrooms.

9 **RUSTIC:** These chops are given a Provençal treatment with roast potatoes, artichokes, *petits pois,* and caramelized onions.

10 **CLAMBAKE:** For a casual supper, nothing beats the classic New England clambake featuring steamed lobster and mussels with lemon wedges, melted butter, and all the fixings.

stations

1 HAM IT UP: To inject an element of personal service into the cocktail-hour food, it's a nice touch to have a carving station, where an expert butcher slices paper-thin prosciutto for each guest.

2 TUSCAN BUFFET: This groaning board is reminiscent of a Renaissance feast, with charcuterie and melon, vitello tonnato (veal in cold tuna sauce) and caponata, bruschetta and shards of the king of all cheeses, Parmigiano-Reggiano.

3 FROMAGERIE: The cheese buffet is anchored on either side by obelisks made from Schiaparelli-pink roses with collars of maidenhair fern arranged in Japanese cachepots.

4 TOWERING TREAT: Who said shrimp don't grow on trees? Here a polystyrene cone is covered in foil paper, and then the shrimp are attached using toothpicks. Silver Revere bowls of dipping sauces ring the structure.

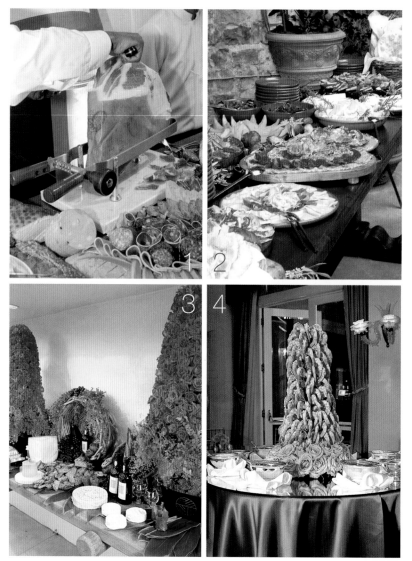

casual plates

5

6 7

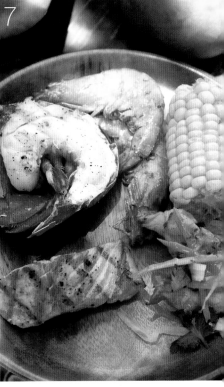

5 INTERNATIONAL BISTRO: An excellent way to serve a casual supper that's sure to appeal to all your guests is to present an international menu, allowing everyone to choose their style of cuisine and scatter to casual seating in a loungelike picnic atmosphere. Include options such as, respectively, a Japanese platter featuring miso soup, edamame, and an assortment of sushi, sashimi, and cooked fish; the French brasserie combination of steak frites, with the french fries wrapped in a napkin and presented in a glass tumbler, accompanied by bitter greens with crispy leeks; or, for a vegetarian option, the classic Italian dishes of hand-made cheese ravioli in light pea sauce served with a simple salad and a wedge of grilled polenta.

6 LAP DANCE: For easy al fresco dining, these large baskets can be comfortably placed on your lap or set on a table. Here they hold grilled prawns and grilled fish with a fresh, lightly dressed salad.

7 GRILLED SEAFOOD: At this beach wedding, guests enjoy seafood straight from the barbecue—grilled salmon fillets, lobster tails, and giant prawns—alongside corn on the cob and a lovely summer salad.

brunch

1 **FRUIT BUFFET:** For Sunday's departure brunch, indulge in the pleasures of juicy fresh-cut fruits.

2 **PASTRY PYRAMID:** The humble morning doughnut is given an exotic presentation with these dramatic pyramids.

3 **EGG STATION:** To signal "the egg station is over here," this antique étagère filled with farm-fresh eggs makes the ideal focal point for the room.

4 **FRITTATAS:** A great way to serve eggs to a large crowd—when it would be impractical to serve everyone custom omelets *à la minute*—is to create an assortment of frittatas with different ingredients, all arranged on a groaning board for quick and easy service.

5 **TOFFEE APPLES:** At brunch's dessert buffet, toffee apples on Popsicle sticks are sure to transport guests right back to childhood.

6 **STRAWBERRIES AND CHOCO-LATE:** The time-tested favorite combination is given a participatory twist here—guests can dip fresh strawberries into a trio of delights: light chocolate sauce, dark chocolate sauce, and toasted nuts.

10
music and the after-party

Close your eyes, take a deep breath, and imagine your wedding. I know what you see, and it's absolutely amazing. Now tell me: What exactly do you hear? Music sets a mood, creates a memory, and renews a spirit like nothing else on earth. So I firmly believe that from the moment your guests arrive, the air should be filled with romance, glamour, sexiness, sophistication, and pure delight—and what better way to get you there than with music! Whether you're kicking things off with a string trio playing at valet parking, or with an impressive show of strength such as an army of fifty violins at the cocktail reception; whether with a gospel choir or a harpist at the ceremony; whether with an iPod-speaker combination near the sign-in table or a world-famous deejay at the after-party, music creates energy and controls the flow of the celebration.

While your guests begin to arrive, prelude music sets the stage for the ceremony. As they move toward the ceremony, be careful to choose pieces that maintain an appropriate energy level for every moment. Next, processional music changes the mood and creates a sense of anticipation as the wedding party makes their way down the aisle. If the aisle is long enough, consider having a change in music just before you begin your bridal entrance. If the aisle is on the shorter side, a music change may seem choppy; instead, time your entrance to a natural break in the music or a change in its rhythm. Pause at the top of the aisle,

CUSTOMIZED FURNITURE: At this party in Anguilla, we used the existing patio furniture with our own custom upholstery and my signature flashlight-illuminated Lucite table.

time, allowing them to check their sound levels and get ready for the guests' arrival. Work with a well-trusted sound company that will ensure that every cable is long enough, that there's no interference with the cordless microphones, and that if there is a sound-related disaster, the company's on-site technician will be able to handle it. (Note that very few hotels or other sites have the proper equipment or staff. Either your band or deejay will provide sound, or you'll need to.) It's absolutely critical to make certain that all the musicians and sound staff share the same understanding of what you want, what you're paying for, and what will be delivered. This goes not only for the style of music; it also means giving the band or deejay specific lists of what *not* to play as well as a playlist of what you do want to hear. It's your party; so if "Pink Cadillac" isn't your favorite, scratch it off with a big red pen to guarantee that it doesn't appear in the repertoire. Last but not least, make sure your contract addresses every detail you can think of, not just band breaks and length of play, but their willingness to play overtime and at what cost. I've seen it all, including a wedding where the band walked away from a packed dance floor because their contract didn't include any stipulations for extended performance. I've been a guest at an all-white wedding where the band arrived in all black. I've even been to one where the band arrived somewhere else entirely, because they'd accidentally gotten the wrong address. I've also gone to parties where the band hits the buffet before the guests! The lesson is simple: Spell out everything in writing. Twice!

For the early parts of the wedding—the ceremony and the transition to celebration—many couples prefer music that's classical and subdued. Each chapter of a wedding has its own energy level, its own mood, with commensurate music. And when it's time to hit the dance floor and party, party, party, you'll want to transition to an upbeat sound and big vocals. I term this stage the "after-party," that moment when it's time to cut loose and bring everyone along for the ride. Get them up and out of their chairs, fill the dance floor, and feel the collective energy of your friends and family laughing and moving together.

The after-party can take place in another room, another area, or even just the center of the party space. Create an atmosphere that's conducive to letting your hair down. Set the lights a notch or two lower, trade in the round ten-top tables, the floral centerpieces, the waiters, and the live chamber orchestra for nightclub elements such as comfortable couches with an abundance of cushions, mirrored

cocktail tables decorated with votive candles, professional bartenders, and a high-energy deejay. For this chapter, regardless of budget, nothing beats the flexibility, verve, and breadth of styles that a first-rate deejay can provide. Bring in whatever you think will keep the party alive, from colored lights to mirrored balls, from an espresso bar to an assortment of specialty cocktails or—one of my favorites—tray-passed shooters that waiters present to guests *while they dance*, providing rocket fuel without missing a single beat. I don't want anybody to look back at their wedding and say, "I could've danced all night"—I want you to say, "I could've danced all night, and that's exactly what I did!"

1 ELEVATED PERFORMANCE: When you have good entertainment, it's important to provide an elevated platform, allowing the talent to have direct contact with the guests and entertain them on a personal level. 2 RETROFITTED CHANDELIER: A humdrum chandelier is reinvented by lifting it higher, and by fitting every bulb with a silk turquoise shade, pulling the light fixture's look into the principal scheme of the event.

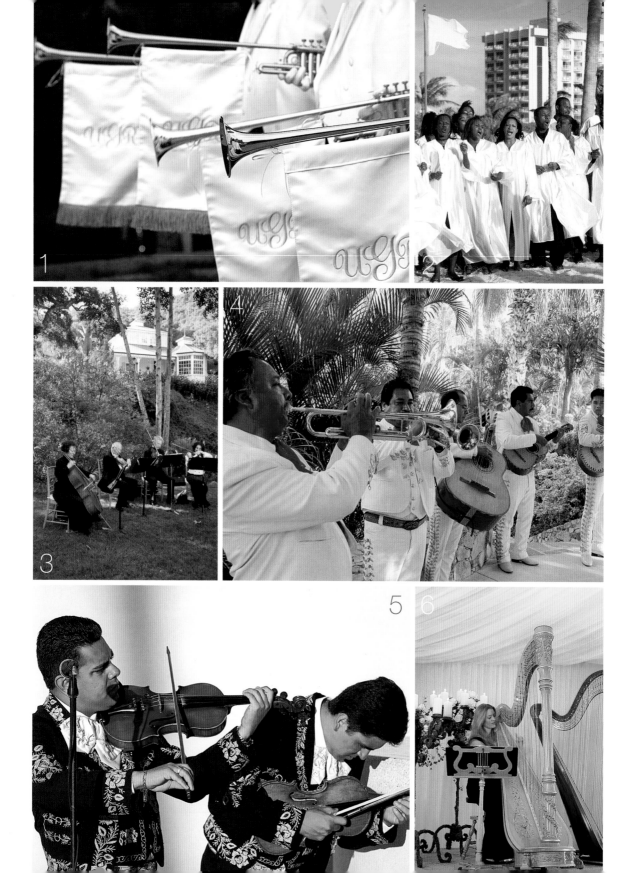

ceremony music

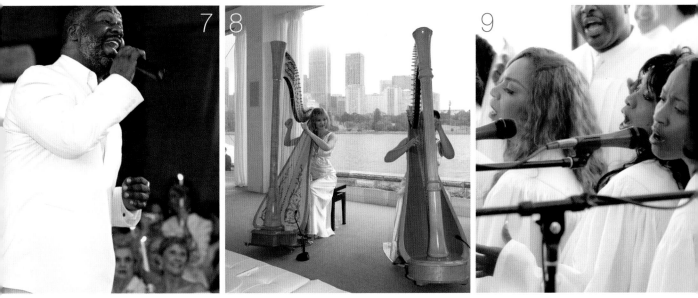

1 FANFARE: There's nothing quite like the sound of horns to herald the bride's entrance to a formal wedding. To personalize the trumpets, we adorn them with fringed banners that bear the initials of the bride and groom.

2 CHOIR: For this Bahamian wedding, the local gospel choir sings "O Happy Day" as the bride and groom are pronounced husband and wife.

3 QUARTET: Always appropriate, the most popular grouping of musicians at a wedding ceremony is the string trio or quartet. (And their most popular music? Handel's *Water Music* and Pachelbel's Canon in D Major.)

4 MARIACHIS: This handsome group welcomes the guests to the ceremony with Mexican love songs. Later the same group will lead guests from the ceremony to the reception, and they will continue to play throughout the cocktail hour—and well into the night.

5 DUO: Many cultures have songs that are particularly apt for weddings, and this string duo plays traditional Mexican wedding songs.

6 HARPS: Another extremely popular musical accompaniment to the ceremony is the harp—a single soloist or up to four of them. Be sure to specify what the harpists should wear, because they'll probably be featured in a prominent position.

7 VOCALIST: A vocalist is always appreciated, and provides the opportunity to create a little extra drama. Here, just before the exchange of vows, all the guests hold lighted candles while the Grammy Award–winning gospel singer B. B. Winans serenades the bride and groom.

8 MORE ROMANCE: A pair of harps is placed on either side of this ceremony area overlooking Sydney Harbor, creating a very romantic ambience.

9 GOSPEL CHOIR: I don't think there's anything as uplifting as listening to a gospel choir during the cocktail reception, to transition from the ceremony to the celebration.

cocktail music

1 DRUMMERS: For this Africa-themed wedding, drummers lead guests from the ceremony site to the cocktail reception.

2 FULL CHOIR: After a sunset barefoot-on-the-the beach ceremony, guests follow a fifty-piece choir carrying tiki torches to make their way to the dinner reception.

3 STEEL DRUMS: For a Bahamian beach wedding, guests are entertained by the traditional percussions of a steel-drum player during the cocktail reception.

4 OPERA SINGER: At a formal black-tie wedding, you can provide a night-at-the-opera sensation with a soprano singing a selection of well-loved arias during dinner.

5 FULL STRINGS: The opulence of this space comes to life with the equally opulent sound of violins, violas, cellos, and double basses.

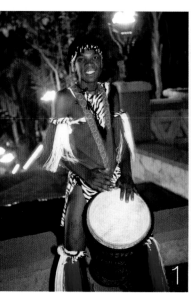
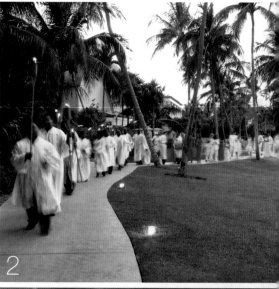

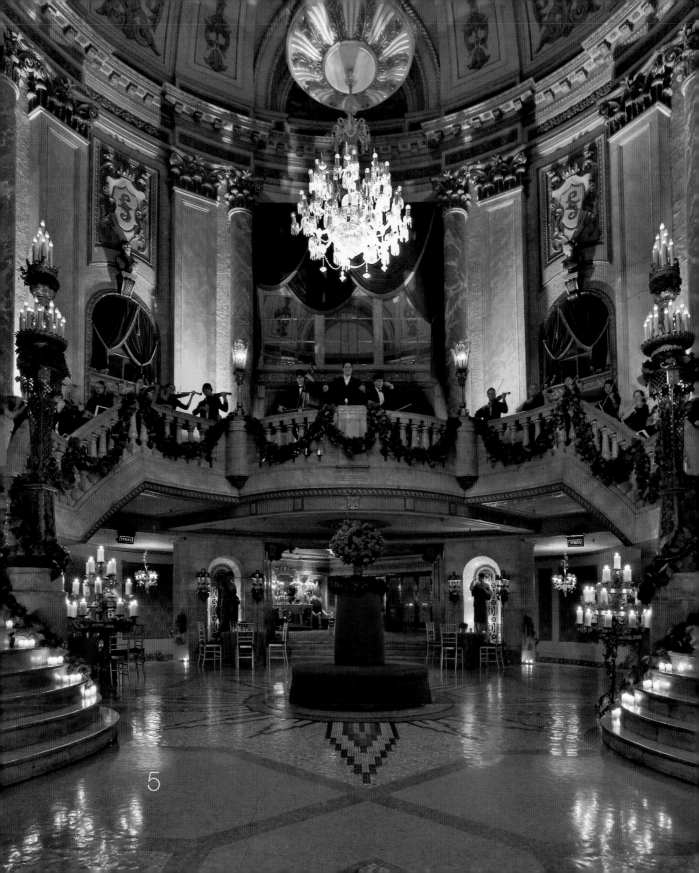

5

deejays and
performance artists

1 FIRE DANCERS: For
this beach wedding,
this series of dancers
ignites the dancing
portion of the evening.

2 HOUSE BANDS: Many
great bands today are
extremely versatile
and can play music
that ranges from the
top forty to popu-
lar standards. When
booking, make sure
to confirm not only
what the band will
perform, but also what
they won't perform
and what they'll be
wearing.

**3 TOMORROW'S ROCK
STARS:** The legendary
deejay Donna D'Cruz
has traveled the world
with me, getting
people on the dance
floor—and sometimes
keeping them there
until the sun comes up.

4 CAMPFIRE GUITAR: At
this beach wedding,
after the dinner and
the dancing, guests
cook s'mores over a
campfire while listen-
ing to the mellow
guitars of Anguilla's
famous Bankie Banks
(left) and his band.

**5 STUPENDOUS SPEC-
TACLE:** My favorite way
in the whole world to
burn money? Fire-
works. There's nothing
quite as spectacular,
and I don't know
a single soul who
doesn't respond to
pyrotechnics—the ideal
way to transition from
the dinner or cake cut-
ting to the after-party,
especially with an
ocean backdrop.

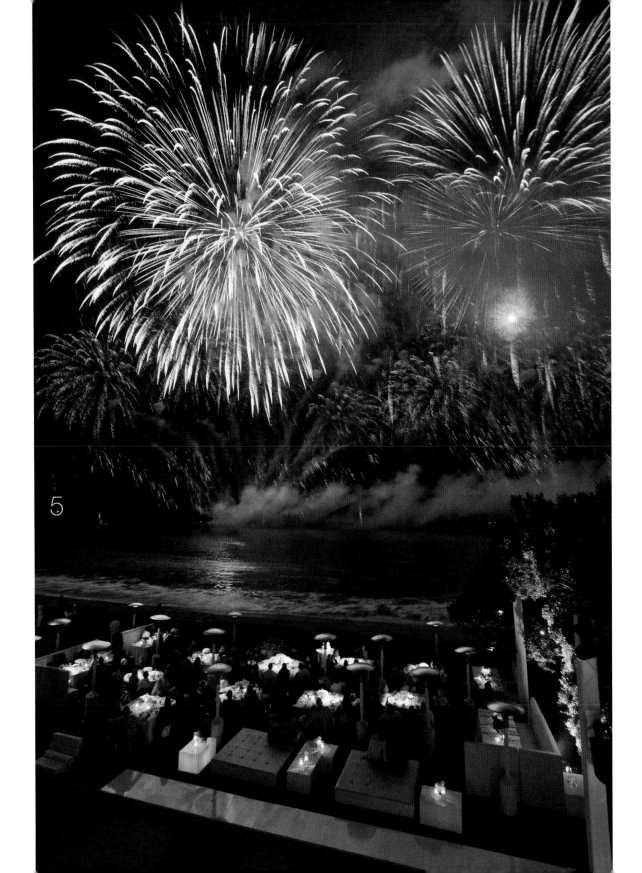

5

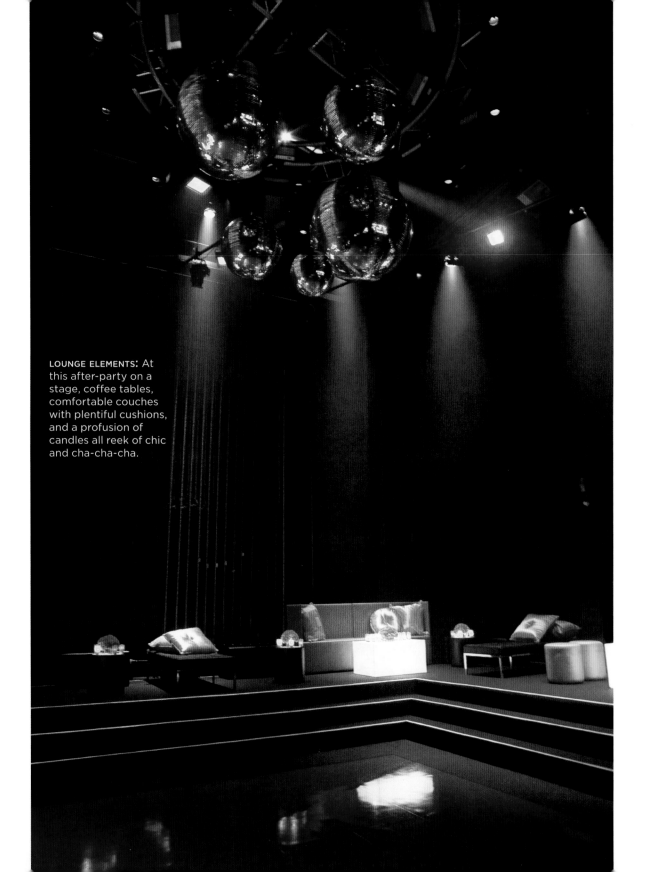

LOUNGE ELEMENTS: At this after-party on a stage, coffee tables, comfortable couches with plentiful cushions, and a profusion of candles all reek of chic and cha-cha-cha.

1 BEAUTIFUL DESSERT CART: This round table laden with a cornucopia of desserts brings a sweet fantasy to life, with a stunning model in the middle and wheels on the bottom, carrying the confections around the after-party.

2 IRIDESCENT DANCE FLOOR: To create this dance floor, we draped the walls in an iridescent gauze, then laid down a wooden dance floor that's covered in gam (a thick, durable contact sheet) in a glittered turquoise.

3 JUMP-START: A little after-dinner entertainment never fails to add a last jolt of excitement to the party.

4 CURTAIN UP: This opulent dinner reception takes place on a platform suspended over the seating area of the auditorium, and after the meal, the curtain rises, revealing the sexy after-party on the stage itself.

5 CLUSTERED MIRRORS: Why have one mirrored ball when you can have ten? This cluster of different-size disco balls, hit from all sides by spotlights, is a mesmerizing way to get your guests spinning on the dance floor.

1 SCULPTURE: For this cocktail reception, sculptural accents are created with standard tables that are decorated with spandex slipcovers punctuated within by hula hoops.

2 ORANGE CRUSH: By bathing the room in one color, we create a uniform look that's further brought to life with candles.

3 TABLE TALK: In any room with a large group of people, it's a good idea to accent the space with tables and bar stools to create small conversational groups, not to mention to allow guests to sit and relax.

4 COLOR PROGRESSION: Here the same room has rotated from pink to orange to red, casting a sexy glow over the celebration.

5 NIGHTCLUB AFTER-PARTY: To create the ambience of a nightclub, large foam beds are slip-covered in tactile fabrics such as eyelash fringe and velvet, then topped with comfortable cushions and surrounded with illuminated Lucite boxes. As in most nightclubs, the mood is set with light and candles, not with flowers.

6 RESTAURANT CONVERSION: This after-party takes place in a restaurant whose dining tables have been replaced by low cocktail tables and pods for lounge-like seating.

7 BREATHTAKING BACKDROP: Behind the stage, a hanging screen fashioned from square mirrored orange Plexiglas panels alternating with round ones creates a dazzlingly glamorous backdrop.

8 SEXY SURFACE: Tabletops are covered with rounds of orange Plexiglas mirror, reflecting not only the ceiling above but the surrounding candles and flowers.

9 MACRO ORGANISM: Thinking out of the box—the boxy dance floor, that is—we create an organic-shaped dancing area by covering the wood with an orange iridescent gam, then a carpet, and then cutting the carpet into a flowing shape for an interesting silhouette.

10 QUICK SET: Punctuating the evening with a high dose of celebrity glamour, the highlight of this reception is a cameo appearance of just a few songs performed by Lionel Richie.

1 SLIPCOVERED STOOLS: Zebra skin, the principal motif of the original El Morocco, adorns these high stools.

2 GLOWING TABLES: I love Lucite coffee tables that are lit from within, and here those interior lights are flashlights that are gelled in a vibrant Schiaparelli pink, creating an explosive contrast with the black-velvet-covered wall.

3 BAR BACKDROP: The cocktail bar is always one of the focal points of the party, so try to transform a makeshift tent bar into something as permanent looking and visually appealing as possible, as was done here with rear-lit Lucite shelves and a wall of black velvet tufted with small square mirrors.

4 LOUNGE DETAILS: It's all about the little touches, such as the silk tassel hanging from the end of a long thick bolster, surrounded by velvet and satin cushions.

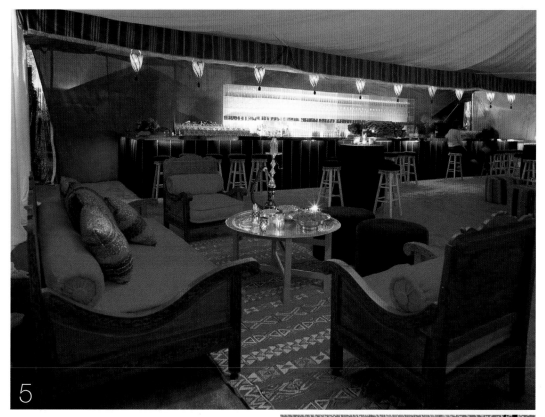

5

6

5 SHOPPING SPREE: Although rental companies can offer nearly any style of décor you want, sometimes it's cheaper to buy. We were in Marrakech to pick up just a couple of things, but ended up sourcing the entire after-party décor—tables, lanterns, carpets—and filling a forty-foot container with the makings of this decadent nightclub.

6 MYSTICAL ARRIVAL: Gold chain hangs at the entrance, imparting a sexy, forbidden quality to the transition.

1 FRINGED SEATS: These inexpensive bar stools are given a full-body makeover with the simple addition of velvet slipcovers with gold fringe.

2 HOOKAH STATIONS: In keeping with the Middle Eastern theme, hookah pipes are set up, and attendants keep them burning with apple-flavored tobacco.

3 CANOPIED BAR: Every bar is a focal point, and this one lives up to its calling with a mirrored top under a billowing canopy punctuated by glowing lanterns.

4 ROSE PETALS: The floor is covered ankle deep in rose petals that were taken from the ceremony site, creating a romantic rug for the ottomans, beanbags, and illuminated coffee tables in this stunning black-and-white tent.

5

5 **AFTER AFTER-PARTY:** After the after-party, the still-standing guests head to the small Moroccan tent for the final leg of the evening, before following lanterns to the valet parking.

6 **CIGAR AFICIONADO:** Since the groom is an avid cigar smoker, we custom-labeled cigars with personalized wrappers for the newly married man and his fellow smokers.

6

1 SUNKEN DANCE FLOOR: The tent of this after-party features a sunken dance floor, white leather seating, and, behind the double doors, a wraparound patio overlooking the ocean.

2 WARM WELCOME: A small bar stands at the very entrance to the party, where master mixologist Dale DeGroff greets guests with a choice of five expertly crafted specialty cocktails.

3 INTIMATE SEATING AREAS: The polished floor is dotted with small vignettes of comfortable furnishings in groups of threes and fours, allowing for intimate conversations in the large nightclub space.

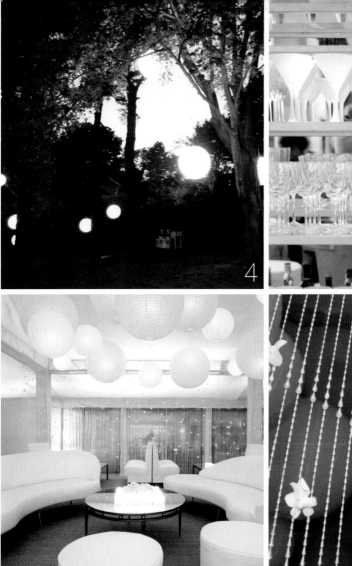

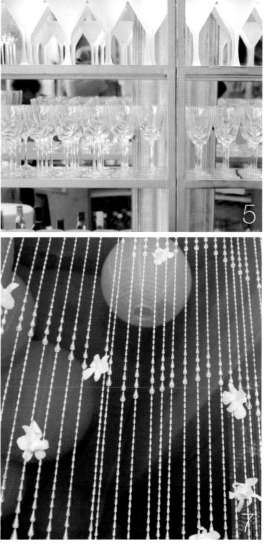

4 CHINA BALL: For an all-white wedding, the visual theme of the after-party is white Chinese lanterns, here hung from the trees to create a path leading to the after-party.

5 FROSTED GLASSWARE: To maintain the all-white theme through every last detail, the bar is stocked with frosted-white cocktail glasses.

6 OVERSCALE FURNI-TURE: The extradeep pieces of white furniture allow for large groups to lounge while overlooking the dance floor.

7 BEADED DRAPES: These minimalist, elegant draperies are punctuated with equally minimalist and elegant dendrobium blossoms.

1 DRAPED IN FABRIC: The dance party for this reception takes place in an unfinished loft building, whose raw cement walls are draped in white fabric, raw floors are covered in white carpet, and raw open spaces are filled with overstuffed furniture.

2 VIDEO GAMES: Behind the bar, a video loop displays some of the memorable moments of the bride and groom's premarital days, hung against a backdrop of yet more white draperies.

3 LE DIRECTOIRE: Instead of bar stools, the seating here is tall director's chairs, imparting the look of a cleanly decorated residential space.

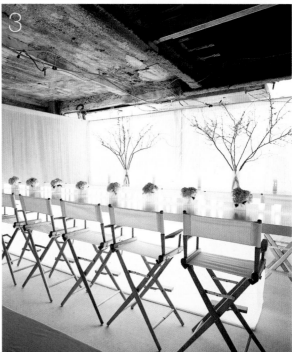

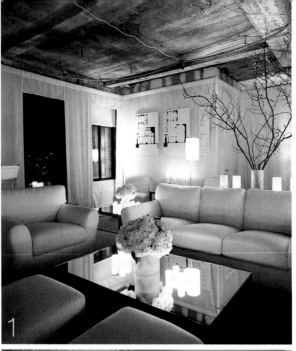

honeymoon suite and after the after-party

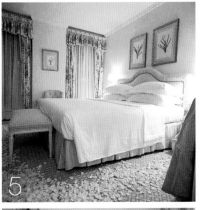

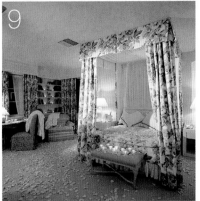

4 BRIDAL SUITE: This elegantly decorated small tent, erected next to the main tent, gives the bride an opportunity to change outfits, remove her veil, touch up her makeup, and take a deep breath with some degree of privacy. (And it also gives the mother of the bride, a closet smoker, a favorite room.)

5 ROMANTIC CARPET: A carpet of rose petals paves the floor of the honeymoon suite.

6 CUSTOMIZED BED: The bride's and groom's initials are created using cerise bougainvillea blossoms.

7 WARM WELCOME: Rose petals are used to create a heart at the entry to the bride and groom's suite.

8 SEXY SHEETS: A bed that's ankle deep in rose petals with pillows garnished by fresh gardenias leaves much to the imagination.

9 FAIRY-TALE ENDING: Rose petals scattered on the floor, candles for the lighting, Champagne next to the bed, a blanket of rose petals . . . and they will live happily ever after.

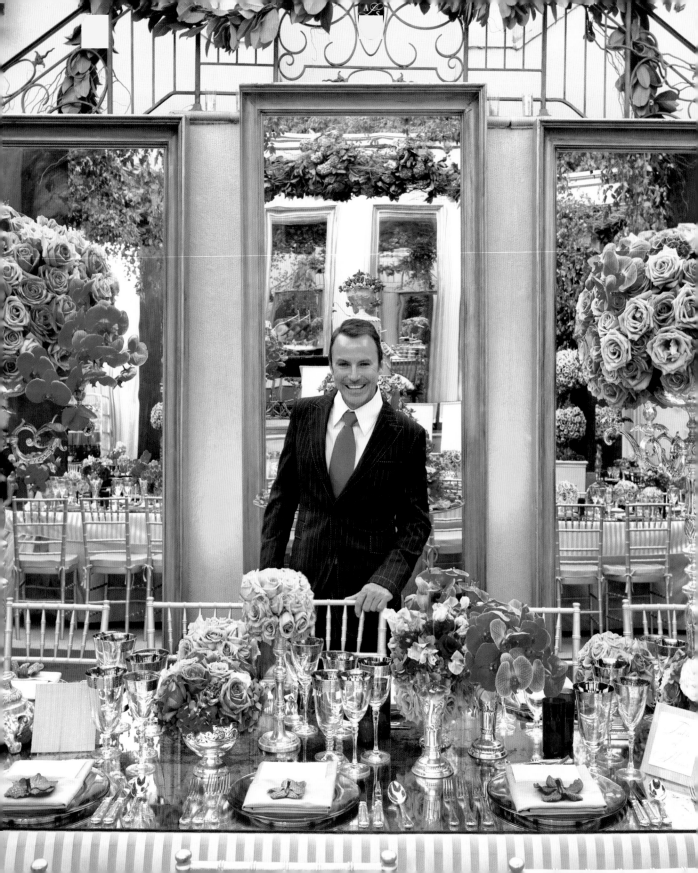

conclusion

Now that it has all come together, you're standing at the top of the aisle, in the dress of your dreams, in a place that means the world to you. The people you love have arrived, the officiant is ready with a reading that never fails to move you, and the band, chef, and waiters are standing by. At this moment, I'd like to share with you the advice I give to every bride and groom I work with: Take a deep breath and let go of the million decisions you've had to make. That's right, I insist you stop thinking of all you've put into creating this day.

Why? Because I want you to enjoy this one special moment, standing right here, right now, ready to take the first steps toward your new life as husband and wife. And then I want you to savor each and every one of the moments that follow.

Yes, you've given a lot of thought to the details that will make up the next few hours, but your family and friends are here for one purpose: to celebrate one of the most significant occasions in your lives. They're not here for the perfect wedding. There's no such thing as the "perfect" wedding. Your best is good enough.

I know you've done your best to make this experience as extraordinarily beautiful as possible for your guests. You've put a lot of heart and more than a little of your soul into every detail. So now it's time to enjoy the celebration! Trust me, if something goes wrong, it won't spell disaster. In fact, very often, you'll be the only person who notices the mistake. So if the band plays one of the songs you crossed out with the red pen twelve times, I beg you: Don't let it be a problem. Remember that you are surrounded by the pure energy and unwavering love of the most important people in your lives. It's time to focus on one thing, and one thing only: the powerful joy of your wedding day.

So sip the Champagne, taste the food, and dance until your feet threaten to strike if you take one more whirl across the floor. Then delight in the cake, be touched by the toasts, reconnect with friends—and create memories that will last forever.

...

SWEET ANTICIPATION: My favorite moment is just before the guests arrive, when every flower is in place, every candle has been lit, every detail has been agonized over, and it's time to let it all go and simply enjoy. . . .

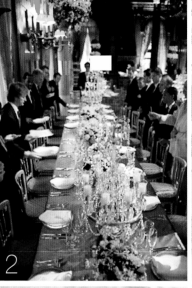

1 Securing the tent frame properly in case of wind, storms, and inclement weather means the difference between a successful party and a possible disaster.

2 Excellent service requires training, training, and more training!

3 Real French doors are built into the tent structure.

4 Crown molding and drapery anchor the dance floor.

5 Champagne glasses are ready for the bridal party immediately after the ceremony.

6 Boxes of flowers waiting to line the ceremony aisle.

7 Being organized is critical.

8 A proper set of plans is helpful when setting the tables and chairs in the dining room.

resources

PHOTOGRAPHERS

Paula Adams Wedding Photography
www.intengu.co.za

Jeffrey Asher Photography
www.jeffreyasher.com

Quentin Bacon
www.quentinbacon.com

Andrew Bicknell Photography
www.andrewbicknell.com

Virginie Blachère Photography
www.virginieblachere.com

Matt Blum Photography
www.mattblumphotography.com

Joe Buissink Photography
www.joebuissink.com

Kaish Dahl Photographers
www.dahlphotographers.com

Yitzhak Dalal Photography
www.dalalphotography.com

Len DePas Photography
www.lendepasphoto.com

Elizabeth Etienne Photography
www.eephoto.com

Jonathan Farrer
www.farrerphoto.com

La Storia Foto
www.lastoriafoto.net

Nadine Froger Photography
froger.pochet@att.net

Matt Gillis Photography
www.gillisphotography.com

Alec Hemer Photography
www.triciajoyce.com

Beth Herzhaft Photography
www.herzco.com

Garett Holden Photography
www.garettholden.com

Eliot Holtzman Photography
www.eliotholtzman.com

Lyn Hughes
www.lynhughesphoto.com

Robert Isacson Photography
www.isacsonphotography.com

Magnus Länje Photography
www.magnusphoto.com

Robin Layton
www.robinlayton.com

Mark Leibowitz
www.markleibowitz.com

Frédéric Marigaux
www.fredwp.com

Colin Miller Photography
www.colinmillerphoto.com

Michelle Pattee
www.michellepattee.com

Cheryl Richards Photography
www.cherylrichards.com

**Donna Salvelio Photography &
 Videography**
www.salvelio-donna.com

Mallory Samson Photography
www.mallorysamson.com

Julie Skarratt
www.julieskarratt.com

Jasper Sky Photography
www.jasper-sky.com

Angela R. Talley Studio
www.angelatalley.com

Timothy Teague Photography
www.photowedding.com

FLORISTS

S. R. Hogue & Company
www.srhogue.com

L'Olivier
www.lolivier.com

Mark's Garden
www.marksgarden.net

Sherry Nahid Design
www.sherrynahid.com

Bardin Palomo
www.bardinpalomo.com

CALLIGRAPHERS / INVITATIONS

La Artista
www.laartista.net

Creative Intelligence
www.creative-intelligence.com

Loon & Co.
www.loon-co.com

Margot Madison Stationery, Inc.
www.margotmadisonstationery.com

Ellen Weldon Design
www.weldondesign.com

LIGHTING

Bentley Meeker Lighting & Staging
www.bentleymeeker.com

Images by Lighting
www.imagesbylighting.com

CATERERS

The Fine Art of Catering
www.thefineartofcatering.com

Mary Giuliani Catering & Events
www.mgkitchen.com

Paula Le Duc Catering
www.paulaleduc.com

Robbins Wolfe Eventeurs
www.robbinswolfe.com

RENTALS
(tenting, props, and décor)

Angel City Designs
www.angelcitydesigns.com

Bruce Thompson Creative Services
brucewt@yahoo.com

Classic Party Rentals
www.classicpartyrentals.com

Mark Daukas Ice Designs
markdaukasdesigns@cox.net

Drew Studio
drew@drew-studio.com

Indigo Moon Linens
www.indigomoonlinens.com

Frank Matullo Production Artist
fmatullo@productionartist.com

Party Rental Ltd.
www.partyrentalltd.com

Props for Today
www.propsfortoday.com

Resource One, LLC.
www.resourceone.info

Stamford Tent
www.stamfordtent.com

Taylor Creative Inc.
www.taylorcreativeinc.com

Unique Tabletop Rentals
www.uniquetabletoprentals.com

Your Green Room
www.yourgreenroom.com

BAKERIES

Margaret Braun's Sugar Objects
www.margaretbraun.com

Colette's Cakes
www.colettescakes.com

Linda Goldsheft's The Cake Studio
www.thecakestudio.biz

Sam Godfrey's Perfect Endings
www.perfectendings.com

Polly's Cakes
www.pollyscakes.com

Sweet Lady Jane
sweetladyjane.com

Sylvia Weinstock
www.sylviaweinstock.com

FIREWORKS

Atlas Pyrotechnics
www.atlaspyro.com

Fireworks by Grucci
www.grucci.com

MIXOLOGISTS

Barmagic of Las Vegas
www.barmagic.com

Contemporary Cocktails
willy@contemporary
 cocktailsinc.com

Dale DeGroff Company
www.kingcocktail.com

Elite Elixers Cocktails
ysfaustin@yahoo.com

VIDEOGRAPHERS

After Image Videography
rosemary.jenseth@verizon.net

Bluecat Productions
Marc@bluecatpro.com

Milk and Honey Productions
www.milkandhoney
 productions.com

Vidicam
www.vidicamproductions.com

ENTERTAINMENT

DeBois Entertainment
www.deboisentertainment.com

DJ Cassidy
damon@dgimanagement.com

DJ Frank Rempe
www.frankrempe.com

Empire Entertainment
www.empireentertainment.com

Rasa Music
www.rasamusic.com

Screaming Queens Theatrical
alexjh2@earthlink.net

Tom Finn/Topspin Entertainment
djtomfinn@yahoo.com

1 Every detail counts, even how the napkins are folded.

2 Floral decorations are waiting to be added to the wedding cake.

3 Flowers are kept out of the sunshine until ready to be set on the dining tables.

4 The finishing touches to the wedding cake are made on-site.

5 Table runners are placed on top of the cloths to finish the look.

6 Once the tables are placed and set, lighting needs to be the focus.

7 The ceremony tent slowly takes shape: flooring is installed, flowers placed, and the team is in full production.

8 The ceremony area comes together.

9 The after-party flowers are set in disco balls converted to vases.

1

2

3

4

5

6

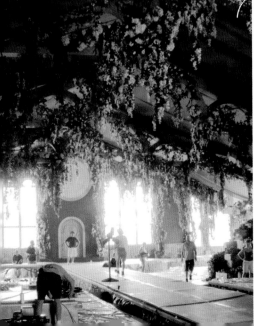

7

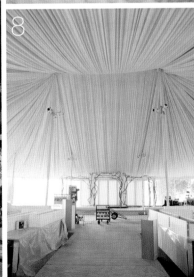

8

9

acknowledgments

So many people had their hands in making this book a reality and to thank each and every one properly would require another hundred pages. It's been an incredible journey of more than twenty years working on five continents with the most extraordinarily talented florists, lighting designers, photographers, prop builders, rental companies, and the glue that's pulled it all together—my dedicated staff of professionals, the team at Colin Cowie Lifestyle.

To each and every bride who inspired my creativity, thank you for making my journey so exciting and rewarding. To every florist who magnificently captured my vision with flowers, your talents have brought my vision to life. To every photographer whose images are showcased on the pages of this book, I know how much love and passion you put into capturing the magic. And to every professional who was involved in each event and helped produce the extraordinary productions for which Colin Cowie Lifestyle has earned its reputation: thank you from the bottom of my heart. With sincere appreciation I thank everyone for the collective effort you've made. The past twenty years of work is a journey filled with memories of laughter, friendship, and ultimately triumph, which all of us event industry understand and appreciate.

Thank you to the talented Chris Pavone, whose idea it was to write this book and without whose energy and enthusiasm it would never have been possible. To Lisa Kogan, whose style with words helped me bring excitement to the text and shape the tone of this book. To the gifted and amazing team at Clarkson Potter: Aliza Fogelson, my dedicated editor, for all her passion; Marysarah Quinn for her incredible vision with the art direction; and Jennifer K. Beal Davis, whose design of the book makes my work come alive.

To my agent, Margret McBride, for believing in my vision and being there from the very beginning when my very first book was penned. To Colin Miller, whose images are spread throughout the book, and whose organization and dedication pulled everything inside to a cohesive whole—a job well done. And finally, to my life partner and business partner, Stuart Brownstein, whose impeccable taste, passion, and commitment are part of every page.

Thank you.

index

photo credits

The author gratefully acknowledges the following photographers who contributed photography for the book:

Colin Miller
Garett Holden
Joe Buissink
Alec Hermer
Julie Skarratt
Annabelle Moeller
Nadine Froger
Deborah Feingold
Robert Isacson
Jeffery Asher
Andrew Bicknell
Matthew Gillis
Mallory Sampson
Len Depas
Timothy Teague
Rafael Reisman
Magnus Länje
Bart Kressa
Cheryl Richards
Jono and Gorman
Beth Herzhaft
Salvelio Meyer
Donna Watson
Kaish Dahl
Quentin Bacon
Brian Miller
Jean Jacques Pochet
Lyn Hughes
Frederic Marigaux

The author gratefully acknowledges the following photographers for granting their permission to use the following photographs:

pages 8, 36 (top right), 40 (top right), 53 (above), 238, 242, 253 (top center), 258 (second row, right), 270: © Matt Blum

pages 28 (above left), 29 (above left), 31 (bottom), 32 (top right), 33 (center), 35 (right), 38 (bottom left), 43 (left, center), 183 (top left), 216 (bottom), 240, 241 (below), 255 (center), 266 (second row, left): © Yitzhak Dalal

pages 28 (below left), 251 (top right), 255 (top row), 267 (second row, right): © Jasper Sky Photography

pages 32 (bottom left), 34 (left and right): © Alison Duke

pages 36 (bottom left), 40 (bottom left), 94 (bottom right), 130 (bottom right), 132 (bottom right), 134 (bottom), 251 (bottom left), 253 (top right), 258 (top left), 267 (top right): © Virginie Blachère

pages 36 (bottom right), 246 (left), 256 (bottom left), 284, 285 (top): © Mark Leibowitz

pages 43 (below left), 266 (top left), 267 (top left): © Robin Layton

pages 177, 239, 260 (far left), 273, 285 (bottom right): © Paula Adams

page 188 (bottom right): © Alan Richardson, originally published in *Brides*